KENT·INSTITUTE OF·ART·&·DESIGN

Canterbury
New Dover Road
Canterbury
Kent
CT1 3AN

Tel: 01227 769371

Fax: 01227 451320

Practical Exposure in Photography

The Practical Series

Practical Composition in Photography Axel Brück
Practical Exposure in Photography Leonard Gaunt
Practical Effects in Photography Carl Bernard & Karen Norquay
Practical Wildlife Photography Ken Preston-Mafham

Forthcoming titles:
Practical Landscape Photography
Practical Black and White Photography
Practical Colour Photography
Practical Colour Printing
Practical Developing

Leonard Gaunt

Practical Exposure in Photography

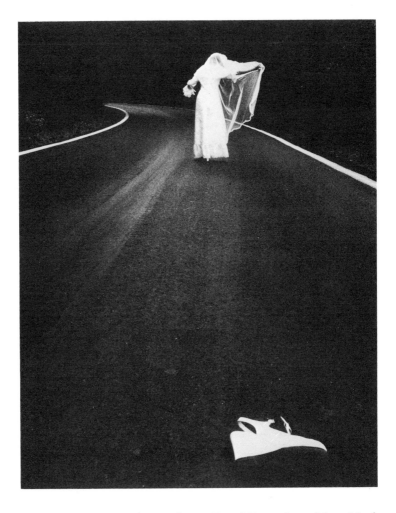

Focal Press Limited, London Focal Press Inc., New York

© Focal Press Limited 1981

🅱️🇱 British Library Cataloguing in Publication Data

Gaunt, Leonard
 Practical exposure in photography. – (The practical
 series).
 1. Photography – Exposure – Amateurs' manuals
 I. Title II. Series
 770'.282 TR591

ISBN 0 240 51058 5
American Library of Congress Catalogue No. 80–40793

First Edition 1981

Focal Press Ltd, London

Focal Press Inc., 10 East 40th Street, New York, NY 10016

Associated Companies:
Pitman Publishing Pty Ltd., Melbourne
Pitman Publishing New Zealand Ltd., Wellington

Series designed by Diana Allen
Printed in Great Britain by A. Wheaton & Co, Exeter
and bound at The Pitman Press, Bath.

Contents

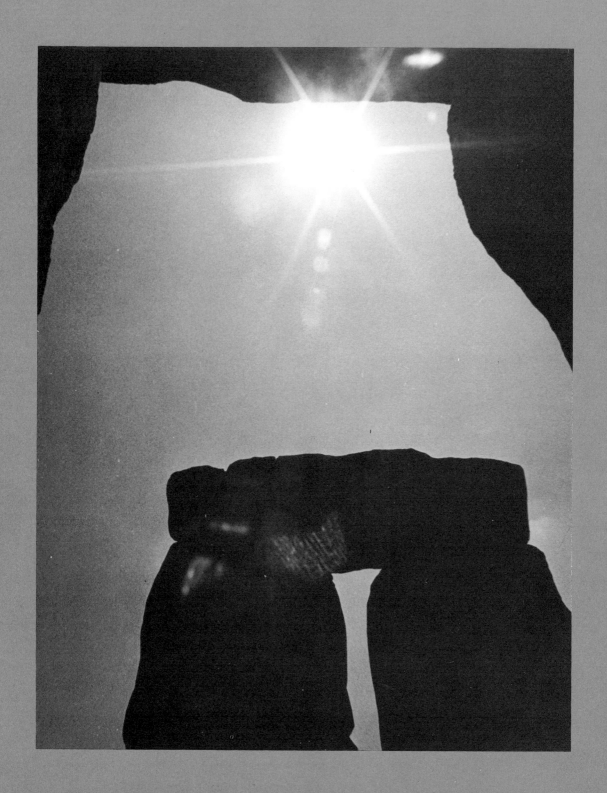

Introduction

Automatic exposure cameras and TTL meters have been with us for a long time now. They are very useful, allowing the average photographer to take pictures with barely a thought about the true function of exposure. Provided the right light blinks, or the needle reaches the right position, exposure will be correct and all you have to do is to press the button.

Fortunately, this is true for most pictures. On the odd occasion when it is not, you have an exposure compensation dial which the instruction book tells you how to set for backlighting and other strange circumstances.

The snag with this automated approach to exposure is that those who have been brought up on it may find it difficult to break away when they start taking their photography more seriously. It is not long since photographers had to rely on the knowledge they gleaned from exposure tables plus their own practical experience to get the exposure right. Experience taught them the basics. They learned to relate exposure to the lighting, the nature of the subject, the developer and the result they wanted. They had to, because their films were less tolerant of exposure variations without compensating changes in processing.

The earlier photographers often developed their films or plates under a safelight, and would see the image build up. So they had a visual system of processing adjustment according to exposure. Nowadays we develop by time and temperature, like baking a cake, and are encouraged to believe that the whole photographic process can be reduced to a simple programme. So it can, for the photographer who needs a camera purely as a tool for recording; for that purpose the automatic camera is a perfectly valid concept. It can also be used much more creatively – but only if the user fully understands what exposure is all about.

Compare the old and the new approach. A landscape photographer might find a softly-lit autumn scene, by the river perhaps, with trees, grassy banks, a building or two, and a little life on the water. It would probably be a long-scale subject with a full range of tones from almost pure white to reasonably deep

shadow. But the light is soft, with no direct sun and a fair amount of cloud cover.

How does the average amateur photographer of today treat such a subject? To him it is obviously made to measure for automatic exposure. All he needs to do is to point his camera at the subject, select a reasonably small aperture for depth of field, line up his needles and shoot. He gets a fully-detailed shot that looks quite pleasant – but somewhat dead. The soft lighting flattens its tones. The whites are less than white, and there is no real black anywhere, because the diffuse light illuminates every shadow. If he does his own processing, he may decide that he has to print on a more contrasty grade of paper.

How would the old-style photographer have treated the same subject? Without an exposure meter, he would rely on his experience for the camera settings. Quite possibly his exposure would be about the same as that given by the modern photographer (allowing for differences in film speed), or more likely a little less. Then he would develop the single film or plate by inspection, watching the image build up. He would know how the image should look under his safelight and would remove the film from the developer at just the right time. This would probably be proportionately longer than that given by the modern photographer (again allowing for differences in materials) and longer than he himself would have given if the scene had been sunlit. The negative would print superbly on his only grade of paper. It would show clean whites, dark shadows and a good rich black in small dense shadow areas. It would still be a softly lit scene, but would look bright instead of dull.

The difference is entirely due to an understanding of the process. The old-style photographer had learnt by experience that soft lighting means low contrast, which is not the same as dull lighting conditions. He knew that a print of such a subject needs the added sparkle of cleaner highlights and deeper shadows. He knew that, within reason, a photograph of such a subject called for the minimum exposure consistent with detail in the shadows and for development prolonged until the required detail showed in the shadow areas of the image.

For him, it was not a matter of underexposure and overdevelopment, as we might call it now: it was standard treatment for that type of subject. He had no exposure meter set to a certain speed figure to tell him that he was departing from the manufacturer's recommendations. No quivering needle or flashing light warned him that he was defying his camera's electronic brain. He knew!

This is the kind of thing the modern photographer has to

learn if he wants to understand the true function of exposure and the limitations of the 'programmed' approach.

But – and it is a big 'but' – few of the old-time photographers worked in colour. With them, exposure and processing went hand in hand. Today's colour photographer generally has to rely on somebody else to apply a standard processing technique to his films.

Even those who do their own colour processing have very little control over contrast and tonal gradation. They can extend or curtail development time, but only to a limited extent. Drastic variations can bring about undesirable changes in colour.

For this reason, there is a tendency in this book to explain the principles in terms of monochrome photography. The principles are exactly the same, whatever type of film you use. Exposure is primarily concerned with densities, and only incidentally with colour. More exposure leads to more density and less colour until, with maximum density, all the colours combine to produce black.

I have deliberately begun this book a little way along the road, believing that most readers will already have some idea of what exposure is all about. If, in fact, you are still feeling your way in the field of photography, read the final chapter first. This chapter contains the basic information which may well be tedious for those who have read it all a hundred times before. It explains how you control exposure by adjusting shutter speed and lens aperture, the meanings of the markings on the lens barrel and the shutter speed knob, and how exposure meters work. It is written with the enthusiastic beginner in mind, and makes the book a little shorter for those who do not need to read it.

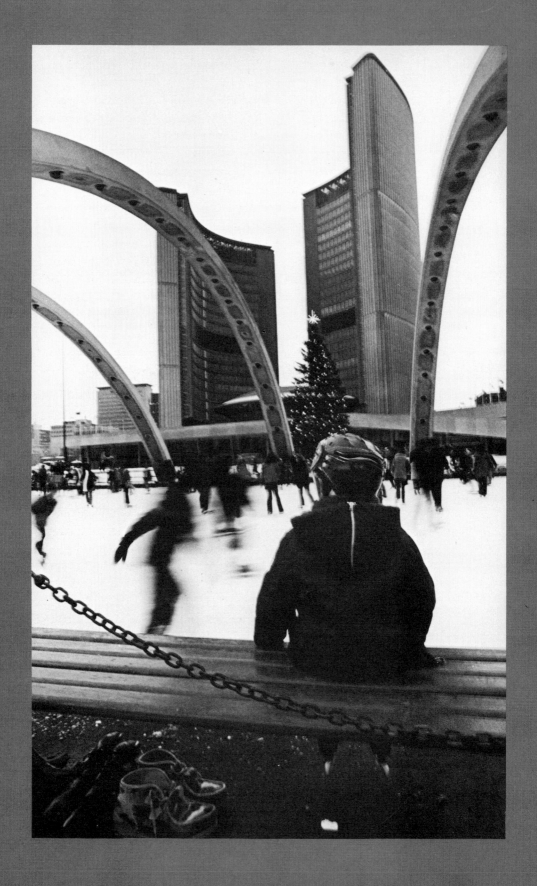

1 The Basic Problem of Exposure

Everybody who writes about exposure sooner or later has to bring in Ansel Adams and his Zone System. So let us make it sooner rather than later. First, Ansel Adams introduced his particular system more than thirty years ago and the tools of photography, particularly films, have changed a lot since then. Secondly, it is difficult to use his system with rollfilm. Thirdly, not one in a thousand photographers has Adams' dedication, organizing ability or patience, not to mention his talent. And, as this book is principally for those to whom photography is a hobby, few will consider that they have the time to make the exhaustive tests or keep the extensive records that Adams' system demands.

Nevertheless, it is possible for any photographer to use part of Adams' system; in fact, much of this book is based on his ideas of tone visualization. He was not alone, of course, in pointing out that both the subject and the photograph consist of a collection of tones. How many discrete tones there are in the original and how many you can reproduce is largely irrelevant. For normal pictorial reproduction the idea is to reproduce as exactly as possible the tones of the original. The fact that we can usually appear to do so is a tribute to the photographic process, despite all its well-publicised limitations.

Limitations of the process

Perhaps the most often quoted limitation is that a black-and-white paper print has a tonal range of only 1:50 or 1:60 (less for non-glossy prints). This is considered very restrictive, yet how many of us can say that we have been frustrated by the fact that the paper is incapable of bringing out the full quality of our perfectly exposed negative? Many of us may well find it difficult to make a good print from a given negative but the fault generally lies in the original camera exposure, not the paper.

Most photographic subjects have a tonal range no greater than about 1:100. If you do not believe this, try it. Take your hand-held meter to your favourite subject and measure the darkest shadow area and the brightest highlight in which you

would want to see detail in the print. If you do not have a hand-held meter, you would be well advised to get one. There are so many occasions when a through-the-lens (TTL) meter is just too clumsy to use. There is no need to spend the earth on it: a good selenium type is perfectly adequate and needs no battery.

A typical amateur film can handle a range of tones in the subject of 1:200 or more. Of course, a subject can have a much greater tonal range than this, but such subjects are by no means as common as you might think. When they do occur, there are special treatments that can help us cope with them. Of all the problems facing the photographer, the unlikeliest is that of running across a subject with which his film cannot cope. His real problem is to learn how to get those tones on to the film. In most cases, it is a question of getting the camera exposure right.

Tonal representation
A very useful way to approach this problem is to follow Ansel Adams' idea of envisaging the tones of your subject in ten steps. Those given here are not Adams's precise groupings, but they are broadly similar, and are more appropriate for the purpose of this book:

1 Total black. Openings into dark areas (windows, doorways, arches, etc.) shot from brilliantly lit areas. Deepest shadows. Any dark area in which no detail is required.
2 Darkest tone short of total black. Deep shadow with some tone but no detail. Some distortion (errors in hues) possible with colour film.
3 First sign of detail in dark tone. Black fur texture. Detail in black ironwork, clothing, wood, etc. Possible distortion in colour.
4 Less than black. Average dark tones of clothing, hair, tree bark, etc. Dark foliage.
5 Average shadow from sun in clear sky. Normal foliage. Very sunburnt or dark skin. Green grass in wet conditions.
6 Standard mid-tone of 18–20% reflectance. Average shadow value in sun plus cloud. Average sunburnt or darkish skin. Red brick. Green grass in dry conditions.
7 Fair skin. Deep blue sky. Stone or light brick buildings. Cornfields. Newsprint.
8 Lightest grey, silvery, pale yellow, green and cream tones. Last sign of colour for colour film. Very pale skin. Paving stones. Snow in shade. Typescript on white paper.

9 White with slight detail. Embroidered table linen, bridal dress, etc.

10 Dead white with no detail. Strong light sources. Fully lit white backgrounds. Specular reflections (ie reflections from polished surfaces).

These are approximately the tones that should appear in the final image, representing recognizable tones in the subject. Check them for yourself, using a reliable hand-held meter and an 18% reflectance grey card (obtainable from photographic dealers) as the standard for comparison. You can, of course, add to this list and even extend it to half-steps if you feel you can work that way. Ten steps such as these, however, are reasonably easy to remember. In a difficult situation you will be able to recall that, on the average sunny day, ground shadows

Few prints achieve the darkest black or the emptiest white. The numbered tones on the grey scale correspond approximately with the numbered tones on the print and in the text.

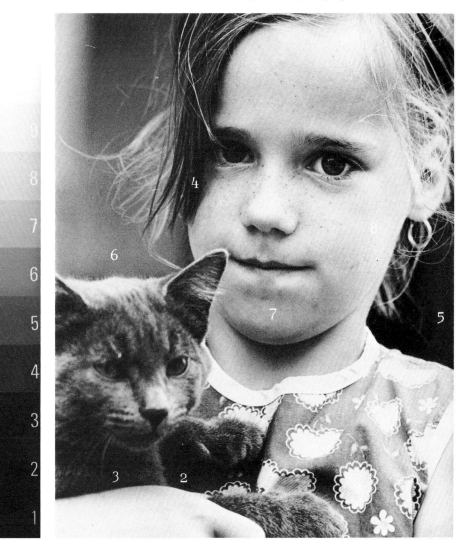

in open areas should be about equal to a mid-tone reading. Alternatively, a direct measurement of a deep blue sky should give you about one stop less than a mid-tone reading.

The principle of this listing is that each tone is approximately one exposure step (or stop) from its neighbour. Within this range the average film can reproduce these tones proportionately. In other words, if one of these tones is reproduced correctly, all the other tones will fall naturally into place. To explain this, we need to go (briefly and with the minimum of technicalities) into the real meaning of exposure and the nature of the characteristic curve.

Exposure as a multiple action

The subject is reproduced on the film by the action of light passing through a lens. The lens forms an optical image of the subject on the film surface, and as that image consists of various intensities of light it has a differential effect on the various parts of the film. Thus an exposure of, say 1/125 second at f8 does not mean that the entire area of film receives one specific dose of light. It receives a whole range of exposures, varying over the image area according to the amount of light reflected from each part of the subject. This is the root of the exposure problem; look at it like this and things become clear.

The characteristic curve

The camera does not react as the eye does. Unlike the eye, the lens diaphragm does not vary its aperture as it scans dark and light areas – at least not in a single photograph. The various intensities of light transmitted by the lens are in a fixed proportion that cannot be varied during the exposure. A tone

A standard grey card is a useful aid to exposure. It represents an average subject in which all the tones integrate to a mid-tone. Without a grey card (or incident-light attachment), the meter can be misled by areas of bright light. In such cases, a substitute mid-tone is generally available.

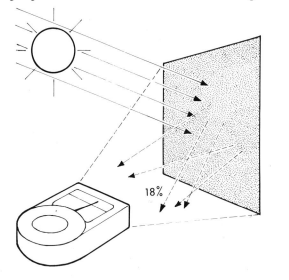

18%

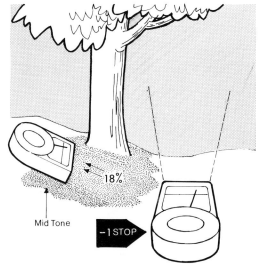

18%

Mid Tone

−1 STOP

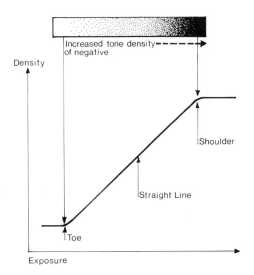

A simplified representation of the characteristic curve. In the toe area, additional increments of exposure build density only slowly. In the 'straight-line' area, density is largely proportional to exposure. In the shoulder area, where density is virtually at a maximum, it again builds very slowly. The ideal general-purpose film has a long straight-line portion.

Increased tone density of negative

Density

Shoulder

Straight Line

Toe

Exposure

corresponding to Tone 6 in our list has just about twice the light intensity of Tone 5. If the tonal range of the subject is within the capability of the film and if you make the correct exposure, the relationships between the tones of the photographic image will be consistent with those between the tones of the subject.

The immutability of this composite exposure is imposed by the nature of the film material. The light-sensitive coating on the film reacts to light in a certain way. A given intensity and duration of light produces a given blackening of the film. If you vary either the intensity or the duration of the exposure, the blackening will vary in proportion. This relationship is so predictable that a graph can be constructed, plotting the degree of blackening against the exposure. This is called the characteristic curve of the film. It is a curve and not a straight line because the proportional relationship between exposure and blackening does not extend to the lowest or the highest light levels. It flattens out at the top into a 'shoulder' region and at the bottom into a 'toe' region. Between these two limits, however, most films have a reasonably linear (straight-line) portion.

Thus the characteristic curve is basically a line progressing diagonally across the graph, low exposures on the left giving low densities on the film and high exposures on the right giving high densities on the film. The shallower the slope of this line, the longer the range of exposures that will produce a given density range on the film. The steeper the slope of the line, the shorter the range of exposures. A short range means high contrast, a long range means lower contrast. So the slope of the

line indicates the contrast characteristics of the film. As already implied, the average film has reasonably low contrast and can produce densities corresponding to a ratio of about 1:200 or so in the subject tones.

How exposure calculations are made

Now we begin to see why automatic-exposure cameras are so successful. The average subject fits easily into a 1:200 ratio. It might have a longer range of tones if you were to measure the extreme highlights and deepest shadows, but you do not usually expect to see detail in these areas, especially when they are relatively small. So variations of exposure simply produce greater or lesser density in each tone. The relationship between the tones is preserved and the negative is quite printable. The ability of a film to cope with variations in exposure is known as its latitude. Thus slight errors in measurement by the automatic camera do not seriously affect the quality of the final print.

Principle of the exposure meter The essence of exposure calculation now begins to emerge. All you have to do is to ensure that one important tone is reproduced correctly on your film. Provided the film has a reasonable latitude (and all amateur films do) all other tones then fall naturally into place. Exposure meters work on the principle that the important tone is a mid-tone which reflects 18% of the light incident (ie falling) on it. You can point the meter at such a tone, either an artificial one such as a standard grey card (see p 24) or a reasonable approximation such as the back of your hand (check this, though: not all skin colours are the same), or you can point the meter generally at the subject.

An essential point to grasp about exposure is that light passes through the lens in varying intensities. The image is formed by innumerable focused beams carrying different intensities of light to different parts of the film – near the maximum possible to some areas, virtually none to others.

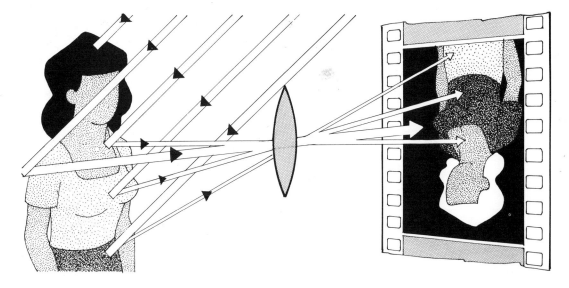

The principle of the general reading is that nearly all subjects average out, or integrate, to a mid-tone. If you scrambled all the various intensities of light reflected from the average subject, the resulting single tone would be an 18%-reflectance mid-tone. So a straight general reading gives you camera settings that will place the mid-tone in its correct place on the characteristic curve, which simply means give it such a degree of exposure that all other tones will fall naturally into place.

For straightforward, run-of-the-mill photography, it really is as easy as that. If it were not, exposure meters, not to mention automatic cameras, would be useless. An overall reading of an 'average' subject will always give a satisfactory exposure. In such cases you can forget about any exposure problems and concentrate on the focusing, framing, composition and impact of your pictures. This applies to most people who use a camera. They want good, sharp representational pictures in daylight, and an automatic-exposure camera or a straight reflected-light meter reading will give them a suitable exposure every time.

Exposure for effect
Sooner or later, however, many photographers feel that they would like to put just a little bit more into their pictures. A child swinging high makes a nice picture with the sun coming from behind the camera or a little to one side. But suppose you shot straight into the sun, waiting until the child's body passed across it? What kind of exposure does that need? Obviously a 'straight' reading will not do. It would indicate a very low exposure because of the high intensity of the light from the bright sky. The result would probably be a thin negative with little or no detail in the figure and only average density in the sky area. It would be unprintable because the exposure of the child itself would be so far down the characteristic curve as to be within the toe region, where different exposure levels produce only slight variations in density.

You have to decide how you want a particular tone in the subject to reproduce. Let us suppose that you want the sky to reproduce with a reasonable amount of tone so that the sun's rays can be seen around the figure. You might meter the sky away from the sun and decide that a mid-tone was about the best compromise. The meter is calibrated to reproduce any tone it reads as a mid-tone, so you would then give the exposure recommended by the sky reading.

In effect, you have placed the sky tone lower on the characteristic curve than it would be in a normal picture, so all

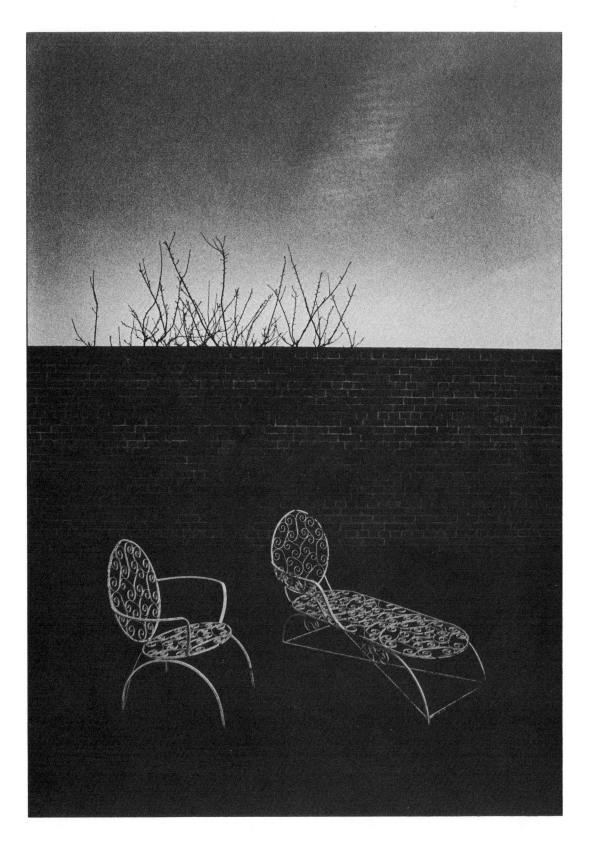

other tones are also placed correspondingly lower. The child's face and clothing, the swing supports and all other parts of the picture will appear much darker than normal on the print, probably approaching solid black.

You might, on the other hand, having decided that you want the figure to be a silhouette, approach your exposure on that basis. You take a close up reading of the figure. That gives you an exposure to produce a mid-tone, or Tone 6 in the tone list. You want it to be reproduced as Tone 1. So you need five stops less exposure. In practice it would be best to use both methods.

Next, you would compare the two readings. If the reading for the sky as a mid-tone and the figure as totally black are close, as they probably will be, give the mean of the readings; if not, try both.

That is just one example of how you might want to take a 'different' picture. At the other extreme, you might want to shoot at night by streetlighting, moonlight, or even floodlights. There you could have great extremes of contrast. Any two enthusiasts might have diametrically opposed ideas of the final image. One might want the moonlight shot to look brilliant, the other to produce a substantially dark image with highlights here

Opposite:
Deliberate underexposure for effect. The foreground could be pegged on tone 1 or 2 to ensure isolation of the chairs and development increased to maintain contrast.

Below left:
Exposure based on backlight. This causes loss of shadow detail and produces a silhouette effect.

Below right:
Two stops more exposure gives more detail in shadow areas.

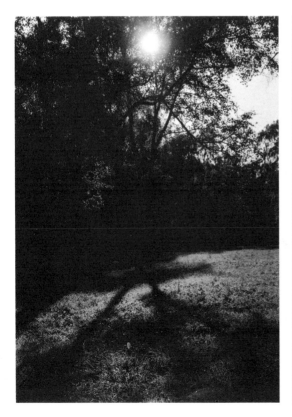

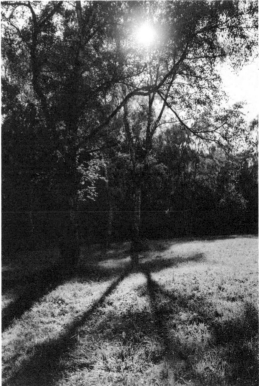

and there. You might well want to change the whole tonal representation of the subject to produce a composition of lines and masses. There are as many possibilities as there are individuals.

There are opportunities in other directions. You do not have to work with natural light. You can modify it with filters and thus change its effect on the film. You can vary the film processing. All we have said so far on the reaction of film to light, its contrast characteristics, etc. depend on standard processing conditions. Vary the processing conditions and those characteristics vary too. Having processed the film, further possibilities arise when you make the print.

Whatever your aim, however, the first thing is to get the exposure right on the film. Ansel Adams' tone visualization ideas are a useful starting point; but you must couple them with a clear idea of what you are aiming at. You want to recognize not only the tones in the subject but know how you want them to reproduce in the print. And you have to consider whether this will mean adjusting film processing, printing on a different grade of paper, using specialized printing techniques, or otherwise modifying normal procedure. All these have to be taken into consideration in assessing the camera exposure.

Colour slides

If you work with colour slide film, you are much more limited. Generally speaking, your exposure has to be 'spot on'. There is little or nothing you can do about it at a later stage. If you do your own processing, you can vary contrast and film speed to a very limited extent in a colour slide by adjusting the first development time. The faster colour films can be uprated for low light work, but there may be unpredictable changes in both contrast and colour balance. With considerable skill, you can print up or shade specific areas when making a colour print, but you cannot do this with slides.

In most cases, however, colour film gives you no opportunity to vary your exposure to allow for subsequent processing variations. You have to get the exposure right; the principles you have to work on are the same as those for black-and-white. Virtually the only other control you have over contrast is your choice of film: in general, faster films give lower contrast than slower films.

2 Recognising the Non-Average Subject

Exposure is no problem with the majority of photographic subjects. It is only when you start to look for unusual subjects that you run into trouble. There are many aspects of the subject that can affect exposure calculations. 'Subject' in this case means not just the actual landscape, figure, street scene etc., but its lighting, tonal range, surroundings and, most important, the representation of it that you want your image to convey.

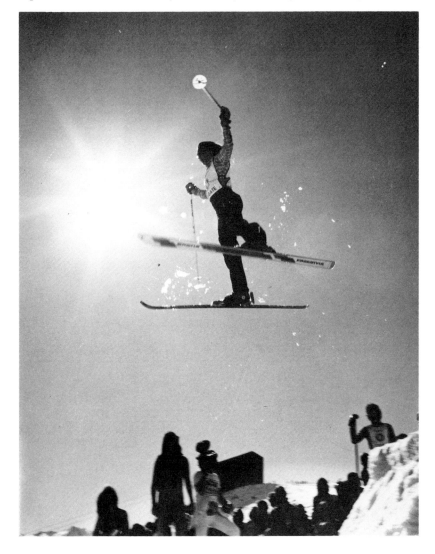

One of the most difficult exposure problems. Shooting into the sun and avoiding a total silhouette. A grey-card reading or 2 to 3 stops more than the meter indicates is a likely solution.

Integration to grey

Most photographic subjects fall into the 'average' category. Quantities of film are expended every summer on buildings, monuments, country cottages, ploughed and unploughed fields, mountains, beach scenes, fairgrounds, faces and figures. As we have seen, these are the subjects that are entirely suitable for automatic-exposure cameras or straightforward exposure meter readings. They consist of a variety of tones which, if they were scrambled together, would integrate to a mid-tone very close to the generally-accepted standard.

Every material reflects some light, however little – nothing but a black hole is totally non reflecting – but no material reflects 100% of the light falling on it. White matt paper approaches the maximum, reflecting some 90% of the incident light. We say 'matt' paper, because we are concerned with diffuse reflection as opposed to specular (direct) reflection from the surfaces of shiny materials such as glass, water, coatings of polish or varnish, which are too unpredictable to handle as a standard. Few materials in nature, however, reflect as much light as white paper. The average reflectance is taken as about 18%.

A standard mid-tone is provided by a grey card produced specifically for the purpose and available from photographic dealers. You can make up your own from substitute materials provided you check it against a standard card. Make sure that it has a matt surface. Glossy surfaces cause specular reflections not related to the tone of the card. The standard grey card is normally supplied in packs of four, measuring 20 × 25 cm (8 × 10 in). One side is grey and reflects 18% of the light incident on it, the other is white and reflects 90%. You use the white side

The standard grey card has a grey side reflecting about 18% of the light falling on it, and a white side reflecting about 90%. Thus, the white side can be used in low light and the indicated exposure multiplied by 5.

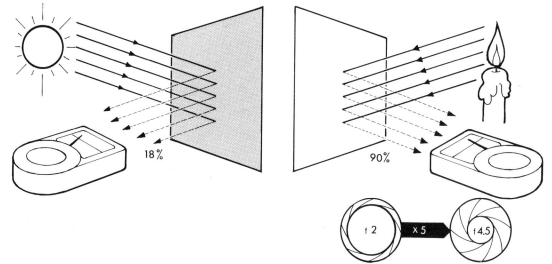

when the light is too low to give a reading from the grey side. You then need to multiply the indicated exposure by 5, ie give a little more than two stops extra.

The average subject gives approximately the same reading as you get from a standard grey card in the same lighting conditions. A subject can integrate to grey, however, without being 'average'. A pure black-and-white chessboard should integrate to grey. So should a landscape with dark foliage, bright cornfields, green grass, a few small white buildings and a bright, slightly cloudy sky. So should a well-lit portrait of a model with fair skin, mid-brown hair and moderately dark clothing against a light background that does not occupy more than about a third of the picture space.

A short-scale subject? Not really. Careful exposure assessment is necessary to preserve detail in both highlight and shadow areas.

Contrast and tonal range

The chessboard is a high-contrast subject. In the sense that it has a wide spacing between its lightest and darkest tones, so is the landscape. The portrait would seem to have a short scale of tones, ie a relatively low contrast, certainly when compared with the chessboard. The portrait also seems to have a shorter scale than the landscape.

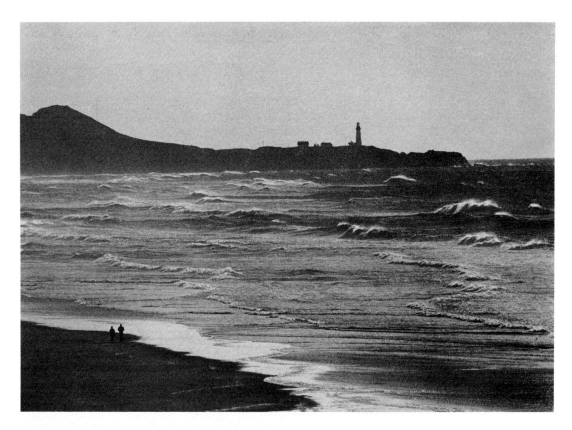

But has it? If you look at the portrait you see the darkest
part as the hair or perhaps some part of the clothing. The
lightest part is perhaps the face or the background. But what
about the eyes, teeth, even the inside of the mouth if the lips are
parted? There should be both deep black and almost pure white
there. These areas might be very small, but they are important.

A long-scale subject needs careful exposure calculation. You
cannot afford to stray far from the optimum, mid-tone-based
exposure, without losing detail either in the shadow or highlight
areas. If you treat the portrait as a short-scale subject and
calculate that you can therefore reduce the exposure to keep the
graininess down or to produce more saturated colour, you will
find that your model looks grey around the eyes or has dingy
teeth.

The true short-scale subject has virtually no highlights or
deep shadows. A misty or foggy scene is an example; so are
some industrial subjects, such as hardware, machinery, textiles,
etc illuminated specifically to show every feature in detail. For
general photography, however, it is as well to forget the concept
of short-scale subjects as far as exposure is concerned. You
cannot go wrong with an exposure based on a mid-tone; you
can go sadly astray if you misjudge the scene and decide for

Unusual, but not such a problem as it might seem at first sight. The lighter tones are obviously the most important, so overexposure must be avoided. A grey-card reading or ½-1 stop less should be suitable, or the dress can be pegged at the desired tone.

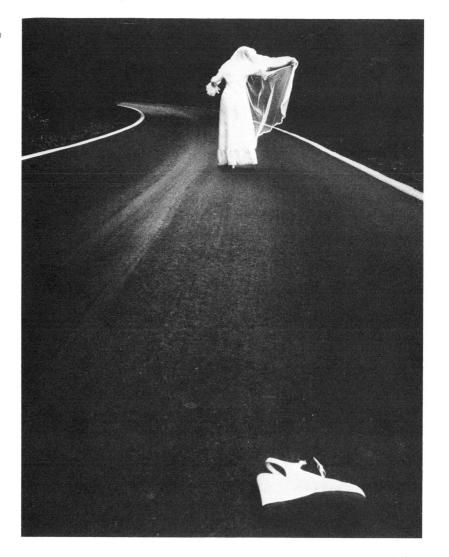

other, less valid, reasons to give a shorter or longer exposure.

High contrast in the subject is a much more difficult characteristic to handle. The chessboard, for example, might seem perfectly simple; but it is not. If it must be reproduced as genuinely stark black and white, you would do best to photograph it on high contrast film. You then simply have to expose and process it to get maximum density in the white square portions. If necessary, you could use high contrast printing material too.

If, as is more likely, both black and white are less than absolute, and you want a 'correct' result, you have a bit of a problem. In a normal subject, you do not often have to handle such extremes of tone and still produce detail. You can generally sacrifice detail in at least one of the extremes to get

the other and the middle tones right. This time, there are no real middle tones and a normal exposure would leave you with a too-light black and a too-grey white. If it does, there is not a lot you can do about it. You can bias the exposure slightly one way to avoid loss of detail at one end or the other, probably the white squares. You might be able to improve matters a little by varying the film processing but, generally speaking, very high contrast raises severe problems if you aim at totally faithful reproduction.

Dealing with high contrast

The chessboard example is somewhat hypothetical; but you can run across similar problems in wedding photography, low-light shooting with light sources in the picture area, brilliant sunlight on white buildings with prominent features, strong backlighting, and in combinations of indoor and outdoor scenes.

A common example is a view of light-coloured buildings with an archway, recessed door, alley or similar heavily shaded area in which you want to show some detail. Take such a building, well lit by a relatively high sun but with a door, in which you want to show at least some detail, thrown into shadow by an arch. A mid-tone exposure should give fine

Provided there is no more than a 6-stop difference between readings from the top of the wall on the left and the deep shadow on the right, the full range of tones can be reproduced.

modelling in the main part of the building but the door could disappear into total shadow. Increased exposure to show detail in the door makes the building look white and lightens its natural shadows too much. What do you do?

The obvious answer is to go home and come back when the lighting is more suitable – sensible, but often impracticable and sometimes impossible. Approaching this problem by the method advocated in the previous chapter, we can recognize the tone in the archway as Tone 3. We cannot hope to make it lighter than that. So we meter it and then meter the brightest part of the picture in which we wish to retain detail. Provided there is no more than six stops between the two readings, taking us to Tone 9, we can get some detail at both ends of the scale. But the highlight area we measured will reproduce as brilliant white with just faintly discernible detail. It could be suitable for whitewash, white-painted pebbledash or other rough rendering. If that is too light for the actual subject, the problem is insoluble unless you can find a method of throwing more light into the doorway. It could, for example, provide concealment for a small flashgun on an extension lead from your camera. A powerful spotlamp could illuminate the door from outside the picture area, but then we are approaching the realms of the professional.

Texture and background

There are other characteristics of the subject, apart from tonal scale and contrast, which raise problems in exposure. One important feature is the texture of the subject. A furry animal, for example, has a certain overall tone; but within that tone

Contrast between leaf and background and in the texture of the background itself needs to be at least maintained, so normal or a little less exposure could be accompanied by slightly extended development.

there are innumerable tiny areas of different reflectances too small to be distinguishable to a meter, if the subject is lit correctly. Flat lighting from a cloud-filled sky or frontal floods kills texture; the fur is reproduced as a lifeless even tone. Sidelighting from sun, spotlight or a directional floodlamp can bring the fur to life as it is reflected differentially from individual hairs and slight variations in colour.

Lighting provides texture: exposure either preserves or destroys it. Underexpose, and the differences are minimized or lost; overexpose, and the higher lights are spread, coarsening the texture and raising the general tonal value. Exposure is not easy to assess in such a case. You have to decide what general value the fur tone has in relation to a mid-tone. It might be, say, two stops darker. That would mean giving two stops less exposure than that indicated by a close-up reading. But, in general, it needs to be reproduced fractionally lighter in order to show the texture to advantage, so 1–1½ stops might be more nearly correct. You should get the same result by adding ½–1 stop to a grey-card or incident-light reading. Incident-light readings require a special opal cover over the light cell, and are made by holding the meter at the subject and pointing it at the camera. Most hand-held meters have this capability.

Direct readings would recommend different exposures but the main subject needs the same exposure each time. Accordingly, a grey card reading is the best solution. Rendering of the glassware naturally varies with the amount of light reflected from the background.

Background tones can also have a significant effect on exposure calculations. You may assess your subject as having a reasonably normal distribution of tones that integrates to grey; but you might overlook an excessively light or dark background. A general reading could be heavily influenced by this background tone and give you a wrong exposure by at least one stop. Close-up readings of the subject are often recommended as a solution to such problems, but this advice too often overlooks the fact that true mid-tones can be difficult to find at close range. You can read from another tone and adjust the reading accordingly, but you are then in the realms of guesswork. The sensible solution is a grey-card or incident-light reading.

Recognising the problem

There are many types of 'subject failure', as it is called (somewhat unfairly because it is the meter that fails); we shall deal with them more fully as they arise. For the moment, it is necessary to learn to recognise the 'non-average' subject. The simplest way to do this is to obtain a good hand-held exposure meter and use it frequently. Take general readings from as many subjects as possible and compare them with grey-card or

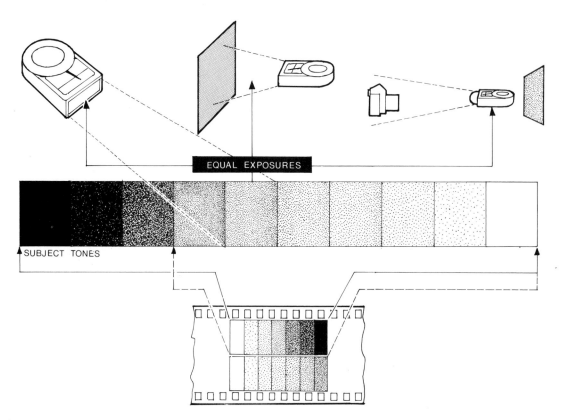

EQUAL EXPOSURES

SUBJECT TONES

incident-light readings of the same subject under the same lighting conditions.

While you are about it, take close-up readings of as many different objects and types of material as you can, and compare them with grey card readings in the same position. Remember that the grey card reading gives the correct exposure for representational reproduction of virtually any subject. Learn how to adjust a reading from various other tones and try to remember the relationship of the various tones to a mid-tone.

Get used to metering the darkest and the lightest tone in the subject (discounting specular reflections). Count the number of stops between them. Your film can handle at least seven. See how often you find a greater range than this, and learn to recognise such subjects.

The quickest way to learn how to handle exposure problems is to recognise their nature as they arise. The more you try to put your own ideas into photography, the more likely you are to be shooting non-average subjects. You need to know when a general reading is not good enough; when you may have to sacrifice detail at one end of the scale or the other; and what is likely to happen if you want to reproduce a particular tone in a lighter or darker shade.

Ten object tones each one stop apart in exposure level represent a tonal range of 1:512, rather too great for most films. On the film, these tones have to be compressed into a seven or eight stop range. A subject with no deep shadow detail may fall within that range and so pose no great exposure problem. Exposure for a subject with a reasonably even distribution of tones can be calculated from a direct reflected-light reading, which effectively meters a mid-tone, from a substitute mid-tone such as a standard grey card, or by an incident light reading. All these readings should indicate the same exposure level.

Colour slide films

Finally, an extra word on colour. We have not paid much specific attention to it so far because there is no difference in exposure calculation for average subjects whether you work in colour or monochrome. When you start to vary your exposures for any reason, however, the treatment can be different for colour. In monochrome you can vary the tonal range almost at will. In colour you can go only so far before the colour starts varying, too, and this is not always acceptable. In monochrome, for example, you may decide that you can sacrifice a little detail in the highlight areas in order to retain important detail in the shadows. It is not quite so simple in colour because the highlight may have a light pastel colour which disappears into complete white with only slight overexposure. You may be prepared to lose a little detail, but not the colour. At the other end, if you decide to let the darker tones go even darker in order to preserve detail in the highlights, you may find you have a greenish or mauve tint overlaying the dark colour you had hoped to see.

The greater variations you might use in monochrome to falsify tones and put across your own particular rendering of a subject are virtually impossible in colour without significant changes in hue, too. You may be able to accept this: you may even welcome it; but you will not be able to predict it without a good deal of experience of that particular film. Not all colour films react in the same way to variations in exposure.

Overexposure results in washed-out highlights and desaturated colours; it emphasizes graininess, and may cause changes in colour balance. Underexposure darkens and desaturates colours, and can lead to varying degrees of distortion of both tones and hues according to the saturation of the original colour and the characteristics of the film. It also gives dense shadows devoid of detail.

3 The Image and the Film

In photography, your raw materials are the subject and the film. Depending on the type of image you want, you have to match the subject or the image to the characteristics of the film. Although there are many different types of film, you are not likely to run into trouble in matching the subject to the film. Modern films can handle a wide range of tones; there are very few subjects that fall outside their capabilities. There are some subjects that are better handled by special high-contrast film, but these are exceptions. With suitably adjusted processing and printing, the average film can give you all the contrast you are likely to want.

To learn how you can adjust exposure, processing and printing to suit the image required, you need to know something about the characteristics of the film.

Colour sensitivity

All general-purpose monochrome films are panchromatic. That means they are sensitive to light of all colours – a sensitivity imparted by the incorporation of special dyes in the film coatings. Thus, even on a monochrome film, a coloured subject is reproduced in a range of tones corresponding reasonably closely to the different brightnesses (strictly, luminances) of the coloured surfaces of the subject. This assumes, among other things, that the subject is to be photographed in daylight or light of similar quality.

If you photograph in monochromatic light (for example, yellow sodium street lighting) the tonal differences in the print are not representative of the brightnesses of the various colours of the subject as seen in daylight. Even by the light of an ordinary tungsten filament lamp the result is different from that given by daylight. This is because there is proportionally more red and yellow in the light from filament lamps, and less blue, than in daylight. Blues therefore tend to reproduce darker than you might expect, and reds and yellows lighter.

The effect is not as pronounced as it was in former times, when it was necessary to use purple rather than red lipstick in female portraiture! However, it cannot be ignored. Similarly, if

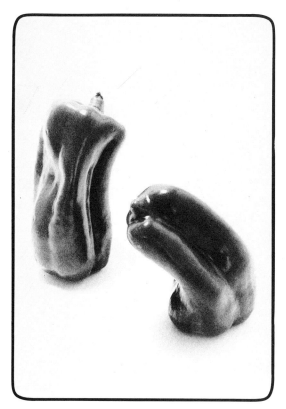 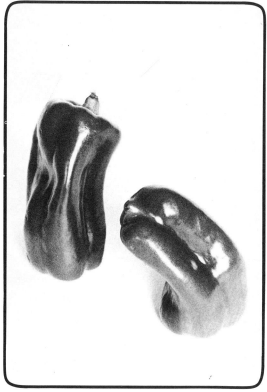

The lefthand pepper is red, the other green. The lefthand picture was by tungsten light, the other by daylight. The predominantly reddish tungsten light makes the red pepper noticeably lighter.

you put a colour filter over the camera lens you alter the colour of the light reaching the film and consequently alter the tonal values. This can be useful in photography. Most people are aware that a yellow filter absorbs blue light and renders blue sky darker, so that white clouds stand out prominently. The principle can be extended to other applications, which will be dealt with later.

The colour sensitivity of monochrome films is not identical with that of either the eye or meter photocells. Even between one type of photocell and another there is a difference. The selenium cell approximates most closely in sensitivity to the film. Generally, all films are rather more sensitive to blue than the eye, so that blue sky tends to reproduce paler than might be expected. Cadmium sulphide (CdS) and silicon photosensors are more sensitive to red than either the film or the eye, and need to be blue-filtered to provide a closer match.

Films are also sensitive to ultraviolet (UV) and infra-red (IR) radiation. UV sensitivity is partly responsible for the excess blueness of distant scenes in clear air photographed in colour (as at high altitude), and also causes a hazy, low contrast effect on black and white film (the effect is also partly due to the tendency for visible blue light to be scattered by solid,

atmospheric particles). Unwanted sensitivity to IR radiation would cause some kinds of green vegetation to reproduce rather lighter than they appear to be.

Specialised films

Some films have restricted colour sensitivity. They are generally available only in sheet form but there are one or two in roll and 35mm sizes. The most common types are orthochromatic, blue-sensitive and infra-red sensitive.

Orthocromatic films Orthochromatic (which means correct-colour) is an unfortunate description nowadays. Originally, films were blue sensitive only. When the colour-sensitising process was first introduced, the films were called orthochromatic because compared with the blue-sensitive types they gave improved tonal rendering with most colours. But they were still largely insensitive to red and orange, which thus recorded black. Even the first panchromatic films were somewhat insensitive to red.

Orthochromatic films are still used in some applications because they give some colour sensitivity but can be handled in red safelighting.

Blue-sensitive films Blue-sensitive films are commonly used for high-contrast, black-and-white work, such as diagrams, charts, printed matter, etc. and can be handled in ordinary darkroom safelighting. They have the additional advantage in this type of work that instructions can be marked on the original in blue. The high sensitivity to blue reproduces it as white, ie maximum density on the film.

Infra-red films Infra-red films are basically blue-sensitive but also have high sensitivity to a limited region beyond the visible red end of the spectrum. Used in conjunction with deep red filters, they produce images of IR radiation only or of IR plus a little visible red.

With a suitable filter over the light source, photography can be carried out almost without visible light.

General sensitivity (speed)

Films differ in their overall sensitivity to light. The amount of light necessary to produce a given degree of blackening is lesser or greater according to the film's sensitivity to light, commonly called 'speed'.

Film speed is indicated by a rating on the ISO scale. The first figure is arithmetical, a doubling of the figure indicating doubled sensitivity. The second is logarithmic, an increase of the figure by 3 indicating doubled sensitivity. These two types of

The dramatic effect provided by infra-red film and a red filter.

figure were formerly known as 'ASA' and 'DIN' speeds respectively. We shall be concerned only with the arithmetical rating.

General-purpose black-and-white films are loosely classified as slow, medium or fast, typical speed figures being ASA 40–50, 100–160 and 200–400 respectively. There are others outside this range at both ends, but these are the types on sale for amateur photographers. The figures mean little in themselves. They simply provide a basis for comparison and a means of calibrating exposure meters and compiling exposure tables. Naturally, they also depend on processing methods. The recommendations given by an exposure meter for a given film speed are accurate only when processing is standardized according to the film manufacturer's instructions.

They depend, too, on the accuracy of the camera shutter speed markings and lens aperture designations. It is not unknown for two lenses set to the same marked *f* number to transmit different amounts of light. As a perfectionist you could conduct tests with all your lenses and every batch of film you buy, and certainly with different cameras. You could rate a film as marked, and a friend could rate it twice as fast; yet both of you might get identical results owing to shutter speed or aperture variations.

A number of qualities are related to film speed. Generally speaking, the easiest way to make a film faster is to increase the size of the silver halide particles that provide its sensitivity to light. This can lead to their clumping or overlapping at different depths in the light-sensitive layer (called the 'emulsion').

Development considerably increases the clumping of the particles so that they form grains, and the granular structure of the image becomes visible on enlargement. The effect is less noticeable than it was in former times; but it is still true that a faster film tends to produce a more grainy image, an important factor when fine detail is required.

Contrast and exposure latitude are similarly affected by the different emulsion structure. Slow, fine-grain films produce somewhat contrasty images the quality of which depends strongly on the level of exposure and development. High-speed films tend to produce less contrasty images, and to have greater exposure latitude, but have larger grains.

Speed, grain and contrast also depend on the developing procedure. The effect may vary with different films and with differing degrees of development but in general, development increased beyond the recommended level increases both contrast and grain size. Prolonged development increases the effect of the developer by reducing more of the individual light-sensitive particles and at greater depth in the emulsion – so increasing individual grain size and the general blackening effect.

The effect on speed is less clear cut. At a given exposure level, the particles in the area of the optical image representing the darkest areas of the subject receive a very low level of exposure. It may even be insufficient for development to have any effect. There is then no increase in shadow detail – the true criterion of increased film speed. Where there are no very low tonal values in the original, density in the film may be increased throughout the range by prolonged development. An increase in film speed then appears to have been achieved.

Similar effects may be provided by different developer formulations; there are several such products on the market for which increased film speed is claimed. There could be some justification for those that claim increases of up to half a stop. Beyond this, any significant increase in apparent speed is likely to be accompanied by a deterioration in image quality.

Colour film characteristics
In basic characteristics colour films are very little different from monochrome films. They are primarily monochrome emulsions with other materials incorporated to release dyes in proportion

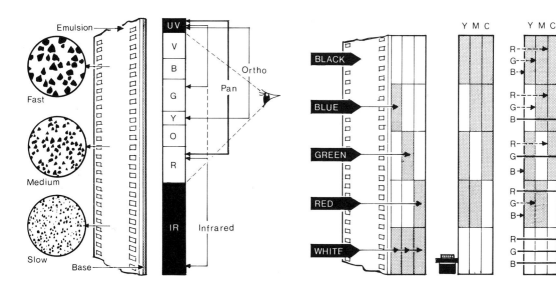

Broadly speaking, faster films need larger grains of light-sensitive material and the final image may take on a noticeably 'grainy' appearance.
The various types of black-and-white film are predominantly sensitive to different parts of the visible spectrum and beyond.
Colour film is panchromatic but also has three emulsion layers incorporating dyes that are released on development.

to the silver image when treated with a specific type of developer. They consist of three emulsion layers sensitised to produce an image in one colour for each layer. As the light has to pass through one layer to reach the second and through two to reach the bottom layer, each must be of a different speed. Overall speed thus depends on that of the bottom layer.

Colour films are slower than monochrome films of similar image quality. In addition, the three image layers, although exceedingly thin, have an effect on overall image sharpness as compared with the single layer of a monochrome film. Of course, the emulsion layers of colour films are also especially sensitive to the colour of the exposing light. Quite wide variations have little effect on the tonal range; but comparatively small variations can affect the reproduction of colours significantly. Most colour films are intended for use in daylight – ideally in daylight from direct sun with white clouds. Early morning or late afternoon light can be different in hue and its effect on colour film is noticeable. The greater proportion of red and yellow in artificial (tungsten-filament) light produces a strong orange-yellow cast.

Matching the image to the film
If you have a reasonable knowledge of the characteristics of your film, you can match the image to it without too much difficulty. In technical terms this amounts to placing a particular tone correctly (for your purpose) on the characteristic curve of the film. As mentioned in chapter 1, the characteristic curve is basically a straight line indicating that density in the negative is proportional to the exposure that each part of the negative gets.

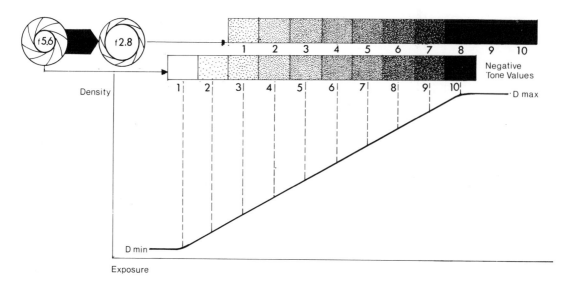

At the highest and lowest levels (the shoulder and the toe) this proportional relationship fails. If your exposure is too low, the darker tones and shadow areas run together as almost clear film. If it is too high, the lighter tones and extreme highlights all reach maximum density and fine detail is lost.

The first simplified graph shows the straight line portion of an imaginary characteristic curve. Each additional increment of exposure marked on the base line produces additional density on the film as indicated by the height of the line above the base line at that point. Assuming correct exposure of a subject containing all the tones in our list, each tone would, in effect, be 'placed' on the curve as shown. Assuming an average subject integrating to a mid-tone, a reflected-light meter reading would have given an exposure that placed Tone 6 correctly in position 6 on the curve. All the other tones must fall naturally into place and reproduce correctly – or as near correctly as the film can manage.

The second graph shows the characteristic curve of a high contrast film. The steepness of the line indicates that only a few exposure steps are required for the film to progress from virtually clear to maximum density. The long-scale subject of the previous graph, indicated this time by the dotted line, needs a 1:10 exposure ratio to accommodate all its tones. They cannot all be compressed on to this film. The fourth exposure increment should not even reach the density required for a mid-tone but, in fact, it puts maximum density on the film.

Thus, if you give the minimum exposure, so that Tone 1 is placed in position 1, all tones in the subject brighter than Tone 4 are rendered as maximum density on the film. If Tone 6 is

A normal exposure can accommodate all tones from virtually clear to virtually opaque film. Two stops extra exposure moves all tones along the 'curve', creating additional density in all areas. Highlights, represented by the black areas, may block up.

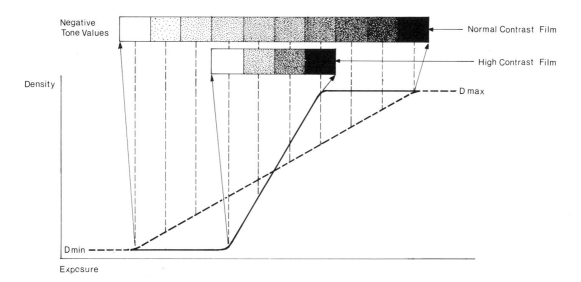

Negative Tone Values

Normal Contrast Film

High Contrast Film

Density

D max

D min

Exposure

A normal general-purpose film has a long straight-line portion to its characteristic curve, with a moderate slope. It is the gradient of that slope that used to be called gamma. It can be affected to a limited extent by development. A high-contrast film has a steeper slope to its straight-line portion.

placed correctly, all tones a little above 7 and below 4 are lost in maximum and minimum density.

This can be a useful characteristic when you undertake 'posterization' work and need to produce negatives with only two tones — completely transparent and completely opaque — but that is beyond the scope of this book.

Although the characteristic curve will be mentioned again, we do not need to go into it more fully. Our simplified description is all that is necessary to understand the relationship between the luminances of the subject and the corresponding densities of the film. By placing a particular subject luminance higher or lower on the characteristic curve, you can dictate the tone in which it will be reproduced in the final image, but only by similarly altering all other tones. You can also adjust the film processing to alter the slope of the curve, and thus affect its contrast. Thus, although the tone in question may originally have been 'misplaced', it can be reproduced correctly, with some compression or expansion of the overall tone range.

For all practical purposes, placing a tone higher or lower on the curve simply means giving more or less exposure than that recommended by a grey-card or incident-light reading.

Variable speed films
The concept of 'correct' exposure is somewhat obscured by the fact that modern black-and-white films have, in comparison with their counterparts of 10 or 20 years ago, quite extraordinary exposure latitude. In the 1980s, this is likely to be exaggerated by the advent of monochrome films that owe their origin to colour film technology and indeed are processed in

41

colour negative film chemicals – the so-called chromogenic films such as Ilford's XP1 and Agfapan Vario-XL Professional. The two films differ slightly in detail but the basic idea is the same.

The Agfa film, for example, has two emulsion layers, one high speed and the other low speed. Both incorporate colour couplers with development inhibitors to combat the effects of overexposure. Processing in a colour developer followed by a bleach-fix gives a single-coloured dye image. As the colour is relatively unimportant, exposure latitude is independent of colour balance problems. The image components are dye instead of solid silver grains, so there are no irradiation problems, with light scatter between these grains and no base development fog. The image has better acutance and a smaller, more compact grain structure, even with considerable overexposure.

In practice, the immense advantage of these films is that they can be regarded as having a variable speed or sensitivity. There is likely to be some overlap between the manufacturers' recommendations and actual practice, but the general principle is that XP1, for example, can be treated as a 400ASA (ISO400/27°) film for most purposes. The fact that such a film generally needs an exposure of about 1/1000 sec at *f*11 in strong daylight need not bother you. You can give XP1 1/1000 sec at *f*4 or any exposure between those limits in such circumstances and still process the film in the same solutions and for the same time.

Overexposure gives finer grain With a normal film, three stops overexposure would give a noticeable increase in grain size and contrast. With XP1, the negative is denser but the grain is *finer*. So the film can be rated anywhere between 50 and 400ASA (ISO50/18° to 400/27°) on the same roll and processed normally. The results vary in density but are comparable in quality to those obtained from a conventional 125ASA (ISO125/22°) film.

There is more. The film can be push-processed up to 1600ASA (ISO1600/33°) by the usual method of increasing development time. Not only that but the three stops overexposure latitude is still available. In other words, the same roll can be exposed as if it had a speed or sensitivity variable from 400ASA (ISO400/27°) to 1600ASA (ISO1600/33°). In this case, however, overexposure is actually overdevelopment, such are the peculiar characteristics of this film, so quality does suffer a little and the grain is noticeably coarser than with the normal procedure with the same film.

Agfa's recommendations are slightly different. They do not assign an actual speed figure to their film but say that it can be exposed for any speed from 125ASA (ISO125/22) to 1600ASA

(ISO1600/33). They say that it achieves the same standard of quality as a 125ASA film if overexposed by up to four stops, which is a little confusing but presumably implies that they rate it at 1600ASA. Processing is the same at all speeds. There are no recommendations for push-processing.

Processing times The Agfa film can be processed in C41 chemicals, as used for colour negative films, or in Agfa's own Process 70 for large users or Process F, which is available in 500ml sizes. Process F, like C41, consists of developer and bleach-fix, to which Agfa have added a 'final bath'. Process 70 has separate bleach and fix solutions.

Processing times in daylight tanks or drums are rather long – 7½ min in the developer, 11 min bleach-fix, 4 min wash and 1 min final bath. That, a minimum of 23½ min and the high processing temperature of 30°C could be off-putting for those users not already geared to colour processing.

Ilford's film can be processed in C41 chemistry, too, but they do not say so. The SP chemicals consist of a developer and bleach-fix, each used for 5 min at 38°C, with a 3 min wash and a recommended final rinse in wetting agent. Processing temperatures can be varied from 30–40°C, the times at 30°C being 9 min each in developer and bleach fix. The push-processing times are 6½ min at 800ASA and 9 min at 1600ASA for the developer only at 38°C. There is no need to increase the bleach-fix time.

Effects on camera practice The advantages of the new films are obviously enormous. The equally obvious disadvantages are the relatively long processing times and high temperatures, the shorter life of the used solutions and the greater cost.

There can be a considerable effect on camera handling. What do you do with autoexposure cameras – or even TTL meters? With XP1, you have a basic 400ASA (ISO400/27°) film. Do you set your meter to that figure and work normally for most shots or do you set it to 50 or 125ASA and take advantage of the finer grain from overexposure – then switch your film speed setting as required for special shots? Do you constantly vary your film speed so that you can always use the aperture and shutter speed combination you want?

4 Film Processing Controls

If the raw materials of photography are the subject and the film, the final product depends on processing the film and making the print. The aim should be to make the printing a straightforward process. You cannot avoid the necessity for occasionally introducing some control, but you should not need to rely on doing so. All the real work should be done in the production of the negative, ie exposure and development.

How the image is formed

The camera lens forms an optical image of varying intensities at the film surface. These affect the light-sensitive particles in the film differentially, as already mentioned. At this stage, however, there is no measurable darkening of the film. We have an invisible or 'latent' image.

To make the latent image visible, the effect of light energy is amplified by a chemical solution which acts only on the light-sensitive particles (which are of silver halide) that have actually been exposed, ie affected by light. This is accomplished with a 'developing' solution containing chemical compounds which reduce the exposed halides to metallic silver.

When developing a film, there is an optimum time and temperature. The developer can continue acting until no exposed halide particles remain to develop (this is called 'development to finality'). This produces a very grainy image, because in order to achieve useful sensitivity the halide particles have to be of a certain minimum size and be generously distributed throughout the depth of the gelatin. Development causes the particles to clump together in silver granules or 'grains', and overdevelopment emphasises the granular structure until on enlargement the grain is obtrusive, and limits image detail. So there is an optimum time and temperature of development that varies with the film-developer combination.

Varying the development time

Development time can be varied to some extent in order to assist with exposure problems, as moderate changes affect tonal values without a drastic effect on grain size.

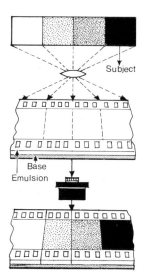

Light reflected from the subject has a generally invisible effect on the film, producing a latent image. On development, the light-struck particles of the emulsion are blackened in proportion with the amount of light received.

Reduction of contrast It is possible, for example, to increase exposure and shorten development to reduce contrast. You may run across a subject with great extremes of tone, such as a wet night scene with brilliant reflections on road or pavement surfaces. Probably you do not want stark white reflections; they should have some tonal gradation; so should some of the darker areas. Normal exposure and development would give a 'soot-and-whitewash' effect. You can tackle such a problem by pegging the highlights one stop higher than the tonal value required – say at Tone 10. Meter this tone and peg the exposure at four stops more than the meter reading (which recommends an exposure to give Tone 6 in that area). Alternatively, you can meter a grey card in the highlight area and use one stop more than the reading. As a further alternative, meter the white reverse of the grey card if the light is very low, and give 3½ stops more than indicated. All of these methods should give a similar result. What you are aiming at is one stop more than the 'normal' exposure. You then shorten development time to approximately three-quarters of the normal time (the exact proportion calls for tests which will be detailed later). The principle is that the increased exposure tends to

Strong sunlight and deep shadow make a difficult metering problem. A full exposure and curtailed development is the usual answer.

increase density by raising all tones except the very deepest shadows. With normal development the highlights would become blocked. Curtailed development has a greater effect on the higher densities (representing the highlights) then the lower. Tones 7, 8 and 9 are brought back to normal, with lower tones progressively less affected.

Increasing contrast To increase contrast in a low-contrast subject the opposite treatment can be used, placing the required tone lower than normal and increasing development by about 30% to bring it up again.

In practice the results of such treatment depend largely on the characteristics of the particular film and developer used. Modern films do not always respond as well as those of some years back. Moderate changes in contrast are possible, but the results are not completely predictable without preliminary tests.

Increasing speed With modern films, variations in exposure and development are more commonly confined to attempts to increase speed. Sometimes the film manufacturers suggest reduction of exposure and prolongation of development to achieve this. The aim is to permit photography in low light conditions. At first sight this would seem to be unnecessary, with modern fast films and wide-aperture lenses; but wide apertures tend to cause flare, and may give insufficient depth of field.

'Push-processing' (forced development)

Forced development, often called 'push-procesing', is normally applied only to fast films in order to increase their effective speed. It simply consists of giving a greatly extended

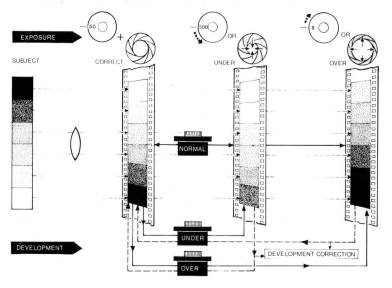

Normal exposure and development reproduces all tones correctly. Overexposure or overdevelopment result in increased densities. Underexposure or underdevelopment produce lower densities. Overexposure can sometimes be compensated for by reduced development and underexposure by increased development. Changes in development time can also effect contrast and can occasionally be used as a form of tonal control.

46

In low lighting conditions, contrast can be improved by underexposure and increased development. In this case, the treatment was one stop underexposure and 50% increased development time.

Overleaf: The deliberate use of a grainy image to depict heavy mist.

development, and can be applied to monochrome or colour negative film, and to colour slide film by extending the first development time. It results in increased grain size, some distortion of tones, and, in colour slide film, loss of contrast and colour saturation. Clearly, this type of treatment must involve sacrificing one thing for another. The manufacturers have set their exposure and processing levels for optimum image quality in regard to both resolution of detail and contrast; if you force the development, both will be altered. If you can tolerate the graininess and are not interested in fine detail, push-processing makes sense. You might, for example, use it in fog and mist on the grounds that the effect suits the subject. You would certainly use the technique in low-light conditions where it is more important to get the picture than to produce a

masterpiece. With low-contrast subjects you may achieve some usable density in the middle tones. Both shadows and highlights are likely to be as empty or emptier than in a normal processing system. Thus there is an apparent increase in film speed in the middle tones, so the technique can be useful with short-scale subjects.

In push-processing the process already described is pursued to the ultimate. The development recommended can be as much as three times the normal. By placing a given tone up to three stops lower on the characteristic curve and developing it up to its original tone, the effect is of boosting an ASA 400 (ISO 400/27°) monochrome film to ASA 3200 (ISO 3200/36°). If the curve were a truly straight line increased density would occur throughout the tone range. However, in practice, exposure at the shadow end is usually insufficient to provide any extra density, and grain size in the middle tones is considerably increased.

Up to one stop or so (a claimed doubling of film speed) the process was a standby long before the term 'push-processing' became common; it worked reasonably well for subjects with no marked shadow areas. Beyond this the loss in image quality is generally too high a price to pay.

The same considerations apply to colour films – only more so. As there is colour to contend with as well as tone, you may not only lose quality, but also lose or distort the colour. The difficulty is that any departure from normal processing can bring about different reactions in the three separate layers. One layer may respond well while another lags behind. The results are largely unpredictable. There is the excuse that at low light levels, colour values are not true to the eye, so anything is acceptable; that is entirely a matter of taste.

Fine-grain developers

Most developers are standard formulations designed to suit the majority of negatives. Within reasonable limits, the formulae can be varied in order to give different results. The current variations with some popular formulae for monochrome negatives are those which increase speed, improve acutance, and give extra fine grain.

This last attribute is rapidly becoming of little importance. At one time it was almost mandatory for 35mm work; but the quality of modern films is such that graininess has ceased to be a problem, and special developers are now justified only for the very smallest formats. Fine-grain developers lower effective film speed, and as slow, very fine-grained films are available, there

seems to be little point in processing faster, less fine-grain types in this manner at the expense of film speed.

High-definition developers
The principle of high-definition type developers is often poorly understood. They have been around for a long time but have received rather more publicity in recent years. The high definition is obtained not from fineness of grain but from increased contrast at the boundaries between different tones – a sort of stepped formation of tones instead of a progressively smooth transition. This gives greater sharpness than conventional processing, though it does not in fact increase the resolution of fine detail. Nevertheless, photography is a visual art; a print that looks 'sharp' is often preferable to a print that is full of fine detail but still does not look really 'sharp'.

Speed-increasing developers
Speed-increasing developers are also a mixed blessing. The manufacturer produces what he considers the most generally acceptable formula, but sometimes offers an alternative that has what amounts to a minimal effect on speed. Independent manufacturers produce their own speed-increasing developers

An interesting effect created by deliberate movement of the camera during a half-second exposure.

and frequently claim much greater benefits. Depending on the particular film, and your requirements as regards quality, genuine increases in sensitivity (in the sense that there is some improvement in shadow detail) can be obtained up to about 50% or half a stop. An ASA 400 (ISO 400/27°) film may be able to be rated at about 640/29°. In most cases, any loss in quality is acceptable. Beyond this there is a noticeable reduction in quality. This varies with the film and the developer, but increased grain size is the most noticeable effect. Lack of contrast, particularly in the shadow areas, and increased fog level (from development of unexposed particles) is usual. Those developers for which the most extravagant claims are made will produce tolerable results only with low-contrast subjects.

Two-bath methods There are older formulae and special processes which formerly worked well; but they are less suitable for modern films. Two-bath processes were once very popular. Of these there were two main types, one using plain water as the second bath and the other using a strong alkali such as potassium hydroxide.

Water-bath method The principle of water-bath development is that the developer continues to work for a longer time where it has the least work to do. With this technique first saturate the film with developer – almost any type – then transfer it to plain water, leaving it undisturbed for several minutes. Then transfer it back to the developer for another saturation, and so on until you judge that development is complete. In the water-bath, the developer in the highlight areas becomes rapidly exhausted, so that development in these areas is retarded. In the shadow areas development also continues until the developer is exhausted, but this takes much longer, and the shadow areas therefore build up in density. The result is an increase in effective film speed without the usual accompanying high contrast and harsh highlights. The immersion in water needs to be fairly prolonged, as the longer the developer continues to work in the shadow areas the more pronounced is the disproportionate shadow and highlight development, and the greater the shadow detail.

The drawback of the technique is that it requires development by inspection; you have much more control if you can see what is going on. With panchromatic films this demands a pre-immersion in a desensitizing bath. In addition, it is not easy to handle rollfilms in open dishes, so the technique is nowadays of limited use.

Alkali-bath method The alkali-bath method is somewhat similar in principle. You first saturate the film with a solution which does not contain any alkali, and thus does not develop

the negative to any extent. You then transfer the film to a solution of a strong alkali to accelerate the developer action. On a similar principle to the water-bath method, the developing agent becomes rapidly exhausted in the highlight areas and less so in the shadows, which are therefore brought up more strongly than the highlight areas.

The great advantage of this method over the water-bath method is that it saves a great deal of time, and can be carried out in a spool developing tank. However, it calls for detailed experiments in exposure and printing procedure to arrive at a fully satisfactory result. As with the water-bath method, it is most suitable for single images and is adaptable to rollfilm techniques only if all the subjects are similar in nature.

Conclusion

It is inevitable that control of image quality during film processing is of limited value with modern equipment and roll and 35mm film. A great deal of control can still be exercised by those using sheet film for single images, but few amateurs have suitable cameras. Nevertheless, film processing is vitally important, and we shall return to this later. It is quite possible to depart from manufacturers' instructions for film speed and for time and temperature; as you progress you almost certainly will, because these instructions depend on various norms which may not be applicable to your particular case. Not all lenses pass the same amount of light at equivalent aperture settings, and not all shutter speeds are accurate. Prolonged development can be accompanied by a significant fall in the temperature of the solution if you work in a cold darkroom. And so on. Above all, there is no single overall density of negative that is ideal for all individual preferences and different types of enlarger. Photography itself is by no means an exact science and, although exposure and processing can be automated to some extent, perfection is an individual goal and the roads leading to it are many.

5 Controls in the Printing Process

The controls available in printing from monochrome negatives are almost limitless (colour printing is more restrictive). But the application required to produce the best print, even from a first-class negative, is considerable; there is much you can do wrong. That does not mean that printing itself is difficult: it is easy enough to produce acceptable prints from good negatives. But to produce the best possible print is another matter.

The printing process is in principle the same as film processing. In practice it is different because printing papers are much slower than films and as a rule are not panchromatic; also one print is dealt with at a time, and is developed by inspection, under a safelight.

In shooting, a lens is used to form an image of the subject on the film. In printing, a lens is used to project that image on to 'paper' (properly called printing paper but often plastic-coated). In effect the negative takes the place of the subject, and the paper, that of the film. When you process a film, you obtain a negative image of the positive subject. You process a print to obtain a positive image from the projected negative. The developers are essentially the same, too, though the proportions of the constituents are changed to provide more vigorous action for a paper developer. There are no problems with grain in a printing paper because the speed of the paper is slow enough for the grain to be infinitesimal; and you do not enlarge it. The only grain is that of the negative image and there is little you can do about this at the printing stage.

Characteristics of printing paper
Like the film, printing paper is coated with an 'emulsion' of silver halide particles in gelatin. There are further layers which do not concern us here. The negative image projected onto the paper contains a range of tones representing (inversely) the tones of the original subject. Just as with the film, when the enlarger lamp is switched on, the paper receives varying degrees of exposure to light according to the luminances of the various parts of the 'subject' (ie the negative). This time the proportions are reversed, so that the greatest exposure is received by the

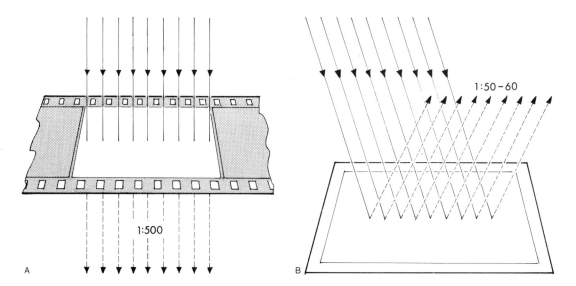

1:50–60

1:500

The ranges of tones that can be represented on film and paper vary considerably. Images on film are viewed by transmitted light which can pass relatively freely through the transparent base or be almost totally blocked by maximum density. Reflected light can be reasonably bright in highlight areas but even the maximum black reflects a measurable amount of light.

areas representing the darkest parts of the original subject, because they have the least density in the negative.

Development of the paper is a process similar to that of development of the film. The exposed silver halide particles are reduced to metallic silver grains, and a positive image appears, reproducing the original subject in all, or almost all, its tones. The contrast range of the tones that the paper can reproduce is limited to about 1:50 or 1:60, compared with the 1:500 or so of the film (maximum to minimum luminance, not usable tones). This is because the film densities are measured by transmitted light and those of the paper by reflected light. Photographic papers are never totally non-reflecting in the black areas and the amount that can be reflected by the white areas is less than that which is transmitted by clear film.

So the wide range of tones in the original scene has to be compressed to a 1:60 range. This, as it happens, is not as drastic as it sounds. It simply means that the 10 tones we have listed at one-stop intervals in the subject have to be represented in the print by 10 tones at about three-quarter-stop intervals instead, because progressing by one stop each time from 1 to 10, gives 1:512, whereas progressing by only threequarters of a stop each time gives about 1:60.

The effect is that the range of tones is compressed; and, at least in theory, we cannot see in the print as many intermediate tones as are present in the subject. But do we really see all those intermediate tones in the original? What we actually see is conditioned by the nature of perception, which is influenced by the way the eye works and by past experience. When we look at a scene, we do not analyse all the various tones in it, and worry

if some are missing. After all, we are used to seeing our friends and relations in a variety of lighting conditions. We are used to looking at newspaper pictures, television pictures, glossy magazine pictures and photographs. Good original photographs are the best quality images of these, but we accept each for what it is. We are rarely, if ever, aware that they lack some of the finer tones of the original, because even if we saw the original we probably did not perceive those tones; and we seldom if ever compare a photograph directly with the original subject matter.

It is as well, nevertheless, to be aware that differences exist between the subject, the negative and the print; but there is no need to feel any sense of frustration about it. A good printer can even manipulate the photographic process to show more in the image than we perceive in the subject.

The photographer's aim should be to produce a negative that reduces to a minimum the need for manipulation in printing. With most subjects, he should be able to eliminate manipulation altogether. However, other subjects remain where exposure and film processing can be adjusted only to a certain extent, the final touches having to be left until the printing stage.

Paper grades vary between manufacturers but the lower numbers always indicate softer grades which are used for overdeveloped negatives or contrasty subjects. Hard grades give higher contrast prints and can improve the image from underdeveloped negatives or flatly lit subjects.

The effect of printing, from left to right, on soft, normal and hard grades of paper.

Overleaf:
The aim should be to get the contrast in the negative. When that is not possible, a hard grade of paper can produce the desired effect.

In most cases this is a matter of contrast. The negative is either just a little too flat or too contrasty to give the best print on normal photographic paper. Most papers are supplied in a variety of contrast grades. Emulsions are manufactured to give low, medium or high contrast results with the most popular papers, from very soft for extra-contrasty negatives to ultra hard for flat, or high-contrast negatives.

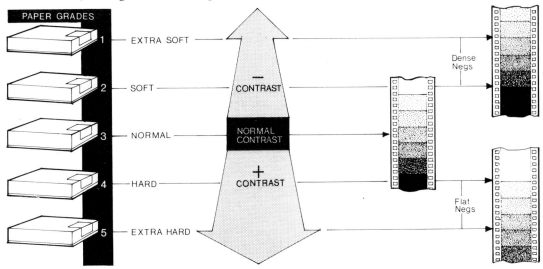

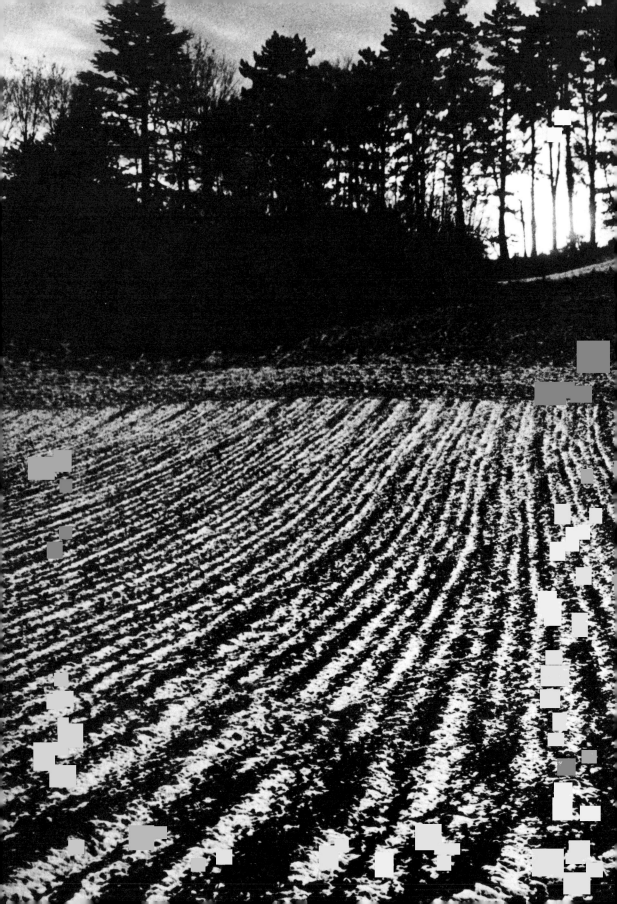

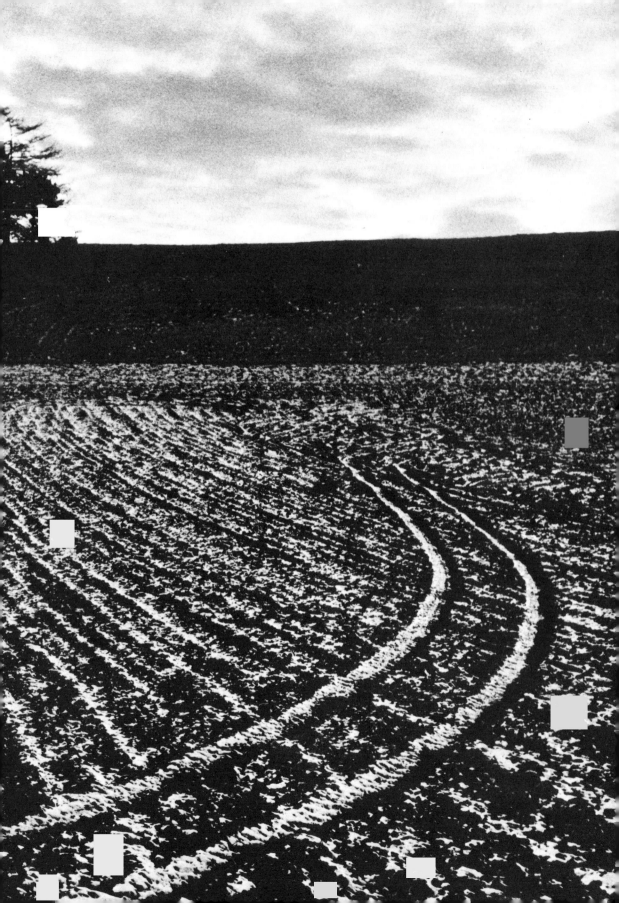

This last-mentioned leads to an illustration of the point that the negative should do most of the work. If you photograph printed matter on white paper, black and white line drawings etc., aim at getting most of the contrast in the negative. Contrast grade 5 or 6 paper should be for emergency use only.

When photographing for pure black-and-white results, use a suitable film and developer, preferably the lithographic (lith) type designed specifically for the purpose. It makes very little sense to use an ordinary, relatively low-contrast film when you know you are aiming at high-contrast results. Failing that, copy the original negative on to high-contrast film, repeating the process if necessary until you have a negative that will print on normal paper.

Using contrast grades

If, in spite of everything, the negative does not fit the paper characteristics, you may find that the print cannot produce a real black without adding too much density to the highlights, or can produce both black and white but not very much in between.

In the first instance, the negative is too flat; there is not enough contrast between the low and high densities. The obvious answer is a more contrasty paper, say one grade up from normal.

In the second case, the reverse applies; but there is somewhat less chance of success. Printing on soft papers is not always entirely successful, as they frequently seem to be unable to produce a good strong black. Their use is best confined to subjects containing very little full black. Used to reduce the contrast of a generally dense negative of a long-scale subject, they tend to look weak. A range of paper contrast grades is indispensable for roll and 35mm film users: the film cannot always receive optimum processing for every image. They are a legitimate part of the photographic process if used intelligently, but they should not be relied on to get you out of trouble arising from careless camera exposures.

For monochrome use there are papers which allow various degrees of contrast to be obtained on the one paper. These multiple-grade papers have a mixed emulsion of differently colour-sensitized silver halide particles. When the colour of the exposing light is varied by the use of special filters, the effect on the emulsion varies to produce higher or lower contrast. The principle is no different from that of different grades of paper, but there is an obvious advantage in needing to stock only one type of paper.

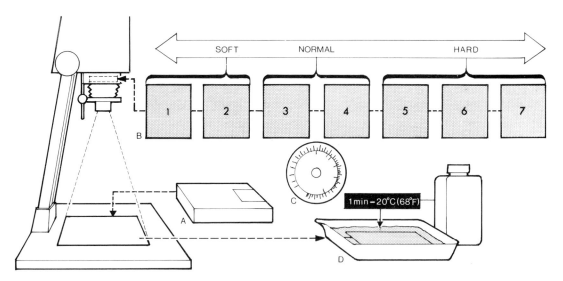

Multigrade paper (A) is designed to be used with a set of filters (B) to give variable contrast. As the filters are of different densities, an exposure calculator (C) is supplied with the filter set. Development (D) is in a special Multigrade developer.

Localised printing control

Contrast grades are used to influence the overall contrast of a print. Sometimes it is more satisfactory to vary the exposure given to different parts of the image. In printing, this is relatively easy as you can see the image during the exposure.

The simplest case is where moderate overexposure of the film has caused faint cloud traces in the sky to disappear in the print. An exposure that produces the required tones in the rest of the print is too short to get through the additional density in the sky, which accordingly prints pure white. Careful shading of the landscape or other area whilst giving extra exposure to the sky area can effect a marked improvement. Slightly more difficult is the case where a small part of the picture area, away from the edge, has been similarly overexposed. Then the whole image has to be shaded, except for that small area.

These techniques are called 'burning in' or 'printing up'. The opposite treatment is 'shading' or 'dodging'. You could regard printing up the sky as the same thing as shading the landscape. The term 'dodging' is applied to holding back the enlarger light from a small area of the print that prints too dark with the correct exposure for the rest of the image.

When all else fails, there is the ultimate control of tone separation (not to be confused with 'posterization'). Tone separation involves the preparation of two copy negatives from the original, one to present shadow detail, the other highlight detail. These are prepared on ordinary camera film and are printed separately on the same sheet of paper. This is a specialized process not recommended for 35mm work except by making enlarged negatives.

Many other darkroom techniques are available to change the nature of the image rather than correct faults in the negative; but these are outside the scope of this book.

An extreme case of printing-up to obscure unwanted detail. A small torch (flashlight) was used to blacken the bottom lefthand corner.

Print processing control

As a print is processed in exactly the same manner as a film, similar controls are available. On the other hand, as various paper grades are available it is not necessary to try to handle contrast by varying exposure and development time or by changing the developer.

Full development Although the procedure and chemicals are more or less the same, there is one significant difference between film and print processing. The print, with its invisible grain construction, can be developed to finality, ie until there are no more exposed silver halide particles left to develop. Full development is, in fact, one way of avoiding the combination of overexposure and underdevelopment, which produces weak blacks and a poor colour.

There is a school of thought which believes that every print should contain a maximum black and a pure white. This assertion is not as silly as it might at first seem. The most offbeat subjects do, in fact, contain at least tiny areas where

such tones appear. You cannot obtain both tones however except by correct exposure and development, ie the minimum exposure that will produce a maximum black at the recommended development time. The advantage of full development is that, provided the exposure is correct, development can be extended considerably beyond the recommended minimum time with little change in tonal values.

Nothing but the best

You must be able to recognize a good print when you see one – that is one of the values of photographic exhibitions. Very few reproduction processes can approach the quality of original prints; and if you have never seen the best you are in no position to judge your own. Correct exposure in the camera is the first vital step in the photographic process. Without it, you cannot get the best possible image in the print. And indifferent printing technique can nullify everything that went before.

The basic technique is the same as that for the film – correct exposure related to the paper characteristics and the developer used. Papers vary; the normal types used with the recommended developers generally require a minimum of some two minutes development at about 20°C (68°F). Others may be happy with

Enlarging exposure meter.
1, Mains connection.
2, Safelight. 3, Enlarger.
4, Sensor. 5, Indicator.
6, Calculator.
7, Enlarger switch.
8, Safelight switch.
9, Exposure switch.
10, Sensor adjustment.
A, Measure lightest tone.
B, Set outer disc to figure indicated. C, Measure darkest tone. D, Set pointer to number for indication of exposure and paper grade.

The effect of print exposure and development time. Left to right: long exposure, short development; normal treatment; short exposure, long development.

shorter times. In general time and temperature are not as critical as with film processing because development can be extended without noticeable loss of quality if the temperature falls a little.

Exposure, certainly, is critical. It is possible to make what might seem to be a tolerable print even by overexposing and pulling the print out of the developer before the minimum recommended time because it seems to have reached the density required. But it will never be the best possible print. It will not have a really good black and will lack contrast throughout the rest of the tones. Similarly, if you underexpose, no amount of extended development will bring up the highlight detail that did not get any exposure, and you may also not be able to get a maximum black.

However, papers designed to produce warm tones – the so-called chlorobromides – can give images in brown tones with the recommended developer and development time, generally about 1½ minutes. Longer development does not significantly affect the quality but it changes the colour to bring it nearer to neutral blacks and greys.

For the best possible results, stick closely to the manufacturer's instructions and to the findings of your own tests. Standardize your paper, chemicals, time and temperature; then you will always know exactly what you are doing, and get the best prints every time.

6 Putting Them Together In Practice

The controls available for use in planning and producing the final image add up to a formidable list, especially for monochrome work. Now we come to using them in practice.

Average and non-average subjects

TTL meters are now commonplace and the general method of assessing exposure is to point the camera at the subject and adjust the lens aperture and/or the exposure time until a readout in the viewfinder indicates that the settings are correct. For most subjects this is enough. What you are doing is taking a general integrated-light reading of the whole subject. The meter scrambles the light it receives and measures its average value. If the subject has a reasonably even distribution of tones, this amounts to the same thing as taking a reading from a standard grey card.

Whatever the reading is, the meter interprets it as if it were taken from a single standard tone and gives the recommended exposures to reproduce that tone. But the subject may not have an even distribution of tones. If it has a preponderance of light tones, they may average out to Tone 7 or 8, so that the meter reads what is in fact Tone 7 or 8 instead of Tone 6. But it is calibrated for Tone 6, so it recommends an exposure to reproduce the average tone as Tone 6 – amounting to one or two stops underexposure. If the subject is largely dark-toned, the meter may read what is in fact an average of Tone 4 or 5, translate it as Tone 6 and so recommend what amounts to one or two stops overexposure.

To avoid this problem, learn to assess the overall tonal value of your subject. Most subjects do, indeed, average out to a mid-tone. Many others may be quite near it. Some may be very obviously nowhere near it. It is those in between that raise difficulties.

We have already indicated the most reliable method of learning to recognize non-average subjects. Using a separate meter and a grey card or incident light reading attachment, meter all types of scene and subject, comparing a direct reading with that of a grey card held in front of the scene. Be careful

Reflections in a pond. The reasonably average distribution of tones makes this a suitable subject for a straight reflected light reading, provided the surface reflections are not too strong.

A lot of deep shadow and plenty of mid-tones. A normal reading could well lead to overexposure.

not to throw a shadow of the meter across the grey card, but at the same time make sure that the meter is close enough to read the card and nothing else. When the main light is directly behind you, this can be difficult, and it is on such occasions that an incident light reading is simpler. Ensure that you are standing in the same light as that falling on the subject.

The average subject – the one that averages out to a mid-tone – gives readings within half a stop of that taken from a grey card. You will be surprised to find how many do, and how many more are within one stop and are therefore well within the latitude of amateur monochrome films. You may also be surprised on a number of occasions to find that a scene you would confidently classify as average turns out not to be so.

Interior plus exterior

Now turn to some subjects that are obviously not average and learn to assess how far from average they are. You want, say, to picture somebody looking out of a window. It is more or less a portrait, so you want a reasonably accurate flesh tone. You would also like at least an impression of the scene outside the window.

Take a general reading of the outdoor scene from the window. Take a grey card reading in the area of the subject's face or other flesh tone. On a bright day with clouds, there could be six stops difference between the two readings. Is the picture possible?

You do not want the interior and exterior scene to look as if they were in the same lighting, so underexposure of one or overexposure of the other is acceptable. It is evident, however,

A high-contrast subject, but one that the modern SLR with centre-weighted metering might cope reasonably well with.

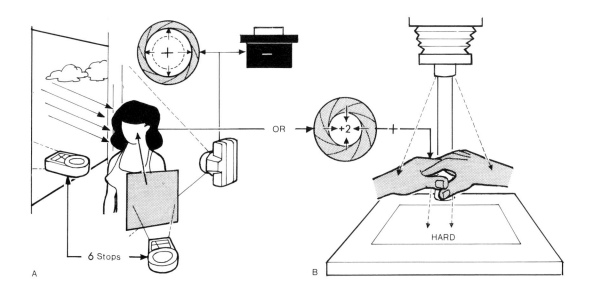

A

B

HARD

6 Stops

that neither can stand a difference of six stops. With modern amateur films the outdoor scene may be able to withstand an error of two or three stops, especially if you expect to exercise some control in printing. But this still leaves the interior up to three stops underexposed, lowering the flesh tone to Tone 4. As the part facing the camera must be somewhat shaded, you might accept Tone 5, but 4 is too low.

The alternative is to let the outdoor scene go to four stops overexposure. Depending on the nature of the scene, there is a reasonable chance that the result would still be printable.

Exposure and development The problem is basically one of contrast. Can you adjust exposure and development? You can in theory, but not very easily in practice. You really need a soft-working developer or a two-bath treatment – fine if you are using sheet film or intend using a whole roll of film on this or similar subjects.

Soft-working developers are useful for high-contrast subjects in which you want to reduce the contrast. They usually contain metol as the only developing agent, omitting its usual hydroquinone companion, and are only moderately alkaline, relying on sodium sulphite alone or sometimes adding a little sodium carbonate. Their aim is to bring up the shadow densities more strongly than the highlight densities. Water-bath and alkali-bath methods (see p 52) are effective, indeed often better. The water-bath technique would be particularly suitable for this subject, if feasible.

A further technique is to increase exposure and curtail · development, though in this case it is not well suited to the

Portrait by windowlight. From left to right, windowlight alone gives uneven lighting. A white reflector improves matters by throwing light back on to the front of the face. Fill-in by flash bounced off the ceiling gives a more even overall light that is more suitable for colour.

subject. With this method you place all tones one step higher than normal and bring them down again by shortening the time of development. The idea is that the increased exposure has little effect at the toe of the characteristic curve while the underdevelopment has a disproportionate effect at the top end. Highlight and middle tones therefore become a little compressed, reducing overall contrast. This treatment is not particularly effective with modern amateur films, which tend to have longer straight line portions and to be without pronounced toe and shoulder regions. Nevertheless, some combinations of film and processing technique work well, so it is worth carrying out your own tests.

If you decide that adjusted film development is not the answer, you are left with printing control. This is possibly the best solution for this particular subject. In printing, you have two possible techniques, namely using a softer grade of paper to reduce contrast, or printing-in the outdoor scene while shading the interior part. Which you use depends on the nature of the subject. If the two scenes blend one into the other with the figure and, perhaps, curtains and furnishings overlapping the outdoor scene, printing-in could call for considerable skill. If you do not have that level of skill, a softer grade of paper is the

only answer. You might even need a combination of both treatments.

Thus, the subject that at first sight seems nearly impossible is not necessarily so. You must decide in advance, however, what method you are going to use to produce the final result. The camera exposure must be based on that method. If you decide, for example, that you must use printing controls, the exposure must be such that printing-in is possible. You cannot expose for the indoor scene alone. Six stops overexposure of the outdoor scene is likely to produce densities in the negative that cannot be printed. On the other hand, the densities for the interior scene must not be so low that they lack the necessary contrast, so that it is almost impossible to print them, even on contrasty paper, and still be able to print up the outdoor scene. You have to assess the exact compromise necessary. In this case, two stops underexposure of the indoor scene is about the limit.

Finally: this subject is virtually impossible in colour, and particularly for a colour slide, without scarificing quality at one or other end of the tonal scale. Drastic adjustments of exposure lead to noticeable colour distortion. The only real remedy in that case – and you might well decide that it is the only sensible course in monochrome too – is to adjust the lighting. It may be

enough to move the subject nearer the window or introduce a large white reflecting surface just out of the picture area to throw light back at the figure. This would probably not be enough for colour and the answer would then be to use extra lighting on the subject. Any such light used, however, must be of the same quality as daylight, suggesting the use of blue-coated flashbulbs or electronic flash. We shall deal with this in Chapter 10.

Sunshine and shadow

Now for a different type of problem. The scene is a wooded area with autumn foliage and strong sunlight throwing shafts of light through the branches. The leaves are transilluminated, showing delicate detail and colour, and the beams of sunlight are reasonably well defined. The overall lighting is good, and grassy patches are strongly lit. What kind of picture are you going to produce and what exposure does it need?

You might well decide that the sunbeams and the finely-detailed foliage are the main attraction. The tree trunks and the ground area are simply a backdrop. The whole scene could quite possibly integrate to grey, so a direct meter reading would give you a possible exposure. The result would be well-defined tree trunks, ground area and general surroundings with the leaves bright and the sunbeams broad shafts of light merging into the background and one another. The overall effect would be of a light airy scene – but without any particular appeal.

This is not the impression you get if you view the subject through half-closed eyes. You become more conscious of the contrast between the sun's rays, the foliage and the general woodland scene. The tree trunks and most of the ground area look darker, the sun's rays are more narrowly defined as shafts of light rather than broad bands, and the foliage appears as a delicate tracery. You may decide that this is the impression you wish to convey.

It is then evident that you want to maintain the contrast, or perhaps even to increase it. You do not want the ground and tree bark detail that your eyes so easily adjust to. You want to see the scene as with unadjusted eyes, like the camera – through a fixed-size iris. The tree trunks might look like Tone 4 or 5 as you adjust your vision to them but they would be quite satisfactory as Tone 3 or even 2. You cannot readily assess the tonal value of the sun's rays or the leaves, but you can decide how you would like them to appear in the print. You would probably want the leaves at about Tone 7. You would not want the sun's rays to go beyond 9.

72

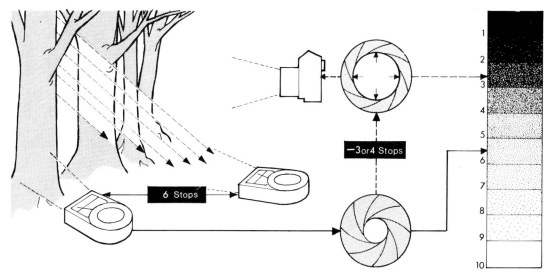



6 Stops

−3 or 4 Stops

1
2
3
4
5
6
7
8
9
10

Sunshine in woods. If readings from sky plus foliage and from the tree trunks are within a 6-stop range, adequate exposure should be obtained by adding 3 or 4 stops to the close-up reading from the trees.

You now have a range of about six or seven stops, just within the capability of the film. Take a close-up reading of a tree trunk. Then point the meter at the brightest area of sky plus foliage. The chances are that the reading will be near enough the value of the sun's rays in the picture area. If the two readings are within the six- or seven-stop range, you have every chance of getting the picture you want by pegging the exposure at that estimated for the trees.

Your close-up reading for the tree trunk recommends an exposure to reproduce it as Tone 6. You want it at Tone 2 or 3. So, if you set your exposure at 3 or 4 stops less than the meter recommends, you should get the picture you want. Thus you have placed Tone 5 in the Tone 3 position. Correspondingly, all other tones are also brought down. The bright rays of the sun and the transilluminated leaves have been saved from overexposure and should retain detail. Any bright sky area visible may be rather light, but that is not important. Parts falling into deep shadow may go completely black. This, too, is acceptable. Now the overall impression will be of strong sunlight in a shady woodland scene and there will be much more warmth and depth to the picture.

Transforming the subject
Progressing further, how do you transform a scene to make it reproduce in a particular manner? You are sitting on the beach on a brilliantly sunlit day. Sky, sea and sand are reflecting enormous amounts of light. Figures with unbelievable energy are racing along the beach at the water's edge. It hurts your eyes to watch them and the glare is such that you can barely make out their shapes at all. Can you show that?

Overleaf:
A total distortion of subject tones by deep filtration, together with processing and printing for contrast and grain effects.

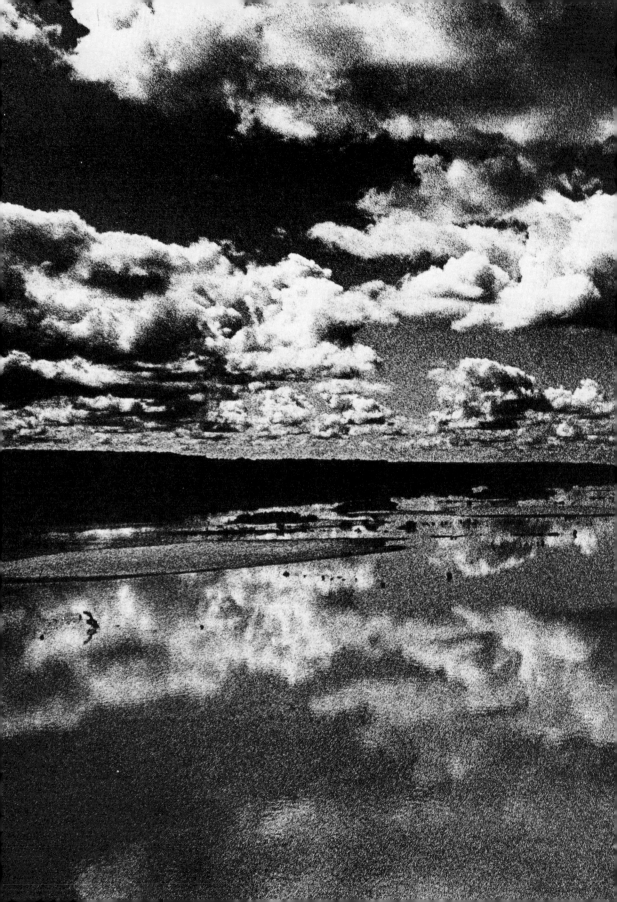

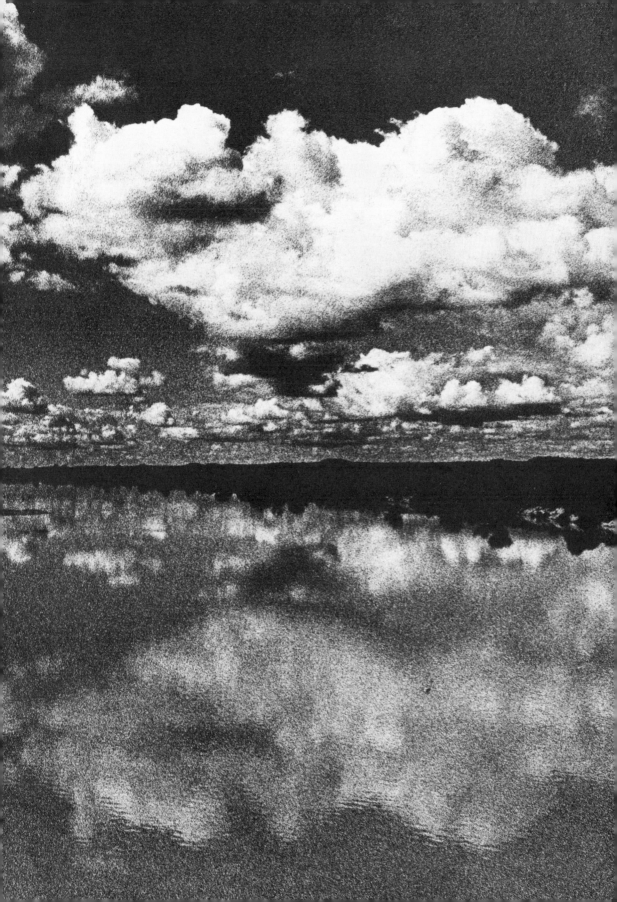

You can, in fact, by careful handling of exposure. You could not make much of it as an ordinary picture. Normal detail in sand and sky would call for an exposure so short that the figures would go into partial silhouette – a possible picture in some circumstances, but not very striking. Shorten the exposure still further and you will get darker-than-normal tones in sky, sea and sand, the figures in full silhouette, and possibly dancing highlights on the sea as well; possible again.

What would a greater exposure do? It could produce an interesting result, lightening the general surroundings perhaps to the point of obliterating detail. You would get detail in the figures but little contrast.

You could get them nearer your painful view of them, however, by using the shutter setting to provide the greater exposure. Suppose you set an exposure time that allows the moving figures to blur quite noticeably – say to about one quarter of the figure width? In other words, the images of the figures move appreciably during the exposure. What happens in fact is that part of the figure moves into an area of the film that has already been exposed to the very strong backlighting – and part moves out of an area that is subsequently exposed in a similar manner. The result is that the edges of the figures

Use of a slow shutter speed to distort figures and emphasise urgency of movement.

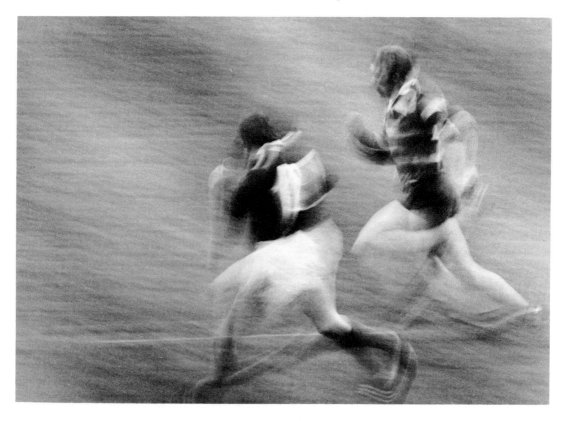

disappear and each is trimmed down to a 'slimline' version rather similar to what you see with unprotected eyes.

The trick is to get the exposure time right. If it is too long or the figures move too fast, they will virtually disappear. You need a speed of about 1/15 or 1/30 second, perhaps 1/60 if they are exceptionally energetic.

The limits of processing variations

Finally, what are the conditions in which adjusted development can be of some value? We have already indicated that generous exposure and curtailed development may have limited uses with some films in reducing contrast. The main drawback is that you do not often shoot a complete roll of film, particularly 35mm, under such conditions. You may well be out on a rather dull day when the light from a grey sky is very flat. Modelling is almost non-existent. Very weak shadows make buildings look like cardboard cutouts and faces uninteresting. Then you can think about the reverse technique, ie curtailed exposure and extended development.

These are relative terms. We talk loosely about overexposure, underexposure, etc. in terms of the norms laid down for average subjects in sun plus cloud conditions. These norms do not apply when the conditions change. The main difference between 'normal' and dull lighting is in the shadow areas. In sun plus cloud, the average shadow value is about Tone 6 or standard mid-tone, perhaps a little darker.

Exposure in dull light For the sake of comparison, take average shadow values as Tone 6. In dull conditions, such shadows could be about two stops lighter, corresponding to Tone 8. So a normal exposure places them there, too light to give any real modelling. You want them to reproduce darker without too much effect on lighter tones. You cannot expect to simulate sunshine and cloud conditions but you can improve matters a little.

In this respect, bear in mind that the dull lighting conditions do not affect the relative tones of areas in the same lighting, ie the unshaded areas. The difference between white and black is still the same proportionately whatever the intensity of the lighting – or near enough so in the conditions that concern us. It is only the difference in shadow values that causes the change in contrast.

To return to our subject in dull light. Take a reading from a mid-shadow area (not the deepest of the shadows). This gives an exposure for reproduction as Tone 6, which would be a two-stop underexposure compared with its true value of 8, but only

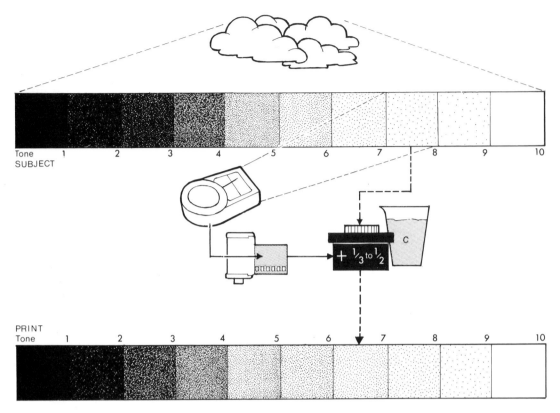

Tone SUBJECT 1 2 3 4 5 6 7 8 9 10

PRINT Tone 1 2 3 4 5 6 7 8 9 10

one stop for its intended value of 7. Set your camera controls to give the exposure indicated by the shadow reading, so pegging the shadows at a value of Tone 6. Treat all exposures on the roll of film in the same manner. If the sun comes out, do not shoot. In fact, do not use this method on changeable days. It is for the dull day with little or no chance of sunshine.

Processing When you process the film, the aim is to bring the shadows exposed as Tone 6 up to Tone 7. That will call for something like one-third to one-half increased development time, or treatment in a more contrasty developer. Both treatments give the characteristic curve a steeper slope. The light shadows and other mid-tones are better separated, while the few really light and dark tones are little affected. It should be easy to make a brighter print that shows improved modelling.

Do not be too ambitious with this treatment. You cannot make a flatly lit subject look as if it were taken in bright lighting conditions. The best you can do is to heighten the contrast in the mid-tones and deepen the shadows slightly to make a generally brighter print. To do so satisfactorily, however, you have to know your materials. Chapter 15 details tests for both film and developer so that you know exactly what you can and cannot do.

Underexposure and overdevelopment. A reading from Tone 8 gives an exposure to reproduce it as Tone 6 with normal development. Extended development may compensate to bring it up to Tone 7.

7 Exposure at Close Range

You will be aware that the amount of light reaching the film is controlled by the size of the lens aperture. Glass reflects some light, and also absorbs some. This means that some of the light that reaches the lens does not reach the film.

Effect of lens extension
In certain circumstances, there are further losses, due to what is known as the lens extension. For distant subjects, the lens is at a more or less fixed distance (the focal length) from the film. You move it in and out a little when focusing, but the movement is very small in proportion to the focal length. When changing focus from 1m to 10m with a 50mm lens, for example, you move the lens no more than about 2.5mm. When focused as far away as possible (infinity), a 50mm lens is 50mm from the film. When that same lens is focused on a distance of 0.5m, it moves about 6.4mm forward from the 'infinity' position.

When you get really close, the lens needs to be moved an appreciable amount away from its infinity position, and the light emerging from the back of the lens has to travel farther to reach the film. The further it travels the weaker it becomes; thus exposure is affected by lens extension. In general photography,

To provide 1:1 reproduction, a 50mm lens has to be moved to 100mm from the film. If there were room, it would then spread its image over a 4x greater area. As the intensity of the light passing through the lens is unchanged, the illumination of this greater area is only one quarter the intensity of that of the original image.

as we have seen, the extension is a small fraction of the focal length at normal distances. It is only about 13% at 0.5m for a 50mm lens. As you move closer, however, the lens movement increases rapidly. At 0.1m (10cm) the extra extension required is about 50mm, or 100% of the focal length.

The loss of light is inversely proportional to the square of the distance between lens and film. When the distance is increased from 50mm to 56mm, the proportion is $(50/56)^2$ or 1:1.25. That is, about one-fifth of the light is lost. This is not important. Generally, no adjustment of exposure is required when working within the normal focusing limits of the lens.

Many lenses have a so-called macro focusing capability, allowing them to produce images at about one-third life size. The added extension in such a case for, say, a 100mm lens is 33mm, which causes a light loss of more than 40%. The proportion is the same for any lens and amounts to about one stop, a significant amount.

When you get to real close-up work with extension tubes or bellows, the effect of the extra extension becomes even more important. With a life-size image, for example, the required extra extension is equal to the focal length. This means the length of the light path is doubled from 50mm to 100mm, the

Where the basic exposure is correct at f 8, as indicated by a grey-card or incident-light reading, the required aperture with a zoom or other lens on its macro setting is f 5.6. With a 50mm lens on bellows or tubes for 1:1 reproduction, the aperture should be f 4, ie two stops more than the basic exposure. A TTL exposure meter gives these readings automatically.

light loss now being $(50/100)^2$ or 1:4, so that the effective exposure is only one–quarter of that with the lens in its normal position. This means that you have to give four times the normal exposure as indicated by a separate meter reading.

This does not apply to meters reading through the camera lens, which take account of the extra extension automatically. But TTL metering is not always reliable at close range any more than is a straightforward reflected-light reading with a separate meter. Close-up subjects are often non-average, with uneven distribution of tones. It is advisable to take the reading from a grey card or to use the incident light method.

Close-up exposure factors

If you use a separate meter, you need to adjust the reading. There is a relatively simple calculation which gives the factor by which to multiply the normally indicated exposure. Add the focal length of the lens to the extra extension you have put in, divide by the focal length and square the result. That is $(E/F)^2$, where E is the total extension (focal length plus length of extension tubes or bellows), and F is focal length.

A typical close-up subject, needing extension tubes. Meter readings, except TTL, must be adjusted to allow for the extra extension.

Thus, with a 50mm lens and a 30mm extension tube you have $(80/50)^2 = 2.56$. You need to multiply the indicated

exposure by 2½. This amounts to an increase of about 1½ stops.

The exposure factor can also be associated with magnification (image size in relation to subject size) because the added extension is always the same proportion of the focal length for the same magnification, no matter what lens is used. As already said, a 33% extension gives an image one-third life size (magnification 0.33). This holds true throughout the range: 50% added extension gives an image half life size; 100% added extension a life size image and 200% an image twice life size. Thus, a 200mm lens extended to 600mm (400mm added) gives an image twice life size. So does a 50mm lens extended to 150mm (100mm added). In each case, the added extension has the same proportion in relation to focal length, so it has the same effect on exposure. A twice-life-size image needs extension equal to twice the focal length. The light path is therefore tripled and, by the inverse square law the light intensity at the film plane is reduced to one-ninth. Therefore the exposure must be increased nine-fold, or about 3¾ stops.

Thus, it is easy to compile a table of exposure factors allied to image size.

The last column in the table indicates the practical

Bird in a cage shot with extension tubes on a 300mm lens. The tubes are used to allow the lens to focus closer than its normal 4m or so but are not long enough in this case to affect the exposure.

Extension (% of focal length)	Magnification or reduction	Exposure factor	Stop value
15	0.15	1.32	$^1/_3$
20	0.2	1.44	$^1/_2$
30	0.3	1.70	$^2/_3$
40	0.4	1.96	1
50	0.5	2.25	1
60	0.6	2.56	$1^1/_3$
70	0.7	2.89	$1^1/_3$
80	0.8	3.24	$1^1/_2$
90	0.9	3.61	$1^1/_2$
100	1.0	4.00	2
110	1.1	4.41	2
120	1.2	4.84	$2^1/_3$
130	1.3	5.29	$2^1/_3$
140	1.4	5.76	$2^1/_2$
150	1.5	6.25	$2^1/_2$
160	1.6	6.76	$2^2/_3$
170	1.7	7.29	$2^2/_3$
180	1.8	7.84	3
190	1.9	8.41	3
200	2.0	9.00	3

adjustments that can be made because most exposure meters are marked with the standard range of film speeds that double up at each setting, with two additional marks between each setting. These intermediate marks are equivalent to one-third stop settings so, while working at a given magnification, the meter can be set to an appropriate film speed to take care of the close-up factor. For an image at 0.7 magnification (70% life size) for example, set the meter to a film speed figure that is four $\frac{1}{3}$ stop divisions lower than the actual film speed. You then get $1\frac{1}{3}$ stops extra exposure by simply following the meter reading. But again it must be emphasized that this applies only to meters that do not read through the camera lens.

Close ups with telephoto lenses
The first column in the table indicates the extra lens extension required for a given magnification. This is where we run across a snag with close-up photography with modern equipment – or, in another sense, an example where modern equipment has built-in protection against its own failings. The figures in the first column relate even to telephoto lenses, many of which are suitable for close-range work, giving a considerable increase in

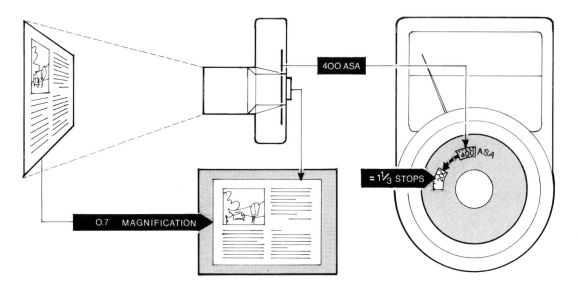

The following are labels within the diagram:

400 ASA

0.7 MAGNIFICATION

= 1⅓ STOPS

400 ASA

lens-to-subject distance. Unfortunately that means that the third column does not apply to such lenses, because the increased extension is greater than the light path in the lens, which is shortened by the special telephoto construction. Consequently, the increase in exposure required is also greater, generally at least twice as much. For 1:1 reproduction with a telephoto lens, the close-up factor is likely to be about 9 or 10, rather than 4.

The same applies to lenses with extra 'macro' focusing ranges, including zooms. The built-in protection referred to is the fact that these lenses are designed for use on TTL metering cameras. The meter takes care of these light losses as it does for others. If you use them on cameras not having TTL meters, conduct a few experiments first, or you will get apparently unaccountable underexposure.

Close-up work involves extra lens extension. The light has to travel further to the film, so extra exposure is necessary. TTL meters read the lower light level. Other meters must be set to allow for the lens extension or a normal reading must be adjusted.

Copying by reflected light

Even when you are not really close enough to make a significant difference in exposure (or when you use supplementary lenses, which do not affect exposure), you have to be careful with metering. Copying is a popular form of close-up work and the subject is often far from average.

When copying printed matter, for example, a straightforward meter reading does not give a correct exposure unless the printed matter is in heavy type and very close set. Average newsprint integrates to a tone 1–1½ stops lighter than a grey card, magazine pages 1½–2 stops. An exposure at the level indicated by a meter (even a TTL type) would give a negative very difficult to print. You need to increase the exposure to the level of the grey card reading. If you use a

separate light meter, you then need the further increase for the lens extension, if any.

Even magazine illustrations generally read lighter than a grey card because they rarely have deep black tones. Good photographic prints, on the other hand, should read in relation to a grey card much as you would expect the original subject to read.

In copying material of this nature, it is rarely wise to stint the development. Generally, an exposure just short of full (no more than half a stop under) plus slightly increased development (up to 10% or 15%) gives the best results. You want at least to maintain the contrast of the original and sometimes to increase it. Do not overlook the influence of lens flare and the basic density of the film. No matter how good the lens, the image never retains the full contrast of the original. Similarly, some unexposed silver halide particles always develop, so contrast is at least minimally reduced. In copying most subjects you must do nothing to lower the contrast.

If you are copying pure black and white material, you should use a suitable high-contrast film if possible, and this is available in 35mm. For rollfilm users the slower films are fairly suitable but even a normal medium-speed film can be used with a high-contrast developer. Prints on Grade 3 or 4 paper should be satisfactory.

When copying a mixture of printed matter and half-tone (continuous tone) illustrations, a grey card reading should form the basis for exposure. Adjust for the exposure factor if necessary and then close down about half a stop. Full development or possibly 10% or 15% extended development should give an adequate result with only a trace of background tone.

Printed matter on a coloured base is more difficult to handle. If, as might be expected, the colour of the print contrasts with that of the base, you may be able to improve its rendering by using a filter of the same colour as, or deeper than, the base colour. With red on yellow, for example, the yellow can be totally eliminated by a yellow-green filter which leaves the red largely unaffected. If the lettering is true black, a filter can have little effect. If the lettering is white on a coloured ground, you need a filter of the opposite colour to the ground, ie yellow, orange or red for a blue base.

Exposure then becomes tricky. In addition to the close-up factor, you have to make a further allowance for the filter. Chapter 9 deals with the use of filters, it is only necessary to note here the fact that filters often have exposure factors printed

on the rim, such as 2x, 4x, etc. You need to multiply this factor by the close-up factor. A factor of 2x for close up and 4x for the filter is thus 8x.

Filter factors are not as precise as they seem, and the effect of a filter on the eye, the film and the exposure meter can vary considerably. It can also vary for different types of exposure meter and under different lighting conditions. In this area, therefore, you cannot be precise about exposure until you have fully explored the characteristics of your filters with your lenses, exposure meter and film. Without this experience base your exposure on the filter factor and then make two other exposures at half and one stop either side. This is called 'bracketing'. With the deeper coloured filters, it may be unwise to rely on reading through the filter with an exposure meter, TTL or other (see p 104).

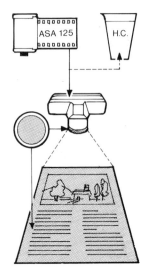

Filters can be useful when copying printed material on a coloured base, sometimes backed up by moderately high-contrast processing.

Copying transparent originals.

You can not always copy by reflected light: transillumination is necessary, for example, in slide copying. There is no great problem as far as exposure is concerned but, as transillumination is likely to lead to higher contrast than reflected light, you can run into troubles in that area. For slide copying and most other photography of translucent materials, therefore, you need to expose and process for a reduction in contrast.

Copying transparencies in colour is catered for by special copying film with a lower contrast characteristic than general-purpose colour slide film. For copying in monochrome there is no such specialized material. There is a temptation to copy on the slowest available material, but this is not generally the best method. Such materials are contrasty and have little latitude. If you do use them, a low-contrast developer is essential. Medium speed materials are easier to handle and give perfectly satisfactory resolution and grain size if properly exposed and processed. Exposure should be a little on the full side and development curtailed.

The difficulty with transparent originals is that too full an exposure can lead to lack of contrast, particularly with tungsten illumination. Highlights do not easily burn out in the yellowish light, while shadow areas are often far from opaque. It is therefore vital to meter the slide as accurately as possible.

Measuring exposure A slide is small, so hold the meter as close to it as possible. The selenium type with a large cell can actually be placed in contact with the slide. Provided it is an average scene that integrates reasonably well to a mid-tone, the

Copying slides is a straightforward close up task. Any kind of illumination can be used for black-and-white copies but for colour, daylight or electronic flash must be used. A meter with a large cell allows readings to be made directly through the slide. It is vital that camera back and slide be parallel when copying.

reading can be taken as the basic exposure. If it is obvious a non-average subject, it is advisable to take a reading through another slide of similar density but a more balanced tone range, and use this as your basic exposure. The same advice applies, of course, to TTL meters, which are also misled by non-average subjects.

Slides of varying densities pose no problems provided they are average subjects. If they are not, you are again in the realms of guesswork unless you have an average slide of similar density.

Once you have the basic exposure, you simply have to adjust for the magnification. Same-size copying means a 4x exposure increase. At other magnifications, calculate the exposure factor carefully.

When processing your slide copies, cut the development time by 10% or 15% as compared with the time recommended for average subjects. If you are prepared to work with more than one type of developer, use a low-contrast type (metolsulphite or metolsulphite-carbonate).

Exposure levels in copying

There is no need to use powerful lights in monochrome copying. They may make the subject look brighter to the eye but they have no effect on contrast. You can make just as good copies with household lamps and relatively long exposures as with powerful floodlights. Excessively small apertures should not be necessary either. Most lenses give their best performance at two or three stops below maximum; and as you are not concerned with depth of field there is no reason to stop down further.

It is better to use lenses constructed for or known to be suitable for, close-range work (not just with a 'macro' facility added). Genuine macro lenses are normally used stopped down for metering purposes; there is a lot to be said for pursuing this practice with other lenses, even if you have a full-aperture-metering camera. It makes more sense where exposure is critical to meter at the shooting aperture than to allow an electronic intermediary to predict lens transmittance. Check the instruction book first, however, because there are some lenses designed for full-aperture metering that do not give accurate readings when used stopped down.

Reciprocity failure The main argument against low-light, long-exposure copying is the possibility of reciprocity failure, when the normal relationship between mathematically equal exposures breaks down: 10 seconds at *f*22 may have less effect than ¼ second at *f*4. Long exposures have been said to have the

advantage that the exposure corrected for reciprocity failure has a straightening effect on the toe and shoulder regions of the characteristic curve. However, it would be unwise to rely on this without practical tests.

You can avoid reciprocity failure effects with most films if you keep your exposure times to one second or less; such exposures are within the capability of household lamps and moderate lens apertures.

A fact of life that must be borne in mind when dealing with any type of exposure problem is that theory is one thing and practice is another. We need the theory, because without it we have no base from which to work. But that is all theory can do: provide a starting point.

To expose the film, light has to pass through a lot of glass in modern lenses. *F*-numbers are marked to indicate light transmission but they in themselves are theoretical and it is not at all uncommon, for example, for an aperture marked *f*2 on one lens to act like *f*2.8 on another. Lenses vary in many ways and light transmission is never what it should be according to theory.

The point is highlighted with the use of some tele-converters. With a 2x teleconverter, the theory is perfectly straightforward. The image is doubled in linear size, quadrupled in area, for the same intake of light. Therefore the illumination at the film plane is reduced to one-quarter at any particular point compared with what it would be without the converter. So a 2x teleconverter calls for two stops extra exposure or, as we usually put it, all aperture markings on the prime lens are effectively doubled.

In most cases, the theory works adequately, particularly in black-and-white. In others it may not. Moreover, the TTL meter reading may not be accurate if the extender is used on a very long focus lens. There may also be some change in the subject, causing the loss of contrast often apparent in long-distance shots.

When putting a new teleconverter into use, it is always wise to use a few exposures on test shots to check whether it really does work as the theory says it should. Preferably, such tests should be made on slow colour slide film. Colour negative, black-and-white and even some fast colour slide films now have enough exposure latitude to mask minor inaccuracies.

8 Using Daylight Indoors

Indoors, exposure is as much a question of lighting as of camera settings. In natural light (window light), you can encounter extremes of contrast, which can be useful for some effects but are useless for representational photography, that is, the way we perceive the subject. Even in a room with large windows and light-coloured furnishings, there can be 10 stops or more between meter readings in important highlight and shadow areas – a range of 1:512. The eye can handle such extremes easily because it adjusts almost instantly from the strong sunlight near the window to the deepest shadow, and sees ample detail in both. The film can manage most of the range, perhaps with the sacrifice of a little detail at one end or the other. However, replace the furnishings with darker colours and make the windows smaller or the room larger, and the range of luminances becomes too great for any film. Even the eye has to adjust consciously from one extreme to the other. In such conditions a truly representational picture of the room is impossible. No detail can be retained in any but the lightest mid-tones without burning out the sunlit areas completely.

Nevertheless, very fine portraits can be taken by window light and nothing else. It can also be used for a variety of other subjects that demand soft illumination. In these cases, however, direct sunlight through the window is unacceptable unless large reflecting surfaces (or other windows) are available to throw light in to the shadow areas.

Sunlight can be used if representational effects are not required. A shaft of light through a window spotlighting a face, ornament, picture etc with only hazy detail in the very dark surroundings, can make an effective picture.

A harsh, contrasty room interior with totally burnt-out highlights in windows and other brightly lit areas can create an atmosphere to enhance the aim of the picture. It would not be very effective with a daintily-furnished bedroom, but it could help to emphasize the story in a dilapidated, paint-peeling slum kitchen. As ever, the problem here is to set the camera exposure at a level that provides the result you want. The automatic-exposure camera has no place in such a scenario, and an

Overleaf
Lit by a shaft of sunlight, fortuitously or by careful posing. A generous exposure is necessary to retain detail in the dark clothing but development must not be so prolonged as to burn out the well-lit flesh tones.

exposure meter is essential. It takes a great deal of experience to assess subjects like these.

Representational photography by window light
To begin with the relatively easy treatments that aim more or less at representational results, let us consider a window-light portrait. We need not go into great detail about the arrangement of the model or the use of reflectors, supplementary lighting, etc, as this aspect is dealt with extensively in other books, such as *Light on People* (see Bibliography).

Whatever your set-up, you are likely to be faced with higher contrast than normal in portrait work, unless you have used extra lights or reflectors. The general problem is that the window-lit side of face or figure is much brighter than the other side. Your model should not be in direct sunlight, which is unsuitable for this type of picture. You are not aiming at any particular effect – just the rather pleasant appearance of smooth, diffuse lighting.

Identifying the tones The only real problem therefore is to identify the tones you wish to reproduce. Naturally, you want the window-lit flesh tone, and you want detail in at least some of the shaded areas. So meter both of these, and note the difference between the lightest and darkest areas in which you want detail. It might be, say, three stops. The window-lit flesh tone you will want to reproduce as about Tone 7. If you do, the shadow areas will reproduce as Tone 4, which is quite dark but still shows some detail. If that is acceptable, an exposure at one stop more than a close-up reading from the window-lit area should be adequate.

If there is a difference of more than three stops between the two readings, you are on the borderline of showing no detail at all in the shaded area. If that is unacceptable you will need to employ a reflector or supplementary lighting, unless your tests have shown that you are still within the required range where exposure and processing adjustments can be used.

You may have found, for example, that you can place the window-lit flesh tone as Tone 8 by a longer exposure and then bring it down again by reduced development. It then reproduces correctly as Tone 7 with some compression of other tones, retaining a little of the extra exposure given to the lower tones. This does not work if the shadow tone is a long way out of range, say more than five stops.

If you think the procedure will work, give two stops more exposure than a close-up reading recommends for the window-

Window-lit portrait. Exposed on the left for the window-lit flesh tone with normal development. On the right, given one stop more exposure and 25% less development.

lit flesh tone and cut development by up to one-third.

The same treatment applies to virtually any attempt at representational results by window lighting. Large windows on overcast days provide very useful light sources for the photography of small objects. Placed close to the window, they escape the drastic fall-off in lighting that affects a large figure, even in the dullest of daylight, but retain some modelling.

Non-average subjects As with all small objects, exposure has to be calculated in relation to the subject, which is often non-average. When using a separate meter, be very careful to point it along the camera axis and, even if the subject does seem to be average, preferably use a grey card or an incident-light reading. This should give you the correct exposure for virtually any subject; it is best to use it here even if you have a TTL meter. You could need to adjust the reading for the subject in special circumstances. If it is glass, for example, with fine, faintly-modelled detail, there is a danger of overexposure. A slightly reduced exposure is preferable, and if you can also extend processing by 10% to 15%, so much the better. On the other hand a dark object with some very light texture could easily be underexposed. An extra half-stop exposure is then advisable.

Window light can be a perfect source for small objects, where fall-off with increasing distance from the window is of little importance.

The window as a spotlight

Breaking away from representational photography, how do you deal with subjects well back in the room illuminated by shafts of sunlight as from a theatrical spot? In many cases quite simply by a direct reading from the illuminated subject alone or from a grey card in the subject position. This is suitable where the surroundings are dark and you want the minimum of detail in them.

With lighter coloured surroundings, there is more light, but to the film there is less than the eye sees. Meter the areas of the surroundings and compare them with a reading from a grey card in the subject area. The reading tells you how they should reproduce. If the wallpaper, for instance, reads two stops lower than the grey card (which is in sunlight), it will reproduce at about Tone 4, which is darkish, but nowhere near black. If you want it darker, you have to be prepared to let your main subject go darker. In the case of a figure this might be acceptable.

Should you decide that the wall is to reproduce no lighter than Tone 2, you have to let the figure go to Tone 4 (or 5 if you can bring in processing control). This may sound a bit too dark, indicating that the lighting is not really suitable for the idea you have in mind. Perhaps the wall is reflecting too much light. Try to adjust the lighting by partly drawing a curtain or erecting a barrier.

Metering with backlit subjects

In another situation, you might use sunlight through the window for backlighting, shooting directly at it with the subject between the camera and the source of light. Now, what effect are you after? Do you see the subject again as a figure? Perhaps

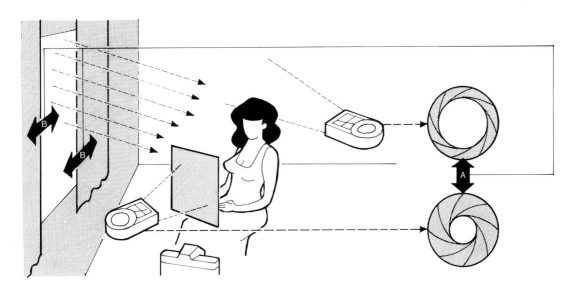

not, in which case you have to adapt the following procedures to your requirements.

First, what is the most important tone in the picture? At what level should it be reproduced? The probability is that you would choose the highlight tone on the figure – the touch of rim lighting provided by the window light. In that case, what tone should it have in the print? Much lighter than the average flesh tone seems reasonable – perhaps Tone 8.

It is not easy to meter the actual rim light but it should be nearly the same as that on the back of the subject, so meter that instead. If you use the exposure now showing on the meter, the rim-lit area will reproduce as Tone 6 – the standard mid-tone. You want it as Tone 8. The indication is that you need two stops more exposure than the meter recommends.

That might be all you are concerned with. Perhaps you are prepared to accept the tone on the front of the figure as anything from almost deep black to a reasonably detailed shadow. But you can also get an idea of what the other tones will be. By placing the rim-lit area at Tone 8, you are giving a relatively short exposure, but it should be enough to burn out the actual window area completely. The illumination on the front of the figure depends to a large extent on the size of the room and the tone of the furnishings. Meter it directly and compare the reading obtained from the rim-lit area, which is to reproduce at Tone 8. At four stops less, it will be noticeably less than black, with fair detail, especially if any parts are significantly lighter or darker, such as eyes or clothing. At five stops less, the darkest parts are approaching black and any greater difference gives you a silhouette.

Similar measurements taken from areas of the floor or other parts that fall within the picture area can give you a clear impression of how they will reproduce, too. Except with the strongest sunlight and the lightest tone, none should be burnt out.

This is the type of subject with which the full use of Ansel Adams's Zone System would demand adjustments in exposure and processing to control contrast, or where you would use different developers. But in this situation you could be taking pictures that need opposing treatments all on the same roll or cassette of film. It is possible to cope in 35mm by organizing your shots so that you shoot all of one type of picture first, and leave an empty frame before those of another type, and so on. Note the number of the blank frame, wind the film back, wind it on again to the blank frame and cut it in the darkroom. With rollfilm use separate films for each type of shot.

Identifying the key tone

The way to solve the exposure problem when shooting by window light is to identify the tone that must be reproduced at a certain level and the tones that you can – or wish to – sacrifice. The most important tone is not usually difficult to identify. Having done so, decide which in our list of tones is nearest to the level you want your important tone to be in the final picture. To ensure that it will be at this level, take a close-up meter reading from it. If you were to give the exposure recommended by your meter, you would reproduce your 'key tone' as Tone 6. So you simply set the exposure the same number of stops higher or lower as the difference between Tone

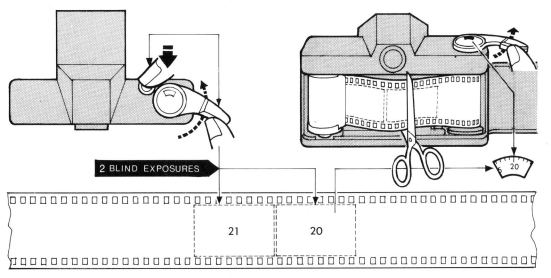

2 BLIND EXPOSURES

21 20

6 and the tone you want. If you want your key tone to reproduce as the lightest possible tone with some detail (but little or no colour) you give three stops more exposure to bring it to Tone 9.

You can check how other tones will reproduce by comparing direct readings of them with the reading from your key tone. In this case, as your key tone is to reproduce as Tone 9, anything with a higher reading will be dead white; anything required to be dead black must be eight or more stops darker.

Again, remember that these predictions of tonal values depend on the characteristics of the film and the processing technique. They are close to what might be expected from a medium-speed general-purpose amateur film developed according to the manufacturer's instructions. To be able to forecast the results you will get with your own materials and technique, you must make tests before you start and as you go along. Even changing the location of your darkroom can affect the results – as can processing in cold weather in an unheated room, compared with processing in warm weather.

9 How Filters affect Exposure

Sometimes you cannot get quite the exposure you want in terms of lens aperture and shutter speed. In bright, sunny conditions, for example, with an ASA 125 (ISO 125/22°) film in your camera, you perhaps want to use a large aperture to restrict depth of field but at *f*5.6 you have no exposure time short enough. It would be worse still if you were using ASA 400 (ISO 400/27°) film. But can you do anything to allow you to use *f*4 or *f*2.8? Yes, if you use filters.

The prime function of a filter is to change, in a selective manner, the colour of the light reaching the film. It does this by transmitting light of its own colour and absorbing light of all other colours to a greater or lesser degree. It can thus change tonal values in monochrome photography, or correct an overall colour cast in colour film.

Filter factors. A factor of 2 (A) means twice the exposure that would be given without the filter (B) or opening up the lens by one stop. A factor of 4 (C) means a 4x increase in exposure or opening up the lens by 2 stops.

Filter factors

The amount of light absorbed by a filter is specified by the manufacturer in the form of a filter factor, such as 1.5, 2, 4, etc. The factor indicates that when you use the filter you should multiply the indicated exposure by that figure. With a filter factor of 2, you should give double the exposure, ie one stop extra, to compensate for the light absorbed by the filter.

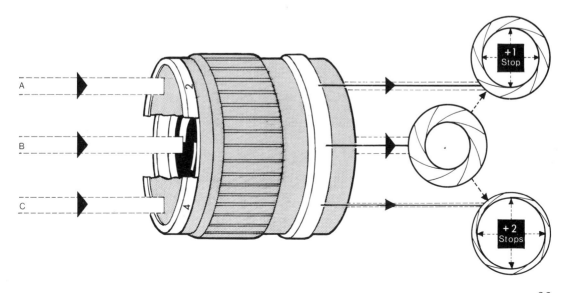

This may seem a little odd because you are transmitting all the light of the filter hue and then giving it extra exposure. The remaining light, which is partly absorbed, gets extra exposure to bring it back to near normal again. In practice it does not work quite like that because ordinary filters are not pure colours, and very few colours in nature are pure.

All ordinary filters transmit light of all hues but absorb some of them much more strongly than others. A red filter for example has little absorption effect on orange or yellow, rather more on green, and a strong absorption of blue and violet. As virtually all colours in nature are mixtures, any given filter is likely to have some effect on most colours.

In the use of a yellow filter for darkening a blue sky in order to allow cloud formations to show up better, the blue light from the sky is strongly absorbed. But the white cloud has a blue content, as do to a lesser extent the green grass and foliage and even many reds, browns and other colours. So you have to increase exposure to avoid underexposure of parts of the scene, but the increase is not sufficient to restore the tone of a colour that is almost entirely blue and therefore strongly absorbed by the filter.

The point is that filter factors are no more reliable than other figures in photography such as film speeds and flash guide numbers. They need testing under the given conditions. The light reflected from white paper in tungsten lighting is yellowish because tungsten lighting has a much lower blue content than daylight. A 4x orange filter might absorb rather less than a quarter of it. Under blue or green filtering of the illumination, more than three-quarters of the light could be absorbed by the

Filters have a selective effect on colours. A red filter, for example, transmits virtually all red light but absorbs other colours more strongly the further they are removed from it in the spectrum. Blue and violet are absorbed most strongly.

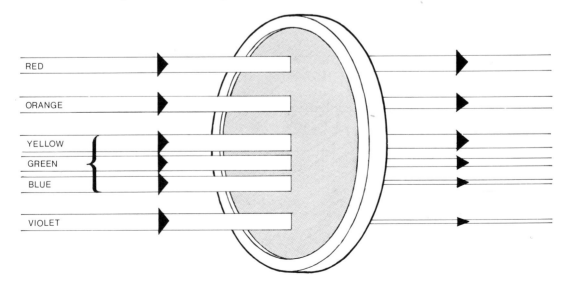

RED

ORANGE

YELLOW

GREEN

BLUE

VIOLET

same filter. Under different conditions you may have a factor that is anything from about 1.5 to more than 4 for the same filter. Even in daylight a yellow filter may have a factor of 1½ in very dull weather but of 2 to 4 when the sky is very blue.

Controlling exposure with filters

Whatever the conditions, any coloured filter absorbs some light and lowers the overall intensity of the light reaching the film. It can therefore be used to control exposure, and, in the example we started with, a 4x filter would allow you to shoot at $f2.8$ instead of $f5.6$. A filter factor of 4, however, generally means a deep orange or red filter. This cannot be used with colour film because it would affect the colour of the whole scene drastically. Even in monochrome it has a strong effect on tonal values. A blue sky becomes very dark; so do other blues, greens and mixtures containing these colours. Red, orange and yellow are reproduced much lighter. If your picture can stand such alterations in tonal values, you can shoot through a coloured filter to allow you to use either larger apertures or longer exposure times than would otherwise be possible.

Neutral density filters If you cannot accept such tonal changes or are shooting in colour, there is another way out. Filters are

The effect of using a red filter on red and green peppers in daylight, left, and tungsten lighting, right. The red pepper is on the left.

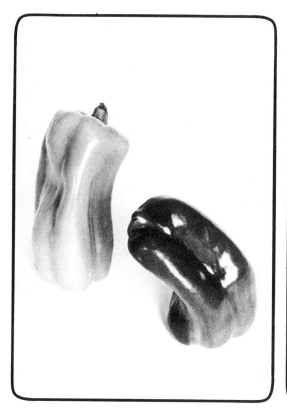
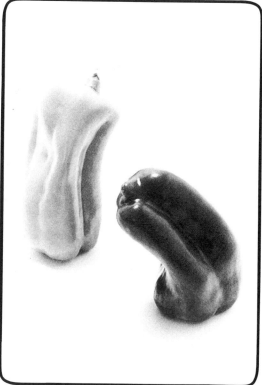

also produced with neutral density, ie with density but no colour. These are specifically designed for exposure control purposes and are available in various densities. You can use more than one, multiplying their factors, or you can use them in conjunction with coloured filters. A 2x orange filter plus a 2x neutral density (0.3 ND) would allow you to increase exposure by two stops, assuming that the orange filter lives up to its factor in the given conditions. The factor of the ND filter is accurate in any conditions because it absorbs light of all hues equally.

Testing filters You can check filter factors with reasonable accuracy by measuring the light passing through them with a selenium meter, which has a colour sensitivity closely matching that of modern films. For complete accuracy, however, you need to make a series of test exposures with and without the filter in various light conditions.

Graduated and other filters One specialised type of filter would appear to meet the requirement of changing the tone of the sky without affecting the landscape area, and therefore allowing unchanged exposures. This is the graduated filter, with colour shading off to clear glass. The general idea is that with the coloured part towards the top of the lens, the sky area is filtered and the landscape is not. This is not strictly true, of course. Every image point on the film receives light from the whole area of the lens, but as the filter is slightly forward of the lens, the coloured part has a greater influence on the upper half of the picture than the bottom, particularly at small apertures. Nevertheless, it still does absorb some light from the whole area, and thus it has a filter factor greater than 1.

Bracketing exposures. When exposure cannot be determined with confidence, make one shot as the meter indicates and then give other exposures on either side of the 'correct' level at one-stop intervals for black and white and half-stop intervals for colour.

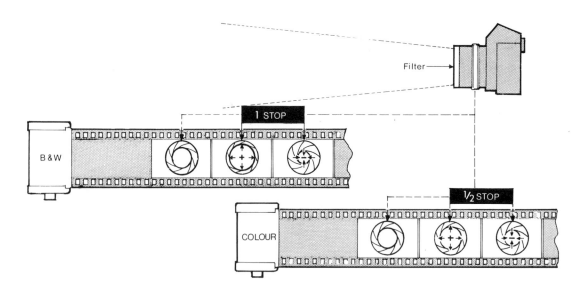

What that factor is depends again on your requirements. With a yellow graduated filter for monochrome work, you darken the sky area but only slightly affect the landscape area if you make little or no exposure adjustment. This may, of course, darken the sky too much for your taste, in which case you should apply a filter factor of 1.5 to 2.

With the oddly coloured types designed for colour film, the effect varies widely with the exposure. With minimum exposure adjustment the sky tone may turn out as a deep chocolate brown, or perhaps a much lighter tone if you apply a filter factor.

It is best to find by experiment the level of exposure that provides the most satisfactory result. TTL meters, especially the spot-reading or centre weighted type, are not sufficiently reliable.

Polarising screens

Much the same considerations apply to polarising screens. These absorb linearly-polarised light when oriented in a particular direction.

Light reflected from polished non-metallic surfaces is partially polarised. Skylight is also partly polarised, and can be darkened by a polarising screen. To the eye the result may be excessively blue but it is less so to the film, which is rather over-sensitive to blue. Thus a polarising screen can absorb some of the blue light and darken the sky while having little or no effect on the tones or colours in the rest of the picture.

All polarising screens have some density and therefore have an exposure factor, usually around 3.5 to 4. A polarising screen

The area of the sky in which light may be polarised is in a band at 90° from a line between viewing position and the sun. Thus, when the sun is high (A), the band is generally low on the horizon. As the sun sinks, so the band rises in the sky (B).
Light normally radiates in all directions from the line of travel. When it strikes a polarising surface, reflected light tends to be plane polarised. A polarising screen suitably oriented can cut out such reflections (C). Not all random light can get through the screen (D), so every polarising screen has a filter factor.

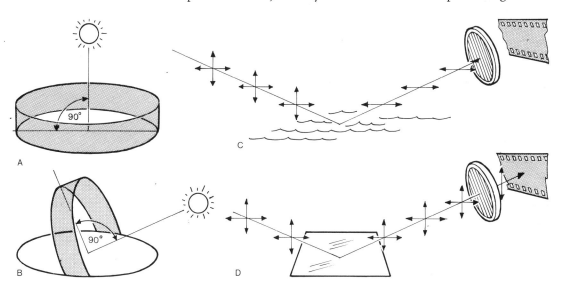

can also be used to allow shooting at larger apertures – even when there is little polarised light about. Like a ND filter it has density but no colour.

Filters and meter readings

Filter factors are applied to the exposure indicated by a separate exposure meter or by the camera meter before the filter is placed on the lens. A TTL meter reading through the filter gives a reasonable indication of correct exposure in most cases but it can lead you astray when you use deeply-coloured filters. This is because most TTL meters have a colour sensitivity that does not match that of the film exactly. Both CdS and silicon meters are more sensitive to red than the average film. This over-sensitivity can be corrected to some extent by filtering the light reaching the meter cell – hence the term 'silicon blue' – but it is seldom fully corrected, probably for reasons of overall sensitivity. A reading through a deep orange or red filter is therefore likely to be over-optimistic, leading to slight underexposure and possibly producing a negative that is difficult to print with the required sparkle.

It is thus advisable, at least with the deeper colours, to make your meter reading without the filter and then to apply the filter

factor as given by the manufacturer or as determined by your own experiments.

If you use such filters with an automatic-exposure camera, switch to manual control or use the backlight or exposure compensation switch as appropriate to give the extra exposure above the filter factor. If the camera is totally automatic with TTL metering but with no form of exposure compensation, you have to adjust the film speed setting. If the meter reads the factor as 2x but it is marked 4x, set the film speed one marked setting lower, ie if the quoted film speed is 125 ASA, set the film speed dial to 64 ASA. You have then calibrated the meter to give one stop more exposure than the film requires in normal circumstances.

Finer control can be exercised if necessary because the film speed scale usually has dots between the marked settings representing $^1/_3$ stop increments in exposure.

For automatic-exposure cameras that do not read through the lens, you can divide the film speed setting by the filter factor. With a 4x factor and a 400 ASA film, for example, set the film speed to 100 ASA. The meter is then informed that it is dealing with a 100 ASA film and gives 4 times the exposure normally appropriate to a 400 ASA film.

Exposure latitude with filters

Exposure is more critical when you use filters, and the latitude even of monochrome films is considerably reduced. The fact that you are using a filter generally implies that there is a lack of tone differentiation or contrast in the subject. No matter how you expose, certain tones are so alike that you cannot separate them adequately. Filtering can alter one of them so effectively that printing is easy. But if you attach the filter and then get the exposure wrong, you could nullify the effect of the filter or overemphasize its effect on the darkened tone.

Overexposure tends to weaken the effect of a filter, whereas underexposure emphasizes it. However, underexposure can also lead to lack of detail in the darkened tone and an overall lack of contrast. Unless you are absolutely sure of the effects your filters have, there is a good case for bracketing exposures whenever you use a filter. Two extra exposures at one stop over and one stop under your calculated exposure should be adequate for monochrome work. In colour, filters are rarely strongly coloured and bracketing at half-stop intervals is more appropriate.

Overleaf
A perfect example of choosing the tone to suit the interpretation plus heavy printing up at the printing stage.

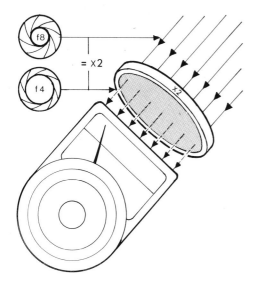

Deeply-coloured filters can mislead an exposure meter. You can check this by taking readings through them and without them and comparing readings with the quoted exposure factor.

Filters and reciprocity failure

There is one special kind of filter that deals with a special kind of problem with colour film, namely the failure of the reciprocity law, which states, in effect, that a given amount of light has the same effect on the film whether it be made up of a short exposure at a large aperture, or a long exposure at a small aperture. In other words, 1/30 second at $f1.4$ has the same effect as 4 seconds at $f16$. The reciprocity law does tend to fail with exposures longer than one or two seconds or shorter than about 1/1000 second.

The problem is greater with colour film because it has three separate emulsions. If the law does fail, it will fail to a different extent for each emulsion. The result is a shift in colour rendering because the relative amounts of red, green and blue that make up the various colours are distorted. The remedy is to increase exposure to compensate for the underexposure that the failure brings about and to add a special filter to correct the colour distortion.

Unfortunately, you do not get that kind of information in the little leaflet packed with the film. You need to obtain it from the film manufacturer, if you know where to contact him. Even then, you cannot get the required filters from the average photographic supplier. It is best, therefore, to avoid excessively long exposures with colour film where colour rendering is important. Do not close down the aperture simply for the sake of sharper results or greater depth of field than you really need, unless the exposure can be kept to no longer than one second.

Colour photography at night or in dimly-lit interiors may well call for long exposures but some colour distortion may

then be acceptable. We do not see colours clearly in dim light and we are generally prepared to accept that the camera is similarly handicapped. We are also well acquainted with the fact that few lights are white under such conditions, and can happily accept the effect of coloured lights on familiar objects.

High-speed reciprocity failure is rare with modern films, and for our purpose can be discounted. It may have some effect when using automatically controlled flash (see p 119).

Dealing with UV radiation

Finally, we should perhaps mention the one filter that has a factor of unity, and therefore no effect on exposure: the UV filter. Strictly, we should really call this a UV-absorbing filter, on the principle that we call all other filters by the name of the

UV filters are not designed to cope with heavy mist or fog. At best, they give a marginal increase in contrast that is generally achieved just as efficiently with increased development and/or a higher-contrast print material. The filtered shot is at the top.

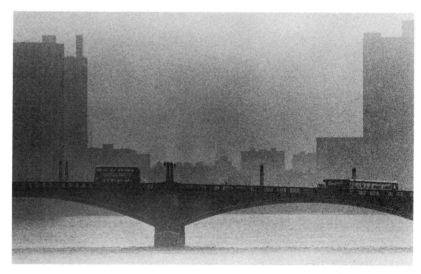

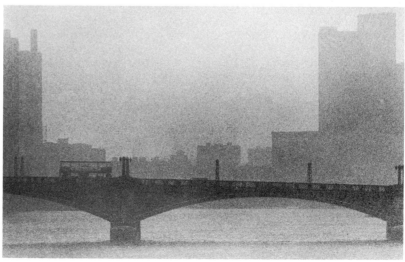

colour they transmit. The common UV filter is colourless and is designed to absorb the invisible UV radiation to which all films are sensitive. UV is very short wave radiation and is scattered by particles in the atmosphere to form an invisible detail-destroying haze in distant shots. Scattered UV radiation aggravates the effect of the visible haze caused by the scattering of blue light.

With monochrome film, both types of haze can be eliminated, if desired, by a pale yellow filter. With colour film, a very pale pink or salmon filter is equally effective. In practice, such filtering is often neither practicable nor desirable. We are quite accustomed to seeing a bluish haze in the distance and, unless we really need the detail, there is very little point in eliminating it.

In some circumstances, however, UV radiation is less scattered and reaches nearby objects in sufficient strength to put a blue cast over the whole picture, although we cannot see it in the subject. Then we need to do something about it, and the usual remedy is the colourless UV filter. It can improve the quality of pictures near large areas of water or at high altitudes, where there is less solid matter in the atmosphere and therefore less absorption of UV radiation.

There is no need for exposure adjustment because the UV content has a negligible effect on overall illumination and does not materially affect meter readings. Some slight adjustment may be necessary with straw or salmon coloured filters commonly sold as haze filters. These are, indeed, also efficient UV filters, as are yellow, orange or red filters and polarizing filters.

10 Flash, the Predictable Light Source

The one great advantage of flash as a light source is that its intensity and duration is predictable, resulting in the removal of at least one variable from the exposure problem.

Flash now almost invariably means electronic flash. The duration of the light emitted by most flash units is in the region of 1/1000 second. Few inter-lens shutters have speeds faster than 1/500 second, so the full duration of the flash is invariably used. With focal-plane shutters the flash must be fired when the blind is fully open, and this restricts exposure times to 1/60 second or longer. So when we use flash we use the whole output of the unit, and that output is measurable and consistent. Thus the only variable on the camera is the lens aperture. As with other forms of artificial light, however, there is also the variable of the distance of the light source from the subject, which affects its intensity at the subject plane.

The guide number of a flash unit is the product of flash distance and lens aperture at which correct exposure is obtained. As the flash distance increases, the lens aperture must be opened wider.

Exposure guide numbers

Both lamp distances and lens *f*-numbers work on a law of squares with respect to illumination. So, with a given flash unit used with a film of given speed, the amount of light reaching the film is the same when the product of distance and *f*-number are the same. In other words, exposure is the same with a lamp

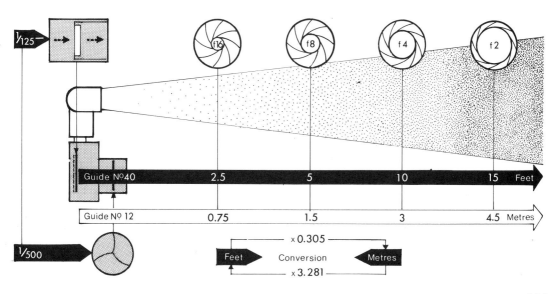

at 10ft and the lens at ƒ4 as when the lamp is at 5ft and the lens at ƒ8 – 10×4 and 5×8 both equal 40. The 'guide number' is 40, for measurements in feet. To convert a guide number expressed in feet to metres, simply multiply it by 0.3, the number of metres in a foot. To convert a guide number in metres to feet, multiply it by 3.3, the number of feet in a metre.

Remembering that we are working on a square law, if the same flash unit is used with a film twice as fast, the guide number will be 40 multiplied by the square root of 2, which is near enough 1.4, giving 1.4×40 = 56. For a film four times as fast multiply by the square root of 4, ie 2. If the numbers are not so convenient, say ASA 125 and 200, multiply by the square root of 200/125, which is 1.26, giving 40×1.26 or approximately 50. However, most flashguns have built-in calculator discs which avoid the tedium of all this mental arithmetic.

There are now on the market many kinds of auto-exposure flash unit; but some of these are limited in their application, and a knowledge of the basic principles is essential if exposure is to be correct.

Flashmeters Flash exposure meters are also available, and the best of them are very easy to use and completely reliable. They

Typical auto flash unit: 1, Battery compartment. 2, Mains connector. 3, Cable connector. 4, Tilting head. 5, Angle calculator. 6, Exposure calculator. 7, On-off switch. 8, Signal light. 9, Mounting lock. 10, Flash tube. 11, Lens. 12, Sensor. 13, Aperture selector. 14, Hot-shoe contacts.

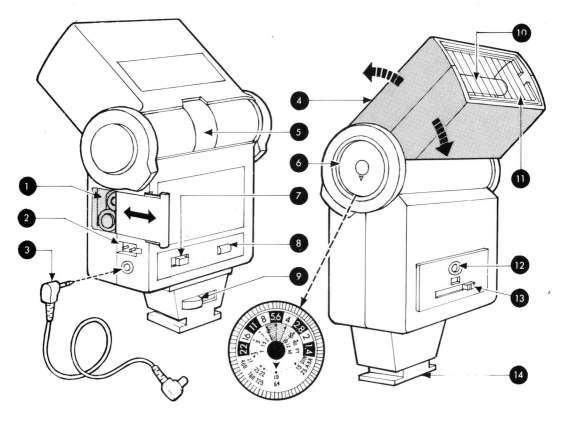

tend to be expensive – but so do some ordinary exposure meters. The cheaper, lesser known models tend to be erratic in use, one in particular giving a higher reading the stronger the ambient light. A good flashmeter is an invaluable aid but if you do not have the opportunity to test before buying, stick to the well-known names, even if you have to pay rather more.

Factors affecting the guide number

The predictability of flash can be overstated. As soon as you start to use it as a serious light source, you run into difficulties. To use flash seriously, you have to position it away from the camera, or restrict the one on the camera to a fill-in light with another unit or head as the modelling or 'key' light. Under these circumstances the focused distance is irrelevant; it is the distance of the flash from the subject that is important.

Flash units give a harsh light compared with skylight or large floods. To soften the effect you can use diffusers or reflectors. If you do, you need to know their effect on the subject illumination. In many circumstances you make use of reflectors whether you intend to or not. The flash bounces off walls and ceilings, to add to the direct light from the lamp itself. The makers' guide number allows for a relatively high level of such reflected light. It assumes the flash is used in a medium-sized room with reasonably light-coloured walls and ceilings. In large rooms or halls, or in any room with predominantly dark tones, the guide number is therefore optimistic. Outdoors, where there are no reflecting surfaces of significance, it may be wildly so.

Finally, the guide number refers to frontal lighting, where few shadows are cast on the subject and what shaded areas there are are of little importance. Move the flash 30° off the lens axis and strong shadows are introduced – shadows that you may not be prepared to accept without at least some detail or tone. The guide number could then be half a stop or more too high for your purposes.

Unless you can afford a reliable exposure meter, the problem begins to look much more complicated than the guide number system would lead you to believe. It is not quite as bad as that.

If you require nothing more than casual snapshots indoors, you can use a single unit on the camera, firing directly at the subject or, better, aimed at the ceiling to provide 'bounced' illumination. In the first case, the direct use of the guide number will give reasonable results. In the second an estimate of the average distance from flash to subject via the ceiling (when

divided into the guide number) provides an aperture setting that should give success.

We are more concerned, however, with the problems that arise when using flash in studio fashion, ie instead of tungsten floods and spots.

Using more than one flash

A popular method for colour work is to use a single flash fired into a large white umbrella which throws a uniform flood of light back on to the subject. It works very well, and exposure is simply a matter of applying the guide number allocated to the 'brolly-flash' combination or conducting tests to determine such a guide number. Monochrome work generally needs rather more modelling than such methods can provide and may be carried out with two, three or more flash units firing simultaneously.

There are two methods of synchronising more than one flash unit with the shutter operation. One uses a separate cable to each flash connected to the shutter contacts via a multi-socket. Because of the clumsiness and danger of multiple trailing leads, this is not a method to be recommended with amateur equipment. Furthermore, except with true studio equipment designed for multiple-head operation from a large power unit, the electrical connections tend to be unreliable and can be harmful to the shutter contacts.

A more reliable method is to attach photocell slave units to each of the flash units, which then need not be directly connected to the camera. The method has many advantages, because it allows you to use any combination of units from

More than one flash unit can be fired simultaneously by connecting them all to the camera shutter contacts via a multi-socket. That generally means lengths of trailing cable and possible damage to the contacts. Slave units can be used instead. They are light-actuated switches. When the unit connected to the camera fires, any other unit within range and connected to a slave is fired simultaneously.

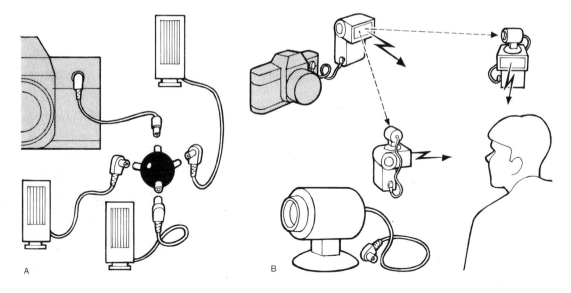

A

B

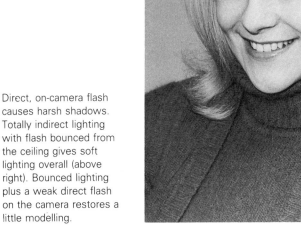

Direct, on-camera flash causes harsh shadows. Totally indirect lighting with flash bounced from the ceiling gives soft lighting overall (above right). Bounced lighting plus a weak direct flash on the camera restores a little modelling.

various manufacturers and of varying powers, provided they have a cable to plug into the slave unit. Modern slave units are extremely sensitive and can work with quite weak triggering lights. In the average room it is quite possible to put the least powerful unit on the camera for fill-in light and to trigger more powerful units placed behind the camera.

Exposure for this kind of multiple flash work is not nearly as complicated as it might seem. A possible set-up is a lamp at 30–45° off-axis as the keylight, another of lower power or greater distance more or less on axis as fill-in light and perhaps another on the background or as a back light. The back or background light has no effect on exposure. It is lighting parts the main illumination does not reach. But how much should you add to the guide number of the main light for the effect of the frontal fill-in light? If the lamps are correctly arranged, with the intensity on the subject much greater from the key light than from the fill-in light, you ignore its effect. Exposure should be correct if you use just the guide number for the key light, giving perhaps half a stop more to allow for the fact that it is off axis, depending on the strength of your fill-in light.

There can be occasions, usually in colour, when you use rather strong fill-in light, almost to the extent of cross-lighting. This time it does indeed affect overall exposure because it is really a secondary key light. This may seem to raise a serious exposure problem because it would take some rather complicated mathematics to work out the result of combining two different guide numbers of lamps used at different distances. But the margin for error is obviously small. You cannot be doubling the illumination on the subject, so your exposure adjustment is within a one-stop range. Lighting of this nature calls for an exposure based on the guide number for the key light less, perhaps, half a stop for the secondary key light.

The need for experiment

Flash work of this kind is always a matter of experience or test exposures. Now that rollfilm and 35mm are universally used in amateur photography, test exposures usually take the form of bracketed exposures while actually shooting. In our case, very little bracketing is required. One exposure based on the key light guide number and two more at half stop and one stop less should cover you adequately and give you useful information for future similar set-ups. Tests and experiments are necessary in flash work because so much depends not only on the intensity of the light but also on its nature. The size of the tube and the reflector, the distance the unit is used at, the nature and

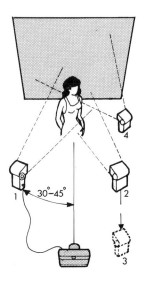

In a multiple-flash set-up, the key light (1) is generally within a 30–45° angle from the lens axis to provide modelling. The fill light (2,3) can be at a similar angle, often preferred for colour, or closer to the lens axis. Its power can be varied by diffusion, inbuilt switching or increased distance. The background light should normally be positioned to avoid overspill on to the subject.

tone of nearby reflective surfaces and so on, all play their part.

Wherever possible, standardise your lighting set-up or at least work around a standardised practice, so that you can get to know the effect of the individual lights. Occasionally modified processing is also called for. With some lamps, particularly the larger types, flash lighting tends to be rather flat: An extra 30% on the developing time may help.

Exposure is always a matter of compromise, and flash exposure is no exception. You need experience with your own units to teach you the compromise that provides the type of result you want. If you do a great deal of flash work, you need ancillary equipment to provide spot and flood effects, and guide numbers then become a hit-and-miss arrangement. They form a useful base for experiment, but that is all.

A flashmeter is essential for serious work, just as the oridinary exposure meter is with continuous light sources. You can work without a meter if you keep to a few well-tried lighting set-ups, but a meter is still helpful in the assessment of the effect of small adjustments in lamp position. A meter helps you to control contrast by balancing the lights. It also avoids the necessity for complicated calculations when you use reflected flash illumination.

Close-up with flash
Flash is useful illumination for close-range work, if only because the light sources are so much more easily handled and they do not get hot. Tiny flash units are available that are particularly suited to close range work, where the power of normal-size electronic flash units is often too great. It is not difficult to fabricate an attachment to place one such unit on each side of the lens or the camera body, connected individually to a multi-socket or with a slave unit on one.

Even the tiniest of these units may be too powerful for the job. One unit with a guide number as low as 35 (feet) for an ASA 100 (ISO 100/21°) film requires you to stop down beyond $f22$ for reproduction at one-third life size, assuming that the flash is on the camera body. If you cannot do so, you will need to use a slower film, or to diffuse the light source.

You have to allow for the extra extension as described in Chapter 7, but when you have two sources illuminating the subject from the front, you have to make further calculations. The two units should have identical outputs, of course, and that means units of the same manufacture and model. This does not guarantee exactly the same output from each but it is as near as you can reasonably get.

The theoretical effect of two light sources at the same distance and near the lens axis is that subject illumination is doubled. So you multiply the guide number by the square root of two, or 1.4. A guide number of 30 for one unit becomes 42 for two. In practice, it is likely to be rather less, because at close range the ratio of reflected light from walls, ceilings, etc., to direct light from the flash is likely to be much lower. The effect could be similar to working in a large hall or out of doors and could demand upwards of a stop extra exposure. You can restore the balance and obtain more uniform lighting by placing reflective surfaces around your subject. Bounced light is often a better proposition in such cases.

As with other flash work, the guide number only gives a starting point for working out the effect of your own set-up. Test exposures are more or less obligatory.

The nature of the subject

You do not generally need to take account of the nature of the subject when using flash. Guide numbers and flash meter readings are akin to incident-light readings, or to reflected-light readings from a grey card. They are not influenced by the subject and should give adequate exposure whatever its nature. That is assuming, however, that your subject is frontally lit, as in copying. This is by no means always the case. Textural shots at close range are by no means uncommon and demand strong side lighting with little or no frontal fill-in. Exposure in such circumstances needs some care.

The prime consideration is the effect you want. Oblique flash throws heavy shadows. Are they to be totally empty or do you need some detail? The effect of 45° lighting could be to

In bright sunlight, with a shutter speed of 1/60 sec (obligatory for flash on some cameras) you have to use a very small lens aperture, but you can still have problems with flash fill-in. Even a low power unit might have an effective guide number for fill-in purposes of 140 or so, which means it would have to be used at least 9ft away at f 16.

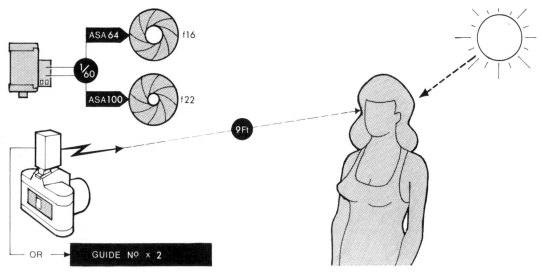

118

A suitable subject for auto-flash exposure. With non-auto units, it is difficult to restrict the light intensity at such close range. The auto unit restricts its duration.

demand up to one stop extra exposure for fully detailed shadows – but that could burn out the highlights. The effect of 'skim' lighting at almost 90° could be to demand two stops or more extra exposure, again with the sacrifice of extreme highlights.

The decision you have to make is how much detail you need in the shadows and whether it is best handled by a weak fill-in because you want to retain detail in the highlights, or by extra exposure because the highlights are small and effectively rendered by empty white. In the former case, you can probably expose in accordance with the flash guide number and add fill-in lighting by reflector or heavily-diffused flash at about one-sixth to one-tenth the power of the main unit. In the latter case, halving the guide number is likely to lead to satisfactory results.

High-speed reciprocity failure
We mentioned the reciprocity law earlier (p 108). It can be important in close-range flash work because most medium-to-small flash units are available in automatic-exposure versions. As the exposure adjustment is made by controlling the duration of the flash, exposures can become very short, sometimes less than 1/10,000 second. Intense light for a very short period is

not necessarily equal in exposure terms to less intense light for a longer period. As already explained, it can lead to underexposure and incorrect colour.

The correct remedy is to increase exposure and add a filter for the colour fault – if you can obtain the necessary information. It may be advisable to avoid using the automatic facility for close-range colour work if you run into this problem. Try it. You may find that your particular unit works satisfactorily with your type of subject and film. In monochrome you might find a way out by setting your lens fractionally wider open than the recommended auto setting on the unit.

Flash outdoors at night makes a nonsense of guide numbers (and auto flash units). There are no reflecting surfaces to add to the direct light. Up to two stops extra exposure might be necessary.

Fill-in flash

At one time, a popular use for flash was as a fill-in light used in strong sunlight. The heavy shadows cast by direct daylight can be lightened by a small flash unit on the camera. The practice has become rather less common with the increasing use of focal plane shutters, most of which cannot synchronise with flash at any exposure time shorter than 1/125 second. With any general-purpose film in bright sunlight such a setting necessitates a very small aperture – and it is the existing light on which the exposure has to be based.

The effect of a straight meter reading at sunset is a virtual silhouette of foreground detail. Heavy overexposure of the sun has led to irradiation into the image of one figure.

Fill-in flash in daylight should not be evident. When it is overdone, the background is severely underexposed and the backlighting contradicts the full light on the face.

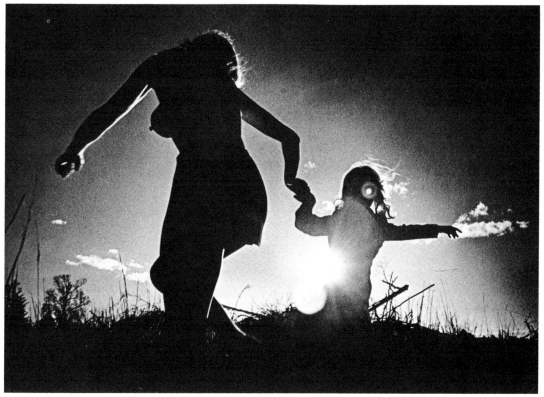

With an ASA 64 (ISO 64/19°) film, you could just about manage 1/60 second at $f16$. With an ISO 100/21° film and lens stopping down to $f22$, you are similarly just able to cope. The idea is to add fill-in flash at about one-quarter the intensity of a full exposure. To obtain this you double the flash guide number. With even a small unit this can give a revised guide number of 140 or more with ASA 100 (ISO 100/21°) film. At $f16$, you would have to place the flash at least 9ft from the subject. With the flash on the camera, your shooting distance is then governed by the required flash distance or by your ability to diffuse the flash to the required intensity. You can separate the flash from the camera by using an extension lead, but are then faced with finding somewhere to put it or someone to hold it. However you do it, it calls for careful calculation and considerable preparation.

Using auto-exposure models
There are two ways out. You can buy the least powerful flash you can find and use it for this particular application or you can make use of the automatic-exposure facility. In theory the auto-exposure facility should work perfectly because it should add the ambient and the flash illumination to give correct exposure. In practice, it may not and, in any case, you probably want a little less than perfect exposure in this case. Moreover, you may not have the required aperture setting on the unit for use with a focal plane shutter.

You may find, however, that your auto-exposure unit responds to juggling for fill-in purposes. You generally want it to give less light than for a full exposure. You cannot alter the lens aperture, so you have to alter the auto-setting. If you can set it so that the aperture required on the lens is one or two stops lower than it actually is, you may get the correct effect. It is worth trying. You may, for example, have to set $f16$ on the lens. If your auto flashgun can be set to work at $f11$ or $f8$ for that film speed, the flash exposure should be cut to one-half or one-quarter the normal output for the camera setting. How much you really need to cut it depends on how your particular unit works and how much fill-in light you need; you should aim for the least possible. Obvious back-lighting accompanied by fully luminous shadows on the front of the subject looks unrealistic. The shadows should generally show only sufficient detail to determine the main features. If you want more than that, you should not have backlighting.

11 Shooting in Low Light

Modern films and lenses have almost put flash and other artificial light aids to photography out of business – or is that wishful thinking? Once we start boosting the natural light to take a photograph, we are creating something artificial. With the lost reality, we are also in danger of losing atmosphere, impact and interest.

Theatre, night-club, discothèque, even some everyday interiors, have characteristic lighting that creates a mood. In the past, books such as this often explained how existing lighting could be augmented by hidden floods or spots to provide enough light by which to take a photograph. Such methods were not really necessary even then. Now, with ASA 400 (ISO 400/27°) films available in colour as well as monochrome, with the possibility of uprating in reserve and with the advent of silverless image films, the proverbial black cat in a coal cellar becomes almost photogenic.

Add lenses with maximum apertures greater than $f2$, and flash begins to look dated. Certainly it is widely over-used. It has its place in simple cameras and in many specialized fields; but in much general photography, it is a mood-destroying escape from a few readily-soluble problems.

The problems of low light
Certainly low light levels do create exposure problems. Night scenes and interiors rarely have the same distribution of tones as the average daylight shot. They are often much more contrasty. You rarely encounter a dimly-lit subject that does not have almost impenetrable shadows coupled with comparatively brilliant highlights. Almost any interior in daylight has windows that you would prefer not to render as blank white and deeply shaded parts farthest away from the window. With dark furnishings, the contrast is severe. Stage shows may spotlight an individual and throw the rest of the cast into comparative gloom. In a musical performance, instruments or costumes may produce brilliant reflections.

Apart from contrast, there is the relatively long exposure time that may be necessary if you need considerable depth of field. This raises the problems of movement and of reciprocity

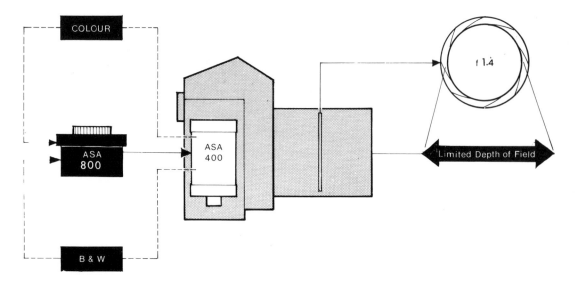

law failure. Yet how often in such circumstances are you looking for pin-sharp detail in movement or 'correct' colour – whatever that may be – in low light? Even the contrast problem is not as bad as it may seem because it is the faster films that handle contrasty situations best.

Your own problem

The real problem in low light photography is a personal one. What kind of result are you trying to produce? No matter what you do, you cannot reproduce the scene as the eye sees it. You cannot even do that in broad daylight, though you can approach it closely. At low light levels, the film cannot alternately peer at light and shade and see colour and movement exactly as the eye does. In fact, the eye rarely sees what we imagine it does. It puts in its own information, in order to translate degraded colours, freeze movement, delineate features that are barely discernible, and so on.

You cannot reproduce photographically what the brain perceives, so you have to create an impression. Generally, you want a relatively truthful impression. Of course, you can go close, fire a flash at the exotic dancer and get a fully exposed picture of a figure in virtual isolation. But that would give nobody an impression of the scene as it actually appeared. A better impression might be created by a shot through smoke haze with a shoulder or head protruding into the picture area and the figure on the stage indicated rather than delineated.

You would not want to show a room interior with every corner, every fold in the curtains, every detail in the furniture and furnishings fully lit and pin sharp, unless it was to be an

Low-light subjects are well within the capability of modern equipment and materials. Fast films are available both in black-and-white and colour and they can be uprated if necessary. Lens apertures of around f 1.4 are available on many standard lenses.

Weak toplighting in a restaurant is not ideal for a portrait but the relatively low light level on the front of the figure is acceptable in the context. A full exposure is vital.

advertisement for, say, a firm of interior decorators. Such people would not want the room to appear natural, but would want every item in it to be seen with the utmost clarity. That is probably not your particular interest. So, as in most photography, you compromise. You trade one aspect against another to produce an image of the subject as you see it or as you want others to see it. Your exposure has to be assessed accordingly.

Facing the practical difficulties

Once you have decided how you want to present your low-light picture, you have to work out the exposure required in terms of shutter speed and aperture. Lacking experience in similar situations, you are lost without an exposure meter. Often, you are not much better off even with one, and still less so if it is only the TTL version in the camera.

Taking a straight reflected-light reading is useless in most cases. Few meters are sensitive enough to give any reading at all for a night scene with relatively few lamps around, and the TTL types that use a needle may present too dark an image for you to be able to see the needle even if it does move.

When the overall light level is too low to provide a reading, you have to find something in the picture area that does

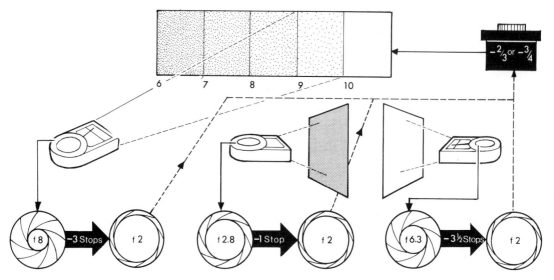

persuade the needle to move or the light to flash. It might be a flesh tone, a reflection on a wet surface, the pavement below a street lamp or even the lamp itself. You might have to introduce a suitable object into the scene purely for metering purposes. A white card (the reverse of a standard grey card) is useful or, failing that, a newspaper or handkerchief.

Make sure your reading is of the selected tone only, but take it into the lightest part of the picture area if necessary. This makes a separate meter virtually essential, except perhaps where you are photographing floodlit buildings on the opposite bank of a river. Then, a telephoto lens could give you a reasonable base reading on your TTL meter.

A reading from the brilliant highlights of a night shot gives an exposure to reproduce them as Tone 6. Add four stops to raise them to Tone 10 and reduce development to bring them back to Tone 9. Readings from grey or white cards (if practicable) can be similarly adjusted to give one stop more than the 'ideal' exposure.

Back to the zone system

Once you have your reading, you have a base to work from. You have first to decide how the tone you metered is to reproduce in your picture. Going back to the tone or zone methods, what depth of tone would you expect, for example, in a flesh tone in the prevailing light conditions? You would not expect it to reproduce as in daylight, as an average skin tone, maybe not even as a standard mid-tone. It would be more like a Tone 5 perhaps. You need to consider this carefully. If the subject is standing right in the lamplight, then you will want to be nearer the daylight rendering. Assuming, say, that you want Tone 5, you give one stop less exposure than the meter indicates, because the meter would aim to reproduce it as Tone 6.

If you had to put in an artificial white tone, decide how you would expect such a tone to reproduce in the position you read

it. You are not likely to expect brilliant white, unless again you were very close to a brightish light source. It would probably be nearer Tone 8. So your exposure would be two stops more than the meter indicates, because it aims to reproduce anything it reads as Tone 6.

If the only reading you can get is direct from a lamp or other light source, you go through the same procedure. If it is a street light, you probably expect it to reproduce as near empty white; a lightly curtained window perhaps Tone 9. So your exposure is three or four stops more than the meter indicates.

With a little ingenuity – and a lot of practice – you can get close to the exposure you want by such methods. You should always be able to get the tone you want in the area you meter but you cannot be sure how the other tones will come out. It is always wise, therefore, to bracket your exposures. Four extra exposures for colour at half stop intervals and two for monochrome at one stop intervals, should achieve the required result.

Aperture or shutter speed?

In low-light photography, it is advisable to control your exposure as far as possible by aperture rather than by shutter speed. Particularly in colour, reciprocity law failure is likely to be a real problem if your shutter speed exceeds two or three seconds, demanding that you bracket your exposures extensively.

Wide apertures are often possible in this type of photography. Your main subject is generally at a reasonable distance and, even at full aperture, depth of field increases significantly with increasing focused distance. Alternatively,

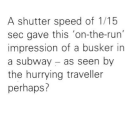

A shutter speed of 1/15 sec gave this 'on-the-run' impression of a busker in a subway – as seen by the hurrying traveller perhaps?

shaded foregrounds may suffer little from lack of sharpness, while somewhat out-of-focus backgrounds for relatively close subjects are frequently acceptable.

The effect of lens extension
Do not forget that low-light photography does not necessarily mean that the subject is dimly lit. It could mean that you have to put in a lot of lens extension for close-range work and have to stop down excessively for depth of field. The illumination at the film plane can then be very low indeed.

The problems are not so great, however, because the subject is reasonably-lit and you have no difficulty in taking a meter reading, unless you are confined to a stopped-down metering camera with a needle readout. Even then, you can take a reading at full aperture and convert it to the shooting aperture. With a hand-held meter, convert the reading as described in Chapter 7.

You still have the problem of reciprocity failure, however. It is more important in this type of work because you are not actually shooting in low light and colour distortion is unlikely to be acceptable. If you find that your exposures run into more than a second or two, you would be well advised to use flash as your light source.

Experience is the best teacher
There is no real substitute for experience in low-light photography. In normal lighting, casual use of an exposure meter will always get you some sort of result, and more often than not a satisfactory result. In low light, few meters work very well.

Jazz club. It would be possible to use flash or to lower the contrast with special treatment, but the bright reflections and dark shadows belong to the scene.

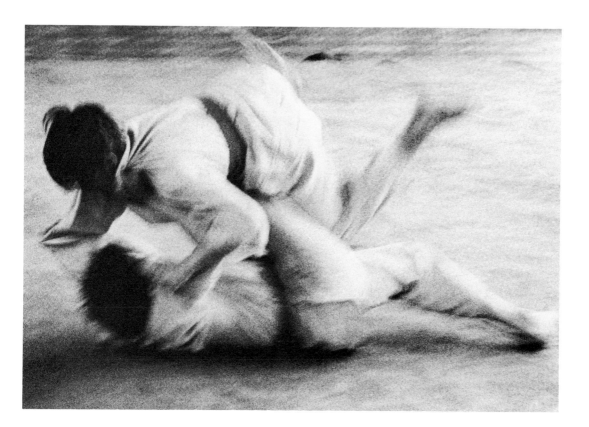

Low light and rapid action. Without flash, there is no way to 'freeze' the movement. A suitable subject for impressionistic treatment. Development could be prolonged to retain reasonable contrast.

Specifications of some modern meters may lead you to believe that they can read candlelight in a field. But it is a fact that the lower down the scale you go the less accurate the meter becomes. You have to use it with considerable ingenuity and read it with more than a little scepticism. With no previous experience, you must bracket widely. With experience, you can take fewer shots and have a reasonable chance of success.

Experience has to be acquired, and it does not take very long if you go about it sensibly. The first rule is to stick to one brand of film, processed always in the same manner. Many films can be uprated, and there is no reason why you should not do this if your first experiments show that you get satisfactory results. But once you have settled on a speed rating allied to a method of processing, stick to it. You will then soon learn how that film can be expected to behave in a variety of situations.

You cannot buy experience cheaply; you have to use a lot of film, so seek out your subjects at every opportunity. Don't wait for the masterpiece to turn up. Shoot anything and everything in low light – street lighting, floodlighting, moonlight and so on. Try the impossible, using a dozen different exposures on it. Keep records of your exposures and any other relevant detail, such as light sources just out of the frame, meter readings, etc.

12 The Unpredictability of Daylight

Daylight may be the most popular light for general photography but it is the light over which we have the least control. Dull winter light with a raincloud-filled sky is of little use to any photographer. Certainly you can still take photographs by it and sometimes you have to. If you are a wedding photographer and your client insists on the traditional group outside the church you have to make the most of it. If you are a press photographer assigned to a particular event on that type of day, you cannot offer to go back when the sun is shining. In those cases you take along your own sun in the form of a powerful flash unit.

Bad weather shooting

Dull days, rainy days and general bad-weather days are part of life, and there are pictures to be made out of all of them. Wet slate roofs under a grey sky with smoke pouring out of factory chimneys form an evocative scene that has been depicted many times, with varying degrees of success. How do you go about calculating the exposure for such a scene? You can take a straight average reading and get a more or less perfect exposure, but the picture will be a rather dull-looking record. You want it to look like a dull, depressing scene, but you still want some quality in the print.

The whole scene is likely to be of very low contrast, and very low contrast prints made up almost entirely of mid-tones rarely appeal. What do you do? Make it darker, or lighter, or increase contrast? All are possible. If you reduce your exposure by two stops, all the tones are pushed two steps down the scale. Weak shadows go black, the sky gets darker, the sense of gloom is greater, but, unless you have reasonably strong highlights on the wet roofs or pavements you still have a flat, lifeless print. You really need a slight break in the cloud cover to provide that little extra reflection. If you get this, then the darker treatment may work. If not, you can try increasing the contrast by extending development by 50% or so. Then you might add print manipulation, using a higher contrast paper and printing up to a darker tone in sky and shadow areas.

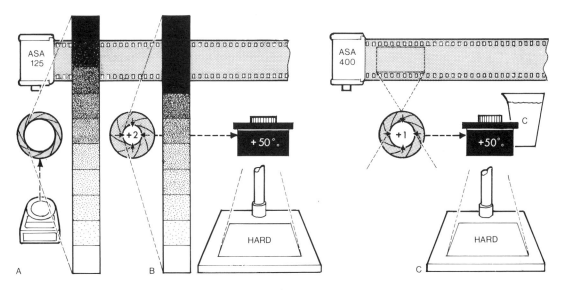

You can go further. You can use a fast film, underexpose it by a stop or so and 'push' the development in a vigorous developer – perhaps a print type. This will give you even more contrast and a prominent grain structure. It should add a brightness to highlights that would otherwise be too little emphasized and, by virtue of the underexposure, leave deep black areas, especially if you print on a contrasty paper.

The way you treat it depends upon the way you see it. Grainy, relatively high-contrast treatment is particularly suitable for many dull-weather scenes. A truthful rendering has scarcely any impact, so you have to exaggerate the effect.

Picking out the telling detail

You can often create more impact by concentrating the interest for this type of shot. A bedraggled figure under a streaming umbrella at a bus stop certainly gives an impression of bad weather; but a close-up of just part of the umbrella and a few running droplets over an unsmiling face is better still.

Let us consider this scene in terms of exposure. There are a black umbrella, water droplets and flesh tones. Which is the most important? In this case, not the flesh tones, so a straight reading is out. You want some detail in the umbrella fabric and, if possible, in the water droplets. If you aim at giving the umbrella a little extra exposure, you should be successful. It would normally be one of the darkest tones in the picture, about Tone 2. We do not want it in the middle tone area, so about Tone 3 would be right. This means one stop more than a normal exposure for the conditions, and pushes the flesh tone up the scale to be reproduced a little lighter than usual, but still

leaves detail in the water droplets. You should have a negative that prints well on normal paper, with the opportunity to move up a grade if necessary.

Making the most of foggy conditions

Of all bad weather conditions, perhaps fog is the most difficult to handle. A foggy scene can be pictorial, evocative, striking. It can also be dull and lifeless. The exposure level is often very important, despite the limited tonal range.

The advantage of fog is that it obscures detail. It reduces figures, buildings, etc. to mere outlines or eliminates them completely from the background, depending on their distance and the density of the fog. The disadvantage is that it flattens contrast almost to a monotone. You must have something to lighten the gloom in at least a small area of the picture.

London today is not as notorious for its fogs as in former times when busmen used to walk in front of their vehicles with flaming torches; but fogs do still occur, and London is still the city of big red double-decker buses. A typical London fog picture could show a bus looming up out of the gloom at a temporary bus-stop sign so frequently used in those conditions. The temporary stop is on a column embedded in a block of concrete, and the actual sign is at about head height. If you shoot from close to it in a fog, it will show up clearly with the bus only vaguely outlined as it approaches. The bus should have headlights on and possibly interior lights as well. There is an exposure problem which could be repeated in similar scenes in other cities.

In ordinary misty scenes, exposure is not too much of a problem, because the subject is generally very short-scaled. Most films have plenty of exposure latitude for such subjects. The difficulties arise chiefly with colour transparencies. The density of the mist or fog has a considerable influence but a straight reflected-light meter reading should not be too far from correct. If it errs at all, it will be on the side of underexposure. You could compare the reading with an incident light or grey card reading. It does not matter much about the direction of the light or where you point the meter, as the fog will be all around you. If the incident-light reading recommends less exposure than a reflected-light reading, take its advice.

In the case of our bus stop the problem is a little easier. We have the bus stop sign itself; it has a white tone that we can aim to reproduce as at least a moderate highlight – say about Tone 8 in our list. A close-up reading gives us an exposure that would reproduce as a mid-tone (Tone 6), so we need two stops

The sun struggling to get through adds a useful feature to a misty scene but it did mean that the sky area of the print needed heavy printing up to obtain the required result.

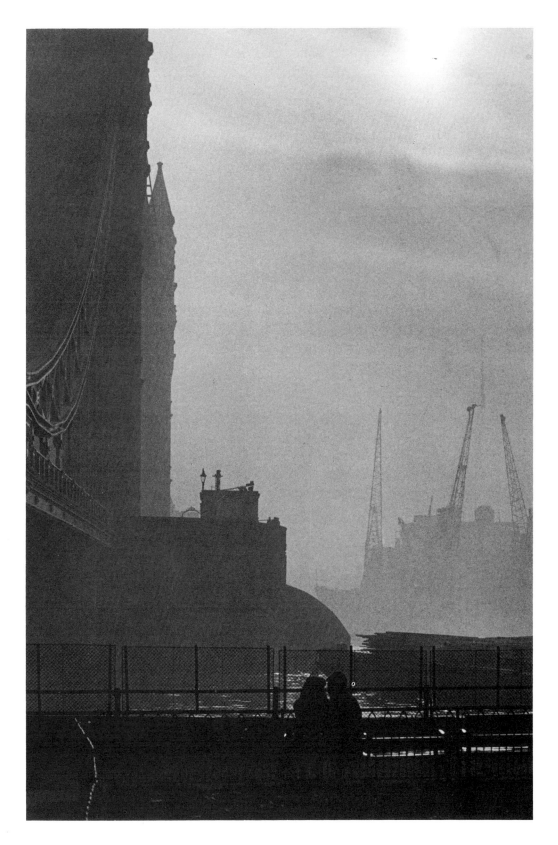

more exposure than this to give it its proper tonal value. That should leave ample scope for the shape of the bus to be outlined against the fog, but what will happen to the lights is anybody's guess, as they will be considerably diffused.

We should not aim at reproducing the white too light. It would not look right, and would raise the level of exposure so that the other tones – the red of the sign, the outline of the bus, and especially the lights – would also be raised significantly in tone and reduce what little contrast is present. The lights could spread excessively.

Snow and frost

Wintry days can also bring snow, ice and frost. These can be difficult to handle, as reflected-light meter readings are meaningless. A blanket of snow over the landscape raises the general light level considerably as it puts natural reflectors on almost everything. A reflected-light meter reading will indicate underexposure by up to two stops.

Photography in snow The nature of the lighting is important. When you photograph snow scenes, you are not so much concerned with the snow itself as with the shadows in it. It is the shadows that provide the texture. There are always shadows

Brilliant reflections from the snow make a close-up reading of the footprint necessary so that its tonal value can be assessed and placed as required.

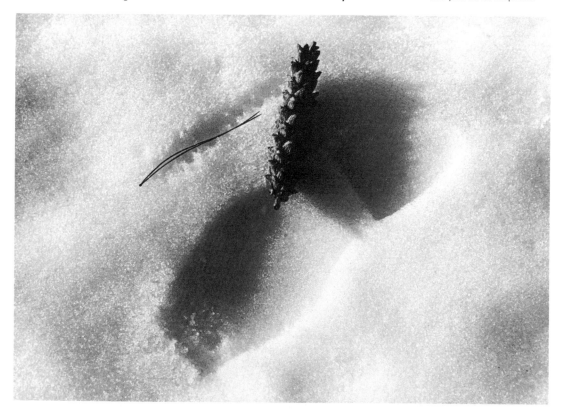

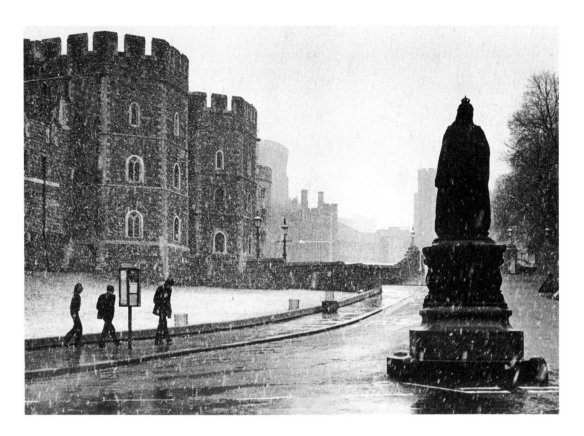

The contrast-flattening effect of falling snow calls for increased development time. A normal exposure meter reading is generally accurate enough but any adjustment made should be toward a shorter exposure.

in snow, even in the most diffuse light, because of its nature, but they are naturally more pronounced in sunlight and even more so with a low sun. You have to judge the density you expect in the shadows in the final result. In low sunlight it could be about that of the standard grey card, in more diffuse lighting one step lighter and in fully diffused lighting another step lighter.

If you can measure a fully-shaded area of snow, base your exposure on that. Give the indicated exposure when the sun is low and direct, one stop more for sun and cloud, two stops more for diffused sunlight. These are exposures for the snow only, of course, where the parts that are not snow-covered are relatively unimportant and you are not too concerned with retaining detail in them.

Frequently your pictures taken in snow conditions do not feature only the snow. Shots of winter sporting events are obvious examples. Then, ideally, you want detail in faces and figures as well as in the snow. That is not easy, especially with colour slides. Winter-sports shots generally show heavily suntanned sportsmen and women dressed in vivid colours. The sky is an unbelievable blue. In most cases, the effect is exaggerated by the nature of the light and the necessity, at all costs, to avoid overexposure. Snow reflects a considerable

amount of light and, if you are to retain any detail in it at all, exposures must be kept as brief as possible. Almost certainly they need to be kept shorter than a meter reading from a grey card or a flesh tone would indicate. This might well give a 'correct' rendering of face, clothing, etc., but the snow would become a uniform mass of white powder. On the other hand, you cannot shorten the exposure unduly or you will lose all detail in the principal subject.

Exposure in such conditions is about as tricky as it can be, especially for a colour slide. Sometimes, as when the sun is in front of the camera, the conditions are next to impossible. The film cannot handle the contrast, texture in the snow has to be sacrificed. You can underexpose the figure by a stop or so and get darker complexions and more saturated colour but you cannot picture the snow satisfactorily.

With the sun behind the camera, you have a better chance. You can meter the flesh tone or a grey card, or take an incident-light reading and adjust the indicated exposure according to the balance you are striving for. In monochrome you can probably underexpose by up to two stops, in colour up to one stop. You are then compromising at both ends, underexposing the figure and getting more saturated colour and slightly overexposing the snow, hoping to retain some detail. Naturally, your chances are better when clouds are present and the harshness of the light is tempered by cloud reflection or slight cloud cover. You can then follow the same course but have a much better chance of picturing the snow more satisfactorily.

For more leisurely subjects, such as general snowscapes, when you want some detail in the foliage, buildings, etc, you can pursue more orthodox zone methods. You can decide how much detail you want in the foliage, tree trunk, stonework, etc. and place that tone accordingly. You might meter a tree trunk, for example, and decide that it could be satisfactorily rendered as slightly darker than usual, say Tone 3 or 4. That would indicate two or three stops less than the meter recommends. If this agrees with a reading from fully shaded snow as already mentioned, you can go ahead. If not, you have to decide where to compromise, remembering that in monochrome moderate overexposure will not completely block up the highlights and you have the opportunity of printing up at a later stage. Underexposure is fatal, however. You cannot print detail that is not in the negative.

Photography in frost Frost is even more difficult. It generally provides a delicate tracery. Overexposure is fatal in this case. All the tiny shadows are lost and the frost looks like flour or

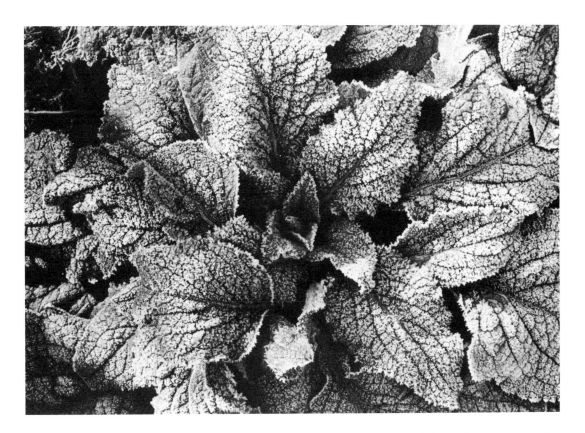

The frost is the most important part of the subject and your aim in metering must be to place that tone correctly.

baby powder. Depending on the nature of the subject, a straight reading is likely to recommend underexposure, which loses the contrast and the sparkling effect. As a general compromise, an incident-light reading is probably best; but it is better to search around for a more direct method.

Shots of subjects in frost generally have to be taken in sunlight. The aim is to make the picture almost entirely out of the reflections from the tiny crystals. The surface on which the frost lies may be vegetation, iron railings, wooden fencing or a variety of other bases, but you rarely want much detail in these. If, therefore, there is a sufficiently large, relatively frost-free area of the base, you can meter that and place it on the desired tone, perhaps Tone 2 or 3, ie three or four stops less exposure than the meter indicates. Alternatively, if there is a large area of solid frost you can meter, you could aim at placing it at about Tone 9, ie three stops more than the straight reading. As always, keep in mind the tone that you want to reproduce in the final result for the most important feature of the subject.

Atmospheric conditions

If you do all your shooting in your home country, you get used to the effect of daylight in general on your photographs. Many

people scorn the aid of exposure meters and claim to be able to get their exposure spot-on in any conditions.

Depending on your interpretation of 'spot-on', that is not so impossible a claim as it might seem. Long experience can lead to a familiarity that breeds confidence. After all, many photographers in years past used such methods quite satisfactorily. Admittedly, they worked in monochrome only and they developed their plates or films by inspection, so that they could control matters to some extent at the post-exposure stage. They tended also to deal with one exposure at a time and were usually expert printers.

Even today, however there are plenty of photographers who prefer to rely largely on their own experience, and come unstuck when they venture into foreign parts. The light in certain parts of the world has a strangely luminescent quality, as many a painter has remarked. There is an obvious difference between the light in a smoke-filled industrial valley and that on the surrounding mountain tops, but there is a more subtle difference in other areas – as on many Mediterranean shores. Sometimes it is due to the lighter colours generally favoured for the building materials or exterior decoration, sometimes to generally cleaner air. Whatever it is, the effect is often noticeable, but it does not fool an exposure meter used with care.

A straight reflected-light reading may in such conditions tend to recommend what turns out to be underexposure. Your colour slides may be that little bit oversaturated, with loss of detail in the shadows. Negatives are thin and may be difficult to print. Often a switch to incident-light readings is sufficient to put matters right; but this is not possible with TTL meters, for which you need a grey card reading.

If you carefully meter a principal tone, or another recognizable tone, and place it as required, you should overcome all problems. You could meter a flesh tone, for example, and place it on Tone 5, 6 or 7 as you wish. Or you might prefer an open shade area as your key measurement (Tone 5 or 6).

Remember always that placing the tone correctly means giving more or less exposure than the direct reading indicates, according to the number of steps the desired tone is away from Tone 6. If you want your flesh tone on Tone 5 (dark skin) you give one stop less exposure than the direct reading indicates.

13 Shooting on the Run

Many photographers may raise the quite legitimate objection to much of the material so far, that it assumes a leisurely approach to photography. It is true that the majority of photographers who concentrate on problems of exposure tend to produce static pictures such as landscapes, architecture, posed portraits and figure studies – the type of subject one can study at leisure and plan in detail. Conversely, those who appear to treat exposure in a more cavalier fashion are apt to be those who shoot a lot of pictures in a relatively short time, in varying light conditions.

The two types are not as far apart as may at first seem. The first relies on careful meter readings allied to his system of working. The second relies largely on experience allied to occasional use of a meter. But his experience is built on the results he achieves. He has learned how to deal with various lighting conditions to produce the type of result he wants. He may sometimes go wrong and when he does, his is often the sort of spectacular failure that his more leisured friend might never experience, but that is the nature of human fallibility.

The case for consistency
Nevertheless, calculated meter readings from specific areas, grey cards, zone systems and so on are not favoured by many photographers. The difference between the superb and the merely very good is perhaps not important to them. Nor is it practicable on many occasions to delve into a well-stocked gadget bag for incident-light attachments, grey cards, lists of zones, etc.

We have to differentiate between run-of-the-mill photography, including a great deal of snapshots not intended for posterity, and more serious attempts to produce something genuinely creative. In monochrome, purist opinions. notwithstanding, exposure latitude is wide and it is possible to produce identical prints of many subjects from negatives that have had up to two stops difference in exposure. Even in colour, there is sufficient latitude to allow a certain casualness of approach to the average subject.

Colour slides Colour slide work is more critical but a stop

either side of the theoretically correct exposure does not ruin a picture that is well within the film's capability. In most cases, it simply leads to different levels of colour saturation, and that can be a matter of personal preference or even artistic licence.

There is an argument in favour of a consistent approach to exposure in colour slide work. If you approach the matter casually and are prepared to accept varying densities of image, you should not present slide shows. If you do, you should select your slides and arrange them with some care, because it is off-putting to see slides of similar subjects but of varying density and colour saturation succeeding one another on the screen.

A great deal of everyday photography consists of hurried shots of children, friends, eye-catching views, public events, interesting buildings, streets, etc, shot while on the move with family or acquaintances where the main aim is not pictorial. There just is not time to ponder the tonal value of this or that feature, to take careful readings and then calculate the exposure required for a particular effect – and, to be honest, a lot of people do not think the effort worthwhile in such cases.

Nevertheless, exposure is important. You cannot make gross errors without sacrificing something – generally definition owing to increased graininess in monochrome, together with loss of detail in shadows or highlights. In colour, the same defects occur in exagerated form together with loss or distortion of colour. So you need to adopt some method or system, however subconsciously, that protects you from such mishaps.

If a bright sky occupies more than about one quarter of the metered area, add one stop to the metered exposure. Greater areas may need up to two stops more exposure to provide foreground detail.

Subject failure

Most cameras in popular use have exposure meters, frequently the TTL type. These are, as we have already implied, almost perfectly suited to shooting on the run. Most of your pictures will integrate to grey, so you can happily follow the indications given by the winking lights, needle etc. The trick is to recognise the occasions when the mindless device misleads you, known as 'subject failure'. Provided you can do that, you can keep exposure calculations within bounds and concentrate on the more important task of actually getting the picture. After all, a poorly exposed shot that captures the decisive moment is preferable to a technically superb shot that misses it.

The most common, and most often quoted, reason for subject failure is the inclusion of a large, light-coloured sky area in the picture. In a view with a beautifully cloud-filled sky, the white clouds have a powerful effect on the meter: the ground area will inevitably be underexposed if you follow the meter reading. The level of underexposure can be as much as two

stops, giving you a cloud-filled sky with a very dark foreground. On a colour slide, your sky will look great, but the foreground is likely to look as if it was taken in the late evening.

Maybe you are quite happy with this – and it can sometimes be very effective. White clouds against a blue sky can look very dramatic in colour with a stop or so underexposure. Generally, however, a mainly white or grey sky influences your meter unduly and you should exclude most of it while taking your reading by pointing the meter slightly downwards. Then disregard the meter indication as you take your actual shot.

A deep blue sky has considerably less effect. It is not far removed from the average mid-tone and should not affect your meter reading unduly. In a colour slide, if you wish to preserve that deep blue, it is in any case better to err slightly on the side of underexposure.

As you shoot on the run, therefore, keep a watchful eye on the sky tone and the amount of it that is included in the viewfinder. If it is more than about one quarter of the picture area, add one stop to the indicated exposure. Greater areas can call for up to two stops extra exposure. In black and white, you can afford to err on the generous side. In colour, particularly with colour slide material, it would be better to take the time

An obvious subject failure. A straight meter reading inevitably leads to underexposure. In these circumstances, a grey-card reading or the equivalent is a reasonable compromise.

needed for a substitute reading, excluding most of the sky area.

The same type of problem arises with backgrounds. Indeed, the sky might well be the background for a portrait, architectural feature, inn signboard, etc. If you are out on a trip when such a shot is likely to occur – and that includes almost any walk around an unfamiliar area – a useful trick if you feel that you cannot spend too much time on the shot is to keep your camera set for a normal exposure in the prevailing conditions.

If a reading for a normal subject gives you 1/125 second at *f*8, the inn signboard against a bright sky is likely to need just that exposure, despite the meter reading of, possibly 1/125 second at *f*16. So, if you have just taken a shot of the general street scene or an average landscape, forget about the meter when you see the signboard and shoot with the same camera settings.

Average and non-average subjects

This is probably as good a place as any to point out that the 'average' and 'non-average' tags that crop up when we discuss exposure are largely a product of the exposure meter age. They are average or non-average only as far as the meter is concerned. If, for example, you pose a head-and-shoulders shot against a relatively large light-toned background or against the same sized dark-toned background, the exposure required is the same. If you worked solely by the little slip of paper supplied with the film, you would give the same exposure in each case and probably not even think about the background. If, however, you were a more sophisticated photographer with an exposure meter (TTL or otherwise) or with an automatic-

Meter readings of the same subject against different backgrounds can show marked differences. Adjusted (A, B) or substitute (C) readings should all lead to the same answer.

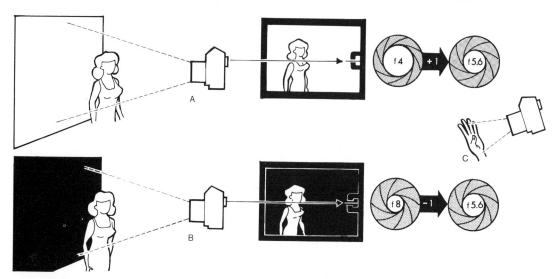

Such shots have to be grabbed. A camera set to a normal exposure for the conditions, or an autoexposure camera, would cope adequately with this shot and many like it.

exposure camera, it is likely that you would get a different meter reading for each shot. And if you were the unthinking type, you might use different exposures for each shot.

Background and foreground tone Excessively light backgrounds or foregrounds that are large in relation to the subject also product subject failure and cause the exposure meter to indicate underexposure. Whenever there are large areas of light-toned flowers, whitewashed wall, snow, sand, etc. in the picture area, add at least one stop to the indicated meter exposure. Preferably, in all such cases, take a substitute reading from a more balanced distribution of tones, from a grey card or from the back of your hand and use that exposure, rather than that indicated by a reading from the subject area.

Dark backgrounds and foregrounds lead your meter in the opposite direction. When the greater part of the picture is

143

composed of very dark tones, an exposure meter always indicates overexposure. It believes the scene integrates to grey, no matter what its actual tonal average may be. So watch out for dark foliage, fencing, walls, etc. If your subject is in light clothing in such surroundings, overexposure can cause serious loss of detail and, in colour, possibly even a total loss of colour in the clothing. In these circumstances, decrease the indicated exposure by at least one stop. If detail in the dark areas is not important, it is all well to err on the side of apparent underexposure in such cases.

Large areas of light or dark tone in the picture area are obvious causes of subject failure; most of us soon learn to recognise their effect. There are other, less obvious culprits. One stems from virtually the same conditions, but often overlooked because the offending areas are not included in the picture.

Hand-held meters commonly have a relatively wide angle of view, and frequently read areas that are not to be included in the picture. The supposed advantage of the TTL meter, that it reads only the tones actually appearing in the picture is not borne out in practice. Strong light from outside the picture area can affect the meter reading. However flare-free your lens may be, some of the light reaching its front surface (not all of which by any means is image-forming) does get through to the meter.

It is common practice nowadays to centre-weight TTL meters, giving them greater sensitivity in the centre of the picture area than at the edges.

In theory this is fine, but in practice it is not very effective, though it does have the advantage of reducing the tendency for light from outside the image area to affect the meter reading.

Readings from the whole screen area (A) can lead to significant underexposure if a large part of the image is light in tone. Carefully designed centre-weighted readings (B) can reduce the risk considerably but there are many occasions when readings from a substitute mid-tone or incident light readings are preferable.

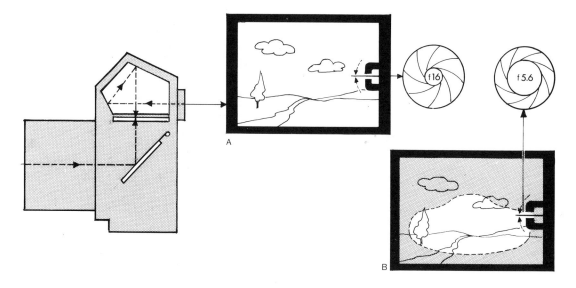

The danger still exists, however, and may help to explain some otherwise baffling errors in exposure.

Distance and atmosphere

Distance is another awkward factor. Distant scenes do not have large areas of shadow, except, perhaps, in the case of low sun on a mountain range. Such shadows as may be present are illuminated by diffused light due to the light-scattering effect of the intervening atmosphere. Consequently, most distant scenes integrate to a tone rather lighter than a mid-tone, the result being that an exposure meter tends to indicate underexposure. This effect, again, is particularly noticeable in colour slide work but is important even in monochrome.

When you take an ordinary scene, including near, middle and far distance, a reflected-light meter reading tends to give an adequate exposure that shows a natural recession of tones, darker in the foreground, lighter in the background as distance increases. The distant scene, regarded as a picture in itself, is in effect overexposed, and may show a certain loss of detail. In context, it looks perfectly natural, but if you try to enlarge up only the background detail, you tend to get a very unsatisfactory picture. You do not expect to see detail in the distance; but when the scene appears to have been shot from much closer the lack of detail is disturbing.

Enlarging up the distant part is more or less the same as taking a telephoto shot of that part of the scene only. If you give it a normal exposure, based on a hand-held meter reading of the general scene, you are liable to get the overexposed shot we have just described. The TTL meter working through a telephoto lens, however, excludes the darker foreground tones and includes only the lighter tones of the distant scene. The meter reading then tends if anything towards unexposure, and further reduces the contrast of a subject already lacking in that direction. Without the use of filters you cannot correct matters to make the distant scene look as if it were shot from close range, because you cannot overcome the effect of the intervening atmosphere. The remedy depends largely on the film material used. In monochrome you can underexpose as indicated and increase development by up to 50% to increase contrast. In colour it is preferable to increase exposure by up to one stop to avoid degraded colour and loss of detail.

Colour sensitivity of film and meter

A less obvious source of subject failure is the colour of the prevailing light. Generally speaking, exposure meters (except

selenium types) are excessively sensitive to red, while films are excessively sensitive to blue. This is a broad generalisation, and must not be taken too literally; but it can have a significant effect on your pictures. Flaming red sunsets, for example, are notoriously difficult subjects to expose satisfactorily, mainly because we would probably like to exaggerate them, and perhaps do exaggerate them in our mind's eye, but partly because of the high red content.

There can be no such thing as an average sunset, so it is difficult to talk of its tonal value. Does it integrate to a mid-tone? Quite often, it probably does, but the meter may still recommend underexposure because the relatively lower sensitivity of the film to red and yellow results in its receiving less exposure than the meter anticipates.

We are thinking largely of colour film here, of course, where moderate underexposure may not be too much of a bad thing. It intensifies the colour, reduces detail in the landscape, and concentrates interest in the sky. It is far preferable to overexposure, which puts unwanted detail into the foreground and desaturates the colour of the sky.

Thus, 'correct' exposure for sunset scenes is likely to be near that indicated by a direct meter reading of the subject area. This is obviously a case for bracketed exposure. There is no reliable way of predicting the effect to be obtained from any method of meter usage.

Artificial light and film speed Manufacturers of monochrome films at one time recommended lower film speed figures for exposure calculations under artificial light conditions. This was because of the film's markedly lower sensitivity to red, even compared with a selenium meter. Tungsten lighting of the domestic variety is, of course, considerably richer in red than daylight. Surprisingly, such recommendations are no longer made, despite the almost universal switchover to CdS, silicon and other highly red-sensitive meter elements.

Red sensitivity and meter errors There is a tendency in some forms of artificial lighting and with some meters for a normal reading to lead to underexposure, again possibly because the film is not as sensitive to the red content of the light as is the meter. We put this at no more than 'possibly' because these conditions generally arise at low light levels and, as already noted, few meters give reliable exposure indications at the lower end of the scale.

The opposite condition, the film's oversensitivity to blue, is rather less marked, but there is still a tendency for exposure meters to under-read the light level in bright blue sky

Sunsets are not average subjects, but a direct meter reading of the whole subject area generally provides a satisfactory sunset effect To record the sun's disc sharply, the exposure level must be low.

146

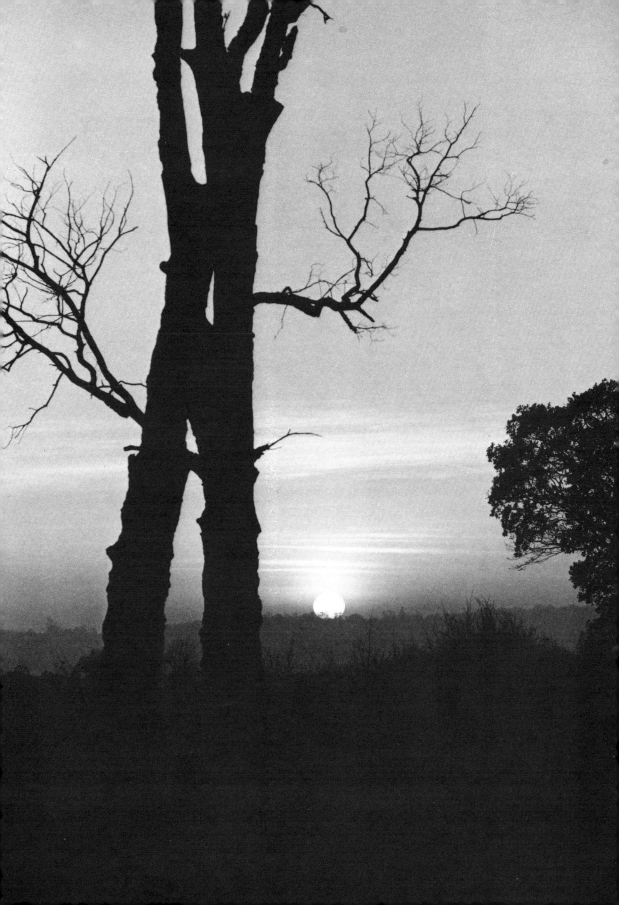

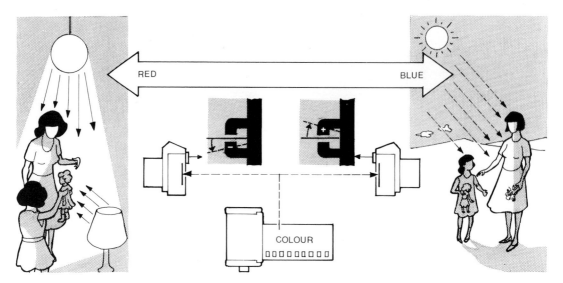

RED

BLUE

COLOUR

conditions, particularly in shaded areas where the direct effect of the sun is excluded. In colour, the result is not only a degree of overexposure but also a noticeably blue cast.

These fallibilities of the exposure meter must be borne in mind by all whose practice it is to rely heavily on the indication in their viewfinders to provide correctly exposed pictures. Those who make a real effort to calculate exposure to the nearest half stop for every shot are heavily outnumbered by those who either rely on experience, have an unshakeable faith in exposure meters, use a mixture of the two or shoot first and ask questions afterwards. It will always be so. Very few people are prepared to make hard work out of their hobby.

Nevertheless, a basic understanding of the ways in which exposure meter can be led astray is a necessity for any enthusiast who wants to be sure he will never have to say 'it didn't come out'.

Exposure meters do not have the same colour sensitivity as film. There is always a tendency for the meter to over read red and to under read blue, leading to a degree of underexposure in tungsten lighting and overexposure when most of the light comes from a cloudless blue sky.

14 Specifically Colour

The greater part of this book relates to monochrome work. This is inevitable because, despite the advances in user processing of colour materials, monochrome film still offers the greater opportunities in control of tonal values throughout the exposing, processing and printing stages. It deals only with tones, not hues, and there is no need to worry about the effect a particular variation of procedure may have on colour rendering. Additionally, a far greater proportion of colour film, particularly colour slide film, is commercially processed and depends on a standardized exposure method.

Nevertheless, or perhaps because of these limitations, colour film does have exposure problems that are specifically its own. All colour films have three light sensitive layers, so light has to pass through the top layer to reach the second and through two layers to reach the third. As the layers are differentially colour-sensitised but all are sensitive to blue, there has to be a filter layer too, and for technical reasons there are various others. Thus there is a delicate problem of balance, to ensure that each layer has the same effective speed. As almost every colour in nature is a mixture of at least two of those used by colour film, it is evident that over-or underexposure can affect the layers differentially and so distort colour as well as affecting the overall density.

Colour-slide films pose an even greater problem because they undergo two development processes. The first produces a normal monochrome silver negative image, and the second puts colour into the parts that were not originally exposed, thus forming a positive image on the film. Colour slides can handle a very wide range of tones because they are transilluminated for viewing; but they cannot maintain correct colour over the whole range.

Rules for exposure

The basic rules for exposing colour film are no different from those for monochrome. Effectively, your exposure must still be based on that required to render a mid-tone correctly. Exposure is based on tone, not colour. A subject can integrate to a mid-

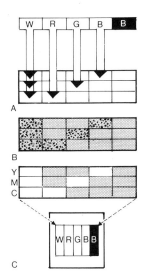

Reversal colour film. Light affects the three layers of emulsion selectively according to its colour (A), producing silver images in the three layers on first development (B). A fogging exposure or chemical then enables a colour developer to produce dye in the areas not previously affected by light. Bleaching out the silver image leaves only the dye images representing the original subject.

tone without integrating to grey. In such cases exposure indicated by a straight reflected-light reading is correct even though the subject may be predominantly of one hue.

The limitations on colour exposure are almost entirely due to the lack of processing and printing controls. We are talking here of the processes and materials within the reach and, probably, the inclination, of the average worker. You can control colour processes, particularly in colour printing, by means such as altering the developer formulation, development time or temperature, by shading, burning in or pre-flashing while printing, and other methods. But all these techniques are considerably more complicated than with monochrome. Moreover, colour film characteristics are constantly changing as manufacturers introduce different chemistry to increase sensitivity, improve definition and colour fidelity, and to speed up processing. Each change can have its effect on processing and thus on processing variations.

Most colour film users have to rely on the standard recommended process for their films, and have very little opportunity to vary exposures to handle contrast. Naturally, they can still use all the exposure variation techniques that do not call for adjustments in film developing or printing. But most of these 'variations' are, of course, not variations at all. They are simply translations of the recommendations made by rigidly-programmed exposure meters.

Most monochrome films now have so much exposure latitude that they can, perfectionism apart, afford to ignore the failings of exposure meters for the general run of subjects. Within two stops either side of 'correct' exposure, they may show more graininess, but they rarely show any loss in tonal range. Colour film is far less tolerant. Even a one-stop variation can have a significant effect on the rendering of some colours, particularly in a colour slide. Overexposure, in particular, can destroy some pale colours altogether. Underexposure can seriously distort darker colours. Where the subject has a long tonal range, therefore, even one stop departure from the ideal compromise can cause loss or distortion of colour.

Nevertheless, both variations can be used in a way that is peculiar to colour images. With the right type of subject (fairly low contrast) overexposure can turn reasonably light colours to pastel shades particularly appropriate to glamour photography, pictures of children and babies, lazy summer days and so on. Underexposure can add brilliance to colours and add contrast, or apparent contrast, to dull-weather shooting.

Both techniques have to be used with great care. The

Opposite, top
Even colour transparency film has relatively wide exposure latitude in low contrast situations. A straightforward reflected-light reading is generally adequate but a certain amount of overexposure can be tolerated if the colour is to be kept subdued.

Opposite, bottom
Zoos can pose tricky exposure problems because you often have to take your reading from a distance. With an integrated reading, assess the overall tone value and adjust the reading accordingly. In this case, the value required was near to a mid-tone. Adjustment would be required only if the lighting was of low intensity.

150

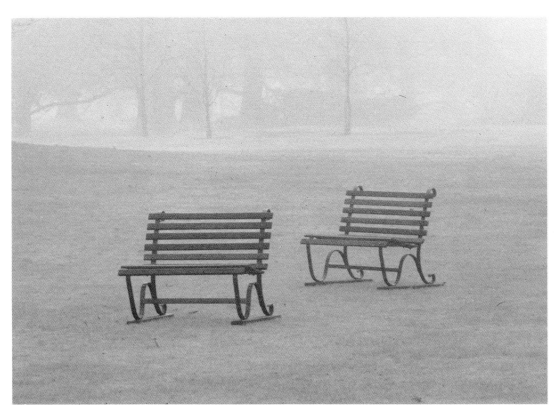

treatment must suit the subject and it must be kept within
bounds. A relatively low-contrast subject is essential in the
second case while overexposure of a high-contrast subject
destroys all highlight colour.

Colour temperature and mired values

Colour rendering is, of course, highly dependent on the colour
of the light illuminating the subject. Most colour films are
designed for use in sun-and-cloud conditions providing light of
a colour temperature of about 5 500 kelvins (K). Colour
temperature is a way of defining the colour quality of light in
terms of the temperature of a body which would give light of
that quality (on the absolute or Kelvin scale). It is usually
preferable, however, to think of colour quality in terms of
'mireds'. This word is taken from the initial letters of the term
'micro reciprocal degree', which simply means one million
divided by the kelvin figure.

By using mireds, we get a clearer view of the difference
between colour temperatures in the form of actual colour. A
mired variation (or mired shift) of 50, for example, represents
more or less the same extent of colour change anywhere along
the scale, whereas a variation in colour temperature at the top

(blue) end of the scale is less significant than a numerically equal variation at the bottom (red) end.

Daylight, for example can vary from less than 5 000K for a cloudy sky to 20 000K or more for a deep blue sky. The commonly encountered range, however, is from about 5 000K to 10 000K or 50–100 mireds. Most colour films can comfortably handle a 50-mired shift.

Lower down the scale, however, a photoflood lamp, for example, gives a much yellower light with a colour temperature of about 3 400K or 294 mireds. This is a long way from the 180 mireds or so for which the film is designed. As a result, a normal colour film used in photoflood lighting gives a distinctly orange-yellow image.

Further still, we have domestic lighting at about 2 600 to 2 800 K or 384 to 357 mireds, sufficiently far removed even from the balance of 3 400K films to make colour rendering less than perfect. In fact, films for 3 400 K photoflood lighting have now largely disappeared. There are a few artificial light films but they are generally balanced for studio type lamps of 3 200K or 312 mireds. These can give reasonable results with powerful domestic lamps and photofloods but are naturally best used in the lighting for which they are designed.

Flash is suitable lighting for daylight colour films in that all electronic flash units are designed to provide light of about 6 000 K and flashbulbs are coated blue to provide light of a similar quality. Flash can therefore be used in conjunction with daylight outdoors or indoors. It cannot be used in conjunction with tungsten lighting, unless it is sufficiently powerful to swamp the effect of the tungsten lighting altogether. Nor can tungsten lighting be used with window light. The window light, on daylight film, gives a normal image, while the tungsten light overlays the parts it reaches with an orange-yellow cast.

The contrast limitation

The greatest limitation with colour film, particularly colour slide film, is contrast. Each individual emulsion has considerable exposure latitude. It is not unlike a monochrome emulsion in that sense. But each layer has a different function and it has to work together with one or more of the others. A red in the subject, for example, may contain a small amount of blue. It is vital that each layer receives just the right exposure so that each produces the correct amount of colour. Over- or underexposure is bound to act differentially to some extent on the different layers so the latitude of two layers is less than that of one. Thus, when the subject has a wide range of tonal values, with

Colour negative. Light affects the three layers of the emulsion selectively according to its colour (A). Development produces dye in the areas affected, complementary in colour and density to the subject colours (B).
White light transmitted through the dyes (C) affects colour print material in the same way (A) reproducing the colours of the original subject (B) by subtraction from the white light reflected from the base of the material.

Above

A chance for the aperture-priority camera to show its worth. A wide aperture must be set to achieve the required shallow depth of field: shutter speed is unimportant. As the subject should integrate to a mid-tone, automatic exposure or a standard reading should be adequate.

very pale yellow, perhaps, and deep blues, browns or blacks, the ideal exposure at one end may be only a fraction of that at the other. The compromise that we have to make by giving all parts of the film the same exposure time means that the colour at one or other end of the scale runs out of tolerance. Not only is it over- or underexposed but the separate layers receive different levels of under- or overexposure. That is why colour slides of brightly sunlit scenes with light tones and deep shadows tend to lose detail and colour at the highlight end.

There is no remedy for such conditions, short of putting more light into the shadow area. If the subject can be moved out of the direct sunlight, some improvement can be expected, but further difficulties may then be encountered. If the sky is very blue it gives light of a very high colour temperature, well above that for which the film is designed. When you exclude the effect of the direct sunlight, you are likely to get a distinctly blue image, necessitating the use of a pale amber or 'skylight' filter. The ideal light for colour slides is that for which the film is designed – sunlight with a fair amount of white cloud to act as natural reflectors and to cover a large proportion of the blue sky. Even then contrast can sometimes be a little high, and a light covering of cloud over the sun might be preferable with

subjects of inherent high contrast. Lowering the contrast improves exposure latitude and makes underexposure, in particular, more acceptable.

In dull weather conditions it is even preferable to give a little less exposure than the meter indicates because this increases colour saturation and allows colour contrast to compensate for the lack of lighting contrast. The lack of tonal contrast in colour images (the type that is dealt with by filters in monochrome photography) can often be overcome by the careful use of colour contrast.

Colour in the dark

Night-time shooting with colour slide film raises problems that are not encountered in monochrome. Contrast is high because night shooting always requires some highlights; frequently they are highlights in which you want colour and detail. In monochrome you can generally overexpose such highlights to retain detail in the shadows and yet still be able to print through them. Or you might be able to adjust the film processing. On colour-slide film, overexposure is likely to send them stark white and lose all detail long before you have sufficient exposure to put detail into the shadows. Contrast-

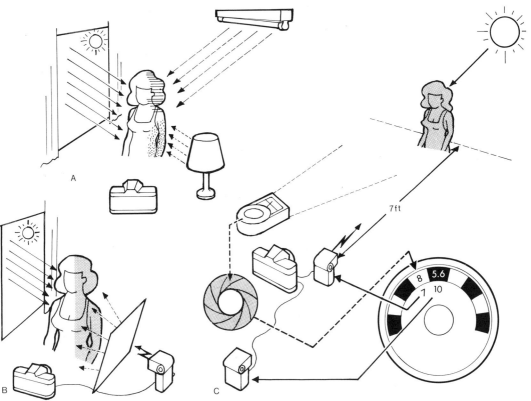

Opposite
You can never be sure
how your meter will
respond to a single colour.
Equally it is not easy to
assess the tonal value of
some colours. In this
case, a direct reading
would lead to too short an
exposure. A grey-card or
incident light reading is
preferably, with suitable
adjustment for any extra
lens extension used.

Wide-angle lenses can
make TTL metering
difficult if tonal masses
are not reasonably well
balanced. The light sky
tone and distant mist
could lead to
underexposure, whereas
the delicate tonal values
are better rendered by
moderate overexposure.

A. Mixed lighting sources
must not be used for
colour photography. B. If
additional light is
necessary for an indoor
shot, use white or neutral-
coloured reflectors or
electronic flash. C. Flash
can be used with daylight
outdoors. First find the
aperture necessary for the
daylit parts at the
obligatory shutter speed.
Then place the flash at
the distance indicated by
the guide number plus the
distance estimated as
necessary to balance the
lighting. Between-lens
shutters give greater
versatility owing to their
lack of restriction on
shutter speed.

reducing processing techniques are not generally available.

The remedy in most cases is to shoot at, or a little before
dusk, perhaps as soon as the lights necessary to make it a night-
time shot have been switched on. What daylight is left can then
illuminate the shadows sufficiently for a much shorter exposure
to preserve detail and colour in lamps and highlights. The
exposure required is less than for the prevailing light if you
shoot early enough because you are, to some extent, faking the
night scene. If there are clouds in the sky, you do not want
them white. Any blue sky that reproduces, you probably want
to see as a blue-black. Exposure is likely, therefore, to be one or
two stops less than that indicated by a straight reflected light
reading. But this is no subject for confident one-shot techniques.
It is worth two or three different exposures.

Colour slide and colour negative

We have concentrated largely on colour-slide materials in this
chapter because their exposure is much more critical than that
for colour-print films.

Colour-print, or colour-negative, films are of similar
construction to colour-slide films, but their processing is
different and considerably simpler. There is only one

development stage, producing colour along with the silver negative image which is then bleached and removed. The image is negative in both tone and colour, and is printed in a manner similar to a monochrome print. However, the processing is similar to that of a colour-negative film.

The printing process uses a three-layer print material, and wide variations of colour filtration can be inserted in the exposing light beam to adjust the colour balance. The duration of the exposure can be varied to provide the correct density. Thus there is a great deal of post-exposure control over both colour and density, but only within the latitude of the film.

In monochrome printing you are concerned only with getting the light through the negative. Provided the highlights are not totally blocked up and the required detail is visible in the shadow areas, you can make a passable print. A colour negative is a different proposition. At the highlight end, colour is likely to disappear before you reach maximum density and, although faint detail may be seen in the shadows, the colour can be severely distorted.

Colour-negative film can handle more contrast than colour-slide film, that is, it can retain accurate colour with relatively contrasty subjects, particularly with skilled hand printing. Nevertheless, high contrast is best avoided because the danger of colour loss or distortion is still there; the colour compensates for the low contrast that would mar a monochrome print.

Colour negative can cope with unsuitable lighting somewhat better than colour slide film. It is sometimes called 'universal' film, because it can (theoretically) be used in both daylight and artificial light. The overall colour cast that tungsten light causes

Opposite, top
Panning and zooming simultaneously give a startling effect of a shuddering slide on a fast bend. Exposure here is preset for the normal subject in the prevailing light conditions.

Opposite, bottom
Panning is a necessary technique with fast-moving subjects travelling at right angles to the lens axis. It also allows a relatively slow shutter speed to be combined with an aperture appropriate to lighting conditions and depth of field.

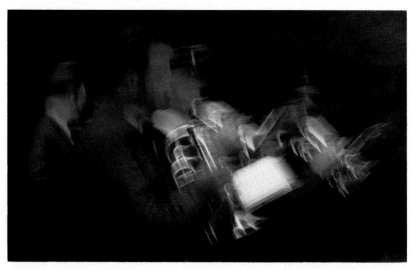

The slow shutter speed required for camera tricks of this nature have to be offset by small apertures. This is a case, therefore, for shutter-speed rather than aperture-priority with autoexposure cameras.

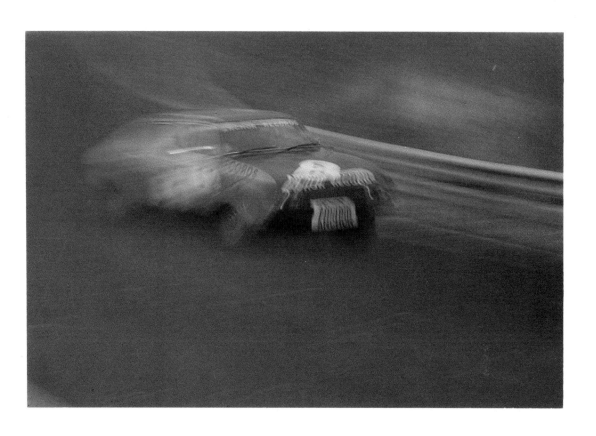

can be filtered out at the printing stage. A blue cast caused by shooting in the shade under a deep blue sky can be similarly dealt with. In fact, any overall variation of this nature can be eliminated at the printing stage provided its effect is not too drastic. However, any deviation from the designed colour temperature lowers the latitude of the film.

On the other hand, no amount of filtering, can put right the effect of using mixed lights, eg tungsten light with daylight in the same shot, or flash with tungsten lighting. The filter needed to correct the 'wrong' colour rendering puts a cast of its own colour over the parts that were correctly reproduced.

Uprating colour film

Fast colour films have become widely available only in comparatively recent years. The earliest films were very slow and, for many years, ASA 80 (ISO 80/20°) was more or less the standard speed for colour-print film and ASA 50–64 (ISO 64/19°) was considered reasonably fast for colour slides. Now we have ASA 400 (ISO 400/27°) versions and a great deal of publicity about rating them even faster.

Uprating simply means setting your exposure meter to a higher film speed figure and adjusting the film processing accordingly.

Below
Sunsets are ever popular subjects but their rendering depends on the individual photographer's preference. Transparency film rarely reproduces this type of subject as the eye sees it. The best procedure is to base a few bracketed exposures on a straight reflected-light reading.

Right
A wide-angle lens can give extreme depth of field even at moderately large apertures. With a static subject, you then have a choice of exposure settings from slow speed and smallest aperture if you can support the camera rigidly, to a hand-holdable speed at a mid-range aperture setting.

Below
Skyscapes can be subjects in themselves or the starting point for combination pictures. Exposure depends on the result you want. You have to assess the tonal value required in the main part of the subject and adjust a direct reading accordingly.

Not all films respond to such treatment without unacceptable loss of quality and, in fact, it is the faster films for which it is usually prescribed.

Naturally, man will always try to scale the highest peak, but the fastest monochrome films commonly used are the ASA 400 (1S0 400/27°) types. Faster versions are available but sales are small. The monochrome types respond to uprating too, but how often anybody bothers to do so is debatable.

Uprating ASA 400 (ISO 400/27°) colour film appears to be a case of gilding the lily. The optimum speed is in fact as stated; if it were not, manufacturers would not miss the opportunity to be the first to introduce an ASA 650 or 800 colour film! So uprating must surely entail a loss somewhere along the line.

The form the loss takes is in poorer resolution due to increased grain size, and a lowering of both colour saturation and contrast. The loss of contrast is not acceptable because it carries along with it a degradation of colour, ie colour contrast suffers as well as tonal contrast. The technique cannot therefore be used as a form of contrast control. Indeed, as with all uprating techniques, it cannot be used with long tonal range subjects at all, because the first victim of underexposure is shadow detail, and, in colour films, shadow colour.

Below, left
Multi-images are closely associated with the pop scene. A relatively small aperture is generally necessary to obtain reasonable sharpness in the secondary images but exposure is based on a normal reading for the main subject.

Below, right
You don't make careful exposure calculations for grabbed shots. Your camera should be pre-set for the prevailing conditions. Then you can make a quick adjustment to aperture or shutter speed if the subject requires it.

Nevertheless, uprating is a way of life for many photo journalists and others. Many laboratories are prepared to undertake the modified processing required; you can follow one of the many published methods yourself.

Colour consistency

Colour film manufacture is a highly sophisticated process. The consistency of the end product is remarkably good but it is not absolute. The emulsion is made in batches; films coated from the same batch should produce virtually identical results, provided they have been stored correctly. There is no such guarantee with films coated from different batches of emulsion. Variations in colour rendering and effective speed can and do occur. Such variations are generally minimal, and pass unnoticed by the average user. They tend to be less noticeable on amateur films than on the larger-format sheet films used almost exclusively by professionals. This film is intended for immediate use and must be kept in cold storage, unlike amateur films which are designed to 'settle down' to their optimum quality after a shelf life of about six months.

When colour rendering is highly critical, batch to batch variations have to be taken into account. This is generally

Below
The figures are brightly lit but the background is in shadow. In this case, the background is of no importance and can be allowed to go as dark as necessary. Exposure is as for the normal sunlit subject.

necessary only in high-quality commercial work involving foodstuffs, fabrics, jewellery, cosmetics, art reproductions, etc. If a large number of pictures is to be taken, it is necessary to obtain sufficient material with the same emulsion batch number before shooting starts. The procedure then is often to use several sheets on test exposures and have them processed by a thoroughly reliable laboratory. Exposure and filtration can then be worked out before shooting proper begins.

With strong lighting from both back and front, you have to be careful not to overexpose the main subject. The flesh tones are obviously important here and exposure is based on their correct rendering.

Clip processing
Some laboratories offer a modified version of this process called 'clip processing'. They offer to process a few frames of your roll of 35 mm film and send them to you for assessment and further instructions. If you are not too sure of the exposures you have given, or have uprated the film, or have set the wrong film speed figure, you can ask them to clip off the first few frames for test processing and adjust the processing of the remaining frames as necessary.

15 Performance Tests

No matter how much care you take over camera exposure, you will get nowhere if you start from the wrong baseline. Your processing and printing technique must be good enough to translate the correct camera exposure into the required quality of negative and print.

We assume in these tests that you do your own processing, because if you do not, all your efforts at correct exposure can be nullified by the printer. Most printing is machine processed. If you do not do your own processing, all is not lost, however. Follow the tests as far as possible, and stick to one processing lab; you would do best to carry out the tests on colour slide film, which has less exposure latitude, shows up errors more clearly and goes through a standardized processing procedure.

If you do your own processing, a few tests of procedure are worthwhile. How you make the various exposures required is a matter for your own ingenuity. It is not easy with 35mm film. You can space various exposures by shooting blank frames between them and carefully measuring and cutting the film in the darkroom. It is more reliable however, to load short lengths of film into cassettes, say 10–12 exposures for each test. With rollfilm, use a complete film for each test.

Testing your basic technique

Choose a subject in reasonable daylight conditions, not brilliant direct sunlight, in which you can meter a light tone with some detail in it and a dark tone with similar characteristics just six stops away from it.

Take a grey card or incident-light reading and expose the subject at that level. As this is a single-exposure test that will be processed normally, you can put it in with one of the other tests or on a film already in the camera.

Process the film normally and make the best possible print from the negative on your usual paper with your usual printing and print processing technique, without shading or burning in. If you find that you have adequate tone rendering and detail in both of the measured areas, there is little wrong with your technique. If you cannot produce satisfactory detail in both

areas in a straight print, there is something wrong with either your film speed setting or your developing procedure.

You might also try a pair of tones seven stops apart. The film can handle this without difficulty, but it is near the limit for a straight print on normal grade paper.

If your print is unsatisfactory, you need to identify the fault. If when you print the lighter tone correctly, the darker tone is detailed but too light, the negative is lacking in contrast. This means either underexposure or underdevelopment. If, on the other hand, when you print the lighter tone correctly, the darker tone goes totally black and loses detail, your negative is too contrasty. This means overexposure or overdevelopment.

So far, so good. Deciding between underexposure and underdevelopment or overexposure and overdevelopment is not so easy, especially when, as should be the case here, the error is slight.

The best course is to review your technique and your equipment. Your exposure should be correct because you metered the two tones as well within the film's capability and gave a reliable grey-card-based exposure. The only way you could go wrong here is with a faulty exposure meter, using the meter wrongly, or with highly inaccurate exposure times on your camera. The second is the most likely. You must make sure you measure only the area of the grey card and that it is so oriented that light falls on it in the same way as it does on the subject. You must not allow a shadow to fall on it while you take the reading. An incident light reading must be taken from the subject, with the meter cell and diffuser pointing toward the lens, not the light source.

You should be able to shoot a subject with a six-stop range of tones (1), process the film normally (2) and make a perfect print on normal grade paper (3, 4). If your result is overexposed (5) or underexposed (6), possible faults are the exposure meter (7), shutter speed accuracy (8), film speed setting (9), shadow on metered area (10), inaccurate thermometer (11) or faulty timing of development (12).

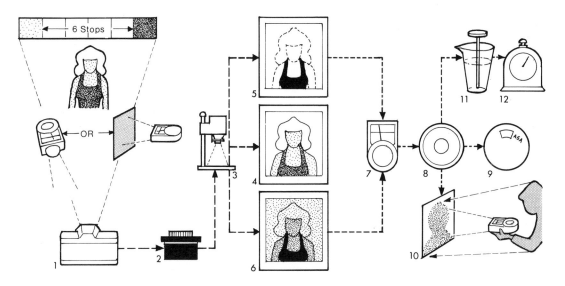

166

A more likely cause of error is the relationship between your film-speed setting and your film processing. There can be a variety of reasons such as errors in your meter indications, shutter settings or lens aperture markings, or your thermometer or timer. These are not generally important provided the degree of inaccuracy is consistent and not too great. Exposure times can vary by up to 20% from the marked values with no significant effect on a monochrome film. A thermometer that under-or over-reads by a degree or so (and a great many do) is still usable provided the error is consistent. Some kinds of thermometer, particularly dial types, read differently in different depths of solution.

Minor troubles of this nature can be ironed out in the next test, which is designed to ascertain whether you are using the correct film speed setting for your processing technique.

Determining your effective film speed

Choose a normal subject with a reasonable distribution of tones including some deep shadow and bright highlight areas. Take a normal reflected-light reading and a reading from a grey card to check that it is an average subject. The readings should be within one stop of one another.

Make your first exposure at the grey-card level with your meter set to the marked film speed. Make four further exposures at half-stop intervals either side, ie ½, 1, 1½ and 2 stops more and ½, 1, 1½ and 2 stops less than the exposure recommended by the meter.

Whether you should use the lens aperture or exposure time as the variable is unimportant with today's improved shutter design and electronic control. Whichever method you choose, avoid extremes. Your aperture group should preferably range from $f2.8$ to $f11$ or from $f4$ to $f16$ depending on the lens used. Avoid exposure times shorter than 1/250 second. If you decide to use varying exposure times you will need a tripod for the longer ones.

As this is the test on which all others depend, it is worth taking some trouble with it. Make no more exposures of consequence on this roll. Unload the film and process it strictly according to the developer manufacturer's instructions. Wait until it is completely dry before examining it.

If you know the type of negative you want, check the nine exposures visually and determine which has given the result required. If you cannot decide that way (and it is not easy), put the strip of negatives aside until you can make prints. When you do so take care to produce the best possible print from each

Exposure latitude. The print above is from a 'correctly' exposed negative. The other negatives had two stops less exposure (top) and two stops more (bottom).

negative on normal grade paper. Examine the prints closely when they are dry, paying particular attention to the rendering of shadow and highlight detail, and maximum black and minimum white.

It is more than likely that two or three prints will be virtually identical, and maybe more than three. With most modern monochrome films, a one-stop exposure error on an average subject has very little effect on the quality of print that can be produced. Make your choice of the best negative according to the density you prefer to print from.

When your choice is made, check the exposure given to that negative. If it was not the one that had the exposure recommended by the meter, your 'personal' speed for that particular film, processed in your particular manner, differs from that of the maker. If it is the +1 stop negative, you should in future set your film speed to half the manufacturer's figure. If it is the −1 stop negative, you should set it to double the manufacturer's figure. If you choose one of the ½-stop negatives, you must then choose one of the intermediate one-third positions normally marked between film speed figures.

Thereafter, this will be your film speed for the camera, lens, film and developer you used for the test – and for your darkroom equipment and materials and printing technique. Change any of those and your film speed figure may also change. Ideally, you should re-test if you make any change. If you work with 'professional' materials, such as colour film in sheet form and professional rollfilm, you may carry the tests further. In general, if you work exclusively with monochrome or amateur colour materials, you can be reasonably satisfied with a single test for each brand and speed of film, unless the test runs into exposure difficulties. When working in colour, it is as well to repeat the test from time to time, as colour emulsions are often changed without publicity.

The film developer is important. The safest method of use for consistency is the one-shot, throw-away system. You use fresh developer for each film or for each batch of films developed together. If you do not do this, follow precisely the manufacturer's instructions about the prolongation development time for each subsequent film. Without absolute consistency in processing, the tests are useless.

Effect of variations in exposure
Having determined your basic effective film speed, you can proceed to test the effect of varying exposure and processing to control contrast. This entails quite a lot of work and you may

finish with little worthwhile data. Nevertheless, there is nothing like finding out for yourself and it just may be that your particular film/developer combination gives useful results.

Uprating technique Load three short lengths of film into cassettes (or take three rollfilms). On each film, take a series of pictures in relatively low-contrast lighting. Suitable subjects are buildings with a reasonable variety of tones, some weak shadow from window sills and some white paint. Space your exposures as before, one at the standard grey-card level and four at half-stop intervals up to two stops underexposure.

Thus you have five more or less identical shots on each roll of film, or multiples of five if you have shot more than one subject. Take one film and develop it as standard. Develop another for 30% longer than the standard time and the third for 50% longer than standard.

Now you have three films showing 15 different treatments of the same subject.

Shot	Exposure	Development
1	standard	standard
2	½-stop under	standard
3	1-stop under	standard
4	1½-stops under	standard
5	2-stops under	standard
6	standard	30% increased
7	½-stop under	30% increased
8	1-stop under	30% increased
9	1½-stops under	30% increased
10	2-stops under	30% increased
11	standard	50% increased
12	½-stop under	50% increased
13	1-stop under	50% increased
14	1½-stop under	50% increased
15	2-stops under	50% increased

If you have not carried out this sort of test before, the first thing that will strike you is that you have 15 negatives that are visually almost identical – a situation that certainly did not exist some years ago. There will probably be surprisingly little difference between no 1 and no 5 and virtually no difference between no 1 and no 15. You are likely to find that every one of these negatives can produce at least an acceptable print. Only if your subject was rather more contrasty than envisaged will

you perhaps find that fine highlight detail has been lost in Nos 11 and 12 or very weak shadow detail has disappeared in Nos 4 and 5.

You will find it very difficult to decide which is the best negative without making prints. Try making the best possible print on normal grade paper from each of them. Then select those that seem to be the lowest in contrast, and print them on a higher contrast grade of paper.

You should now be able to come to some conclusions about increasing contrast by reducing exposure and extending development, or placing a tone lower on the curve and bringing it up again by increased development. Study all your fifteen prints carefully from this point of view. Has overall contrast increased in any of them? Are the shadows deeper or the highlights brighter? Are the middle tones better separated? You will probably not see any dramatic differences as modern films are not made that way; but you might see some subtle effects you could make use of, to add that little extra quality to your prints.

One thing you certainly will notice is that you have discovered the origin of the uprating technique. If your subject has no extreme highlights and shadows, you can underexpose most monochrome films by up to two stops and overdevelop by 50–75% to produce a negative very similar to that produced by normal exposure and normal development. When you come to make the print, you may find that the quality is not quite as good. Graininess will have increased marginally. Overall contrast may be slightly higher. But you will apparently have increased film speed by a factor of 4. This is a valid operation

Conducting these tests in exposure and development teaches you a lot about film speed and its 'elasticity' in relation to the nature of the subject. With the right subject, underexposure and overdevelopment can give an apparent increase in film speed.

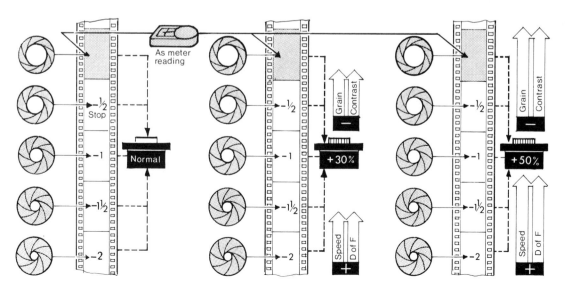

with the right subject and when carried out to cope with subject movement, to obtain the required depth of field etc – not just to show how clever you are.

If you repeat the test in bright sunny conditions on a subject with weak highlight and shadow detail, you will find a different story. You will certainly lose the shadow detail at two stops underexposure and normal development and the highlights are very likely to block up completely at normal exposure and 50% overdevelopment. But, more important, extended development is not likely to bring back the shadow detail lost by two stops underexposure, and the highlights may become too dense to print easily. Overall contrast can also increase (but that was not the object of the exercise).

Downrating technique Now we move to the next test. Can we reduce contrast by generous exposure and curtailed development – or placing a tone higher on the curve and bringing it down again by adjusting the development time? You need another three short lengths of film with at least five exposures on each. This time, however, you want a contrasty subject; you will supplement your normal exposure with four others at half-stop intervals up to two stops overexposure. This is the technique that used to be known as 'exposing for the shadows and developing for the highlights'. At the processing stage, develop one film normally, one at 15% less development time and one at 30% less.

Again, you have 15 treatments:

Shot	Exposure	Development
1	standard	standard
2	½-stop over	standard
3	1-stop over	standard
4	1½-stops over	standard
5	2-stops over	standard
6	standard	15% under
7	½-stop over	15% under
8	1-stop over	15% under
9	1½-stops over	15% under
10	2-stops over	15% under
11	standard	30% under
12	½-stop over	30% under
13	1-stop over	30% under
14	1½-stops over	30% under
15	2-stops over	30% under

Again, your results will look remarkably similar. Repeat the assessment and printing procedure, and see what conclusions you come to this time. Look for the subtle effects. Can you improve your negatives sufficiently by this technique to make it worthwhile (particularly with 35mm film, where it is not easy to separate subjects by contrast on to different cassettes)? Rollfilm workers can weigh up the balance more critically. What may not offer a marginal advantage for 35mm workers may be worthwhile for them.

If you do manage to produce significantly improved negatives by one or other of these techniques, it is worthwhile pursuing it. It is always better to get the quality into the negative if possible and to aim at printing everything on the same grade of paper. You cannot always do this; but the nearer you get to it, the easier it becomes to produce first-class prints.

Darkroom tests

In monochrome and to some extent with colour negative film, exposure must be related to the whole process of picture-making, right through to the final print. It may be unacceptable to the purist, but it remains true to say that different photographers like to print from different types of negative. Some like a 'meaty' negative with noticeable density even in the darkest shadows: others prefer to print from the thinnest negative possible. Enlarger characteristics can also affect the type of negative that prints best. Even colour slide materials do not have a single correct exposure. There is sufficient latitude to allow you to produce a denser slide for powerful projectors.

So it is advisable, unless you know the type of negative you are looking for, to take all tests through to the final print stage. The theoretically perfect negative may not be perfect for you. By striving to make the best print from a given negative, moreover, you can learn a lot about print quality.

Performance of materials A useful exercise, rather than a test, to start with is to check the behaviour of your usual paper and developer combination. How many different recognizable tones can you produce? What is the minimum exposure to produce maximum black through clear film – a frame of unexposed, fully processed film? With test strip type exposures of 2, 4, 6, 8 etc. seconds at a moderate aperture on a 10×8 in sheet of paper, you should be able to make out 30 or more different tones, any of the last half-dozen or so of which you might have considered to be maximum black until you tried this experiment. This range of tones gives you a much clearer idea of the capability of your paper than the normally-quoted 60–1

ratio. When you see all the tones and the barely discernible differences between them, in fact, you may wonder what the talk of restricted tonal range is all about. What it is actually all about is fitting as many as possible out of the longer range of tones in the negative on to the paper. And that is largely a matter of emulsion chemistry.

Another useful piece of information can be obtained from this experiment. Suppose you were using the enlarger lens at $f11$ and you found that you did not get a maximum black until you reached an exposure of 70 seconds. Then you know that no print of that size made from a normal negative can show a maximum black anywhere with an exposure of less than 70 seconds at $f11$ or its equivalent.

The effect of using different paper contrast grades is well illustrated if you repeat this test on as many different grades as possible. If you want to be really industrious, try it with different developers, too – or with developer well below the recommended temperature, say at 13°C (55°F).

Personal performance Darkroom tests relate largely to checking your own technique. Take your best negative and make your best print from it by your usual methods. Use fresh materials and solutions at the manufacturer's recommended temperature.

Set your best print aside and then give another sheet of paper exactly the same exposure through the same negative. This time, however, develop it for twice the recommended time. (This is for monochrome only, of course.)

When both prints are fixed, washed and dried, examine them carefully. There should be little, if any, detectable difference. If the second print is noticeably darker than the first and the highlights are not clean, your enlarger exposure was too long. Make another pair of prints, and a third if necessary with shorter exposures, until you can develop two identically exposed prints, one for the recommended time and the other for twice the recommended time, and not see any noticeable difference between them. Then compare those prints with the first (your best) print. There is a very good chance that they will look brighter, with better tonal separation and richer blacks.

Overexposure in the enlarger is a common fault, often leading you to remove the print from the developer before it has fully developed because it seems to be going too dark.

Underexposure is even more common, especially among those who believe that they can judge the quality of a print in safelight conditions and while it is still under the developer. This will show up in the test but not so noticeably as in the case

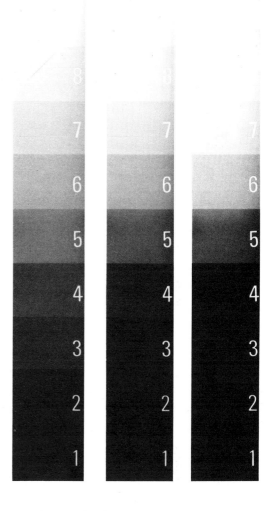

The range of tones available on, from left to right, Grades 0, 2 and 4 paper.

of overexposure. If the second print looks a little darker than the first but rather contrastier, try increasing the exposure until you can produce two identically-exposed prints that look near enough the same whether you give them normal or twice-normal development. Compare them with your best print. They should look stronger, with considerably increased contrast caused mainly by a deeper shadow tone.

Exposure estimation Despite all the electronic aids now available for the darkroom, the test-strip method is still the most reliable for judging the correct exposure required for any particular negative. For the best possible print, however, a single test strip is rarely enough.

The normal test-strip method is to take a generously-sized piece of bromide paper – at least 35mm wide – and to lay it

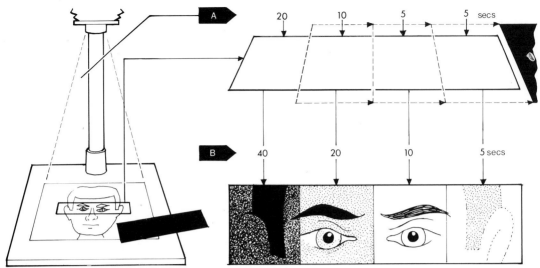

across the image area on the enlarger baseboard so that it covers as wide a range of tones as possible. Moving a piece of black card across the strip, give three or four doubled-up exposures through your chosen negative – say 5, 10, 20, 40 seconds. Move the card across the length of the strip so that all tones appear on each segment.

Process the strip and examine it after blotting it dry. Ideally, it should be completely dry but at least take the water sheen off it. Use strong light, preferably daylight, to examine it by. If all the segments are too dark or too light, you will need to start again with a different series of exposures or a larger or smaller lens aperture. Assuming that the results run from too light to too dark, check the shadow and highlight areas in the middle segments. Provided the negative is not over-contrasty, you should be able to see detail in both areas, while deep shadow should be maximum black or very close to it. You may have to test again, with more closely-spaced exposures, before you are certain that you have the right one.

That is the normal test-strip procedure. It generally gives enough additional information to tell you whether any special treatment such as shading or burning-in may be necessary. This means giving the extra exposure that a highlight area is shown to need, because its best rendering is in a segment other than that containing the best shadow area rendering; or giving the exposure that renders the highlight correctly while shielding the shadow area.

The experts do the shading with their hands, but to begin with it is easier to use pieces of card, fixed to a length of wire. The card must be kept gently moving all the time to avoid forming a sharp edge between tones.

Lay the test strip across the image area to cover as many tones as possible and hold a piece of black card just above it. Switch on the enlarger lamp and draw the card back to give the exposures indicated (A). The actual exposures of each portion of the strip are then as shown (B). Naturally other figures can be substituted in the light of experience.

A more refined type of test strip concentrates on single tones. If you have an area that you want to reproduce as maximum black for example, lay your test strip over that tone only and find the minimum exposure to produce the tone required. You can do the same for any other tone, of course. If you test two important tones in this way and the indicated exposures are the same or very close, you know that you are well on the way to producing the kind of print you want. If the two indicated exposures are slightly different a change of paper grade should solve the problem. If they are markedly different, selective exposure treatment is necessary.

Exposure meters for printing

Various forms of exposure meter have been developed for darkroom use. They fall into two basic groups: those using a light-sensitive probe placed on the baseboard and accepting light direct from the lens, and those held at a fixed position above the baseboard and reading the light reflected from the paper surface.

The latter are commonly automatic exposure types, ie they meter the exposure as it is given and switch off the enlarger lamp at the appropriate time. They can work very well for the rapid production of a series of prints from different negatives at different degrees of enlargement. They read a large area of the image, however, and work on an integration-to-grey principle. The precise area read is not immediately obvious and they are easily misled by 'non-average' images.

The probe sensor is more versatile. It generally works in conjunction with a timer so that, as you turn the timer dial an indication is given when you have set the correct exposure time. Light-emitting diode (LED) indicators, are now commonly used. The advantage of this type of meter is that it can measure a very small area directly or the whole negative area by placing a diffuser over the lens.

The diffused reading uses the integration-to-grey principle and is satisfactory in most cases. The spot-reading facility enables you to assess the exposure required for maximum black or for a flesh tone or any other key tone you like to select.

All such meters have to be calibrated by the user for his own materials and techniques. Naturally, different papers have different sensitivities, and developers vary in their action. The meter has a 'paper speed' dial which needs to be reset for each set of circumstances – paper, developer, lens and, in the case of spot readings, the type of reading required. For this, you must first produce a first-quality print from an 'average' negative.

Then, with the enlarger at the same setting of the lens and head height, you set the exposure time given on the timer dial. Place your probe on the baseboard to give the type of reading required, switch on the enlarger lamp and turn the 'paper speed' dial of the timer until correct exposure is indicated. The dial is now set for all subsequent operations in the same conditions. It will vary, of course, with the type of reading you use; you need to keep a record of the settings for averaged readings, flesh-tone spot reading, maximum-black spot reading, and so on.

No enlarger exposure meter can give you 100% correct results. According to the expertise you acquire in using it, it can produce prints varying from acceptable to very good; but it is basically only a guide, because the print is the final result. Because you cannot see the image you have to compromise in the production of a negative. You can see the print image as you process it, and you can control the process at every stage. So you can continue trying until you produce the best print you are capable of.

The importance of print quality

It is not much use taking infinite pains over the exposure of a negative if you are not able to do justice to it in the darkroom. To get the exposure right the answer is careful and intelligent making of test-strips aided (if you wish) by an exposure meter, and a reluctance to be satisfied with the first print. The perfectionist regards the first print as the last test-strip. On it he reassesses the exposure for the whole print, and notes the areas that need further attention.

No matter how careful you are with exposure, you will not get perfect prints unless everything else in the darkroom process is working efficiently. Always use fresh paper, properly stored away from damp, heat and chemicals. Your developer must be fresh and at the correct temperature. The fixer must be fresh and the print adequately washed after fixing.

Safelight and stray light testing Above all, your safelight must be really safe, and there must be no light leaks in your darkroom. Light safety is easily tested. Set up the enlarger to make a print with all blackout arrangements in place and the safelight on. Position the printing paper on the baseboard. Place a coin over an area on the paper that is to be reproduced as a light to mid-tone. Leave the paper and coin in place for two or three minutes, then remove the coin and make your print in the usual way. When you examine the final print, there should be no trace of where the coin lay. If your lighting is unsafe, you will find that the position of the coin is visible as a lighter area.

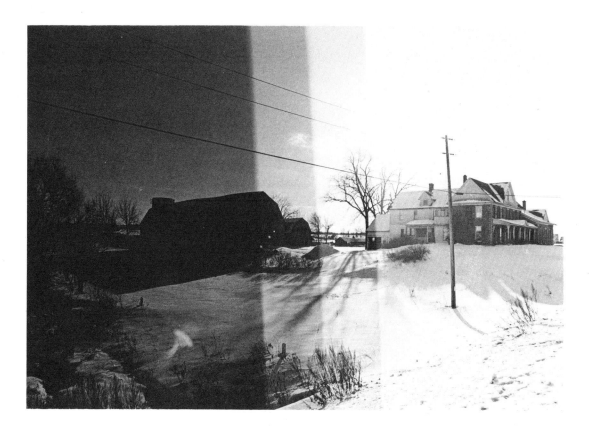

Print exposures of 5, 10, 20 and 40 seconds. Note that each strip covers a wide range of tones.

It is essential that you make the test in this way, because your lighting may be only marginally unsafe. If you developed the paper without making a print, you might see no fogging, but the extra exposure given by the enlarger is enough to bring that latent fog up in the final print. The result of stray light is that your prints lack the extra bite that is associated with clean whites and good separation between the delicate lighter tones.

16 Matters Mechanical

This is the chapter that you should read either first or not at all. It deals with the basic facts without which some parts of the rest of the book may not be too clear to the reader who has little experience of cameras and photography. After all, we have not explained elsewhere exactly what we mean by the term 'exposure'. Let us put that right first.

What is exposure?
The film you put in your camera is coated with a light-sensitive material. When it is exposed to light it undergoes a chemical change. The effect is not visible but it can be amplified until it is, by immersing the film in a solution known as a developer. The parts that have been acted on by light are then further attacked by the developer, which has the effect of turning them black. If the whole film has been exposed to light it all goes black. If only parts of it have been exposed, as by projecting an optical image on it via the camera lens, only those parts that the light has reached will go black.

The light-sensitive layer has thickness and scattered throughout this thickness are minute particles of silver compounds known as silver halides. It is these particles that become black on development. Where the light level in the optical image is very low only a few particles, mostly towards the upper part of the layer are affected. With a little more light, more particles are affected (made 'developable'); with more light, more still are affected, and so on.

Thus there is a different amount of blackening across the film according to how much light reaches the various parts. If a very bright light reaches part of the film, all the particles are affected and on development the film in that area becomes almost completely opaque. A 'negative' image is therefore formed with large range of densities or 'tones'. It is a negative because the film blackens to a greater extent where more light reaches it, so that the image is darker where the subject was lighter, and vice versa.

To produce a positive image of the original, you effectively repeat the process. You put the negative in an enlarger between

Image formation. 1, The camera lens projects an image on to the film. 2, Developer. 3, Fixer. 4, The image is negative because the developer activity is proportional to the amount of light that the film received. 5, The negative image is projected on to print material. 6, Developer. 7, Rinse or stop. 8, Fixer. 9, The print is positive because most light passes through the least developed areas of film.

a lens and an illuminating lamp, so that its image is projected on to paper similarly coated with light-sensitive material. The image on the paper is also 'negative'; the darker parts of the negative image when projected on the paper produce little effect, and, on development, the paper shows lighter tones in those areas. Conversely, the lighter parts of the negative produce darker tones on the paper. The image is thus a negative image of the negative, ie a positive.

Exposure is simply the act of allowing light to fall on the light-sensitive material. The action of the light is cumulative; the longer the light acts on the film, the more particles are affected and the blacker the film becomes on development. Eventually, the whole film goes black and you have no image. The trick is to allow only sufficient light through to provide a fully detailed image of the subject. The brightest areas blacken the film very quickly. You have to stop the exposure before any of the less bright parts catch up and go equally black, but not before the darker parts have had sufficient time to produce an effect.

Exposure controls
You can control the exposure in two ways: by exposure time, and by the lens aperture. The first is more or less self-explanatory. The shutter is a mechanism which prevents light from reaching the film until you want it to. You open it to let light through by pressing the shutter release button. The shutter opens and then closes again after a precise interval, usually a definite fraction of a second. The time for which it remains open and during which light passes through to the film is called the exposure time, and it is controlled by a knob on top of the camera or a ring on the lens barrel with marked settings.

Exposure time The figures on the exposure time (or shutter speed) control are:

1 2 4 8 15 30 60 125 250 500 1000

These figures represent fractions of a second. Thus 1000 means 1/1000 second, 60 means 1/60 second and 1 means 1/1 or one second. There is also a 'B' setting, where the shutter is held open for as long as the shutter release button is depressed. Some cameras have a longer range of slower speeds marked 2, 4, 8, etc. in a different colour to indicate that they represent whole seconds rather than fractions. On simpler cameras only a few of the above speeds may be available.

Aperture The shutter allows you to control the duration of exposure. You have a further control, based on the principle that a small window admits less light than a large window. Your lens contains a multi-leaved structure forming a more or less circular hole and known as an iris diaphragm. Its diameter is controlled by a ring on the outside of the lens. This has marked settings in the series

1 1.4 2 2.8 4 5.6 8 11 16 22

Each figure represents the previous one multiplied by 1.4. Each successive setting represents an aperture that is twice as great in area as the previous one (moving from the larger numbers to the smaller). Thus, setting '11' gives an aperture one-half of the area of setting '8', and thus admits only half as much light.

The numbers indicating the size of the aperture are called *f*-numbers. Altering the aperture is frequently referred to as 'stopping down' when moving from a larger to a smaller aperture or 'opening up' when moving from smaller to larger. We also use the term 'stop' to indicate the difference between

Exposure controls. A, Shutter release. B, Shutter speed setting. C, Lens aperture. The shutter speed and lens aperture can be varied over a very wide range to control the amount of light transmitted to the film.

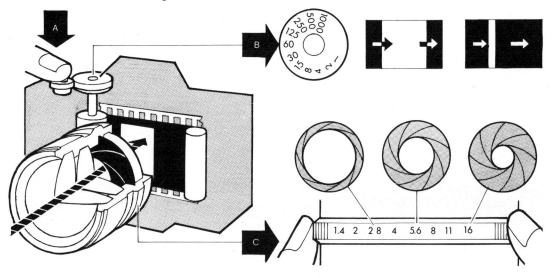

one setting and the next. Moving from $f11$ to $f4$, for example, is opening up by three stops – $f11 - f8 - f5.6 - f4$.

The f-numbers allocated to each aperture are indicators of light transmittance, ie light-passing capability. At a given f-number setting, any lens passes or transmits the same amount of light to the film, allowing for manufacturing tolerances. The actual size of each aperture is directly related to the focal length of the lens, which governs the size of the image it produces. At, say, $f8$, a lens of longer focal length has a larger aperture diameter than a lens of shorter focal length; but the light has to travel further from the lens to the film. The net result is that the image intensity is the same, ie the same amount of light falls on the film in both cases.

As exposure times and f-numbers both work on a doubling-up principle, we also use the word 'stop' to denote any variation of one setting in exposure. Thus, giving one stop extra exposure can mean opening up the lens by one stop, say from $f8$ to $f5.6$, or lengthening the exposure time by one setting, say from 1/250 second to 1/125 second.

So the exposure controls are the shutter setting and the iris diaphragm and, on a good-quality camera, they give control from 1/1000 second at $f16$ to 1 second at $f2$. That, believe it or not, is a ratio of 1:65 000!

How we use the controls
We rarely use the controls at such extremes, of course. Scenes seldom vary so much in brightness. What does happen is that for a given scene we may need to use a large aperture with a short exposure time or a small aperture with a long exposure time. We may want to use a short exposure time because the subject is moving. The faster the motion, the shorter the exposure time you have to use in order to avoid blurred pictures. But a very short exposure time reduces the amount of light energy reaching the film, so we must increase its intensity by using a large aperture.

We may on the other hand want to use a small aperture to obtain greater depth of field. Let us explain what we mean by this term. When you focus your lens, say on an object 3m from the camera, you get a sharp image of that object, of course; but other objects nearer to and further from the camera are also fairly sharply focused. The distance between the nearest and farthest planes of acceptably sharp focus is called the depth of field, and it varies with the lens aperture, being greater at small apertures.

We might wish to use a large aperture in order to be able to

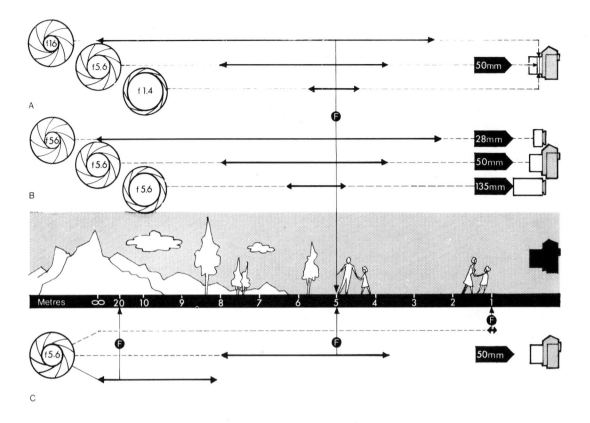

Metres ∞ 20 10 9 8 7 6 5 4 3 2 1

B

C

use a relatively short exposure time. We might also want to
restrict the depth of field so that unwanted detail in the
background is put out of focus and thus becomes less
distracting. On the other hand we might wish to use a small
aperture, because the background detail is part of the subject
and we want it to be sharp, in which case we have to use a
relatively long exposure time. Of course, we may sometimes
need a large aperture and a long exposure time together to
gather as much light energy as possible when the subject is
poorly illuminated. We may thus find that we have conflicting
requirements: a small aperture for maximum depth of field and
a short exposure time to arrest movement. If the subject is
poorly illuminated, we may have to compromise.

Because both aperture and shutter speed settings work on a
doubling-up principle, 1/125 second at *f*11 is effectively the
same as 1/60 second at *f*16 or 1/250 second at *f*8, and so on.
This principle is known as the Law of Reciprocity, and all
exposure meters depend on it.

How we arrive at the correct settings
When you buy your film, you find a leaflet packed with it that
gives brief exposure recommendations. It might tell you, for

Depth of field is controlled
by the size of the lens
aperture (A, B) and by
focused distance (C).
Focal length has an effect
only in so far as it controls
the aperture size at a
given *f* number. At the
same focused distance,
depth of field is least at
the widest aperture. At
the same *f* number, depth
of field is least at the
longest focal length
(because the aperture is
larger) and at the shortest
focused distance.

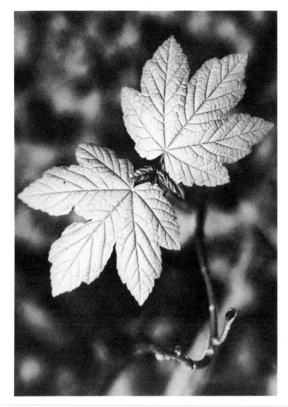
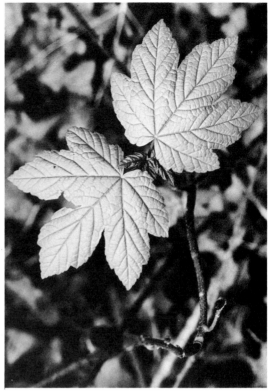

You can change the lens aperture to control depth of field. Changing the shutter speed in unison maintains the same effective exposure.

example, to expose at 1/125 second at *f*11 in bright sunny conditions. We have already seen that you can change both settings in sympathy if you wish. If the subject were fast moving, you could set 1/500 second and *f*5.6.

The leaflet gives you enough information to enable you to get accurate exposures for most of your shots but most people feel safer with an exposure meter.

Indeed, most cameras now have built-in meters. Under normal conditions the exposure meter gives you exactly the same advice as the leaflet — as it should. It will only do so, however, if you first set on it the speed (or sensitivity) of your film. This is marked on the box, as an ASA or DIN figure. For our purposes the derivation of these figures is unimportant. They are simply comparative. An ASA 100 film is twice as fast as an ASA 50 film, ie other things being equal, where you could shoot at 1/125 second at *f*11 with the ASA 50 film, you could use 1/250 second at *f*11 or 1/125 second at *f*16 with the ASA 100 film.

What is an exposure meter?
An exposure meter is basically a very simple instrument. It is a light sensor connected to a microammeter which moves a

needle, or triggers miniature lamps which give a 'go' or 'no go' indication. Meters built into cameras are frequently coupled with the camera controls so that as you vary aperture and shutter speed, the needle moves to a 'correct' setting mark or a specific lamp glows. In a hand-held meter, the needle moves across a scale.

The meter has a 'window' which receives light reflected from the subject. This window has an 'acceptance angle' about the same as the field of view of the camera lens, and it thus averages or 'integrates' the light over this area. The meter reading depends on the intensity of this average light level. The exposure recommendation can then be read off, or in the case of some built in meters, the meter itself sets the exposure. Every time it reads the same average light level, no matter what the contrast of the subject may be the meter makes the same exposure recommendations.

How does it work? The principle of the light meter is as simple as its construction. It works on the basis that all photographic subjects are 'average', ie they have a reasonably equal distribution of light and dark tones that average out or integrate to a specific mid-tone, specified as one that reflects 18% of the light that falls on it. That being so the meter simply needs calibration so that it gives the film manufacturer's recommended exposure for an average subject in given light conditions. All the photographer needs to do is to set on the meter the speed of the film he is using and point the meter at the subject.

Built-in meters

There are various types of meter built in to cameras but they all follow the same principle. Most are coupled to the camera controls, so you set the film speed on the camera and adjust either the aperture or the exposure time until the needle moves to the right position or the appropriate lamp glows.

In a single-lens reflex (SLR) camera, the meter window is nearly always the camera lens and the indicator can be seen in the viewfinder. This has the advantage that the meter reads only the picture area, no matter what lens or other attachment you put on the camera, and metering and shooting can be almost simultaneous. Such meters are called through-the-lens (TTL) meters. The principle, however, is exactly the same as that of any other meter.

TTL meters are basically of two types. The first reads through the full aperture of the lens and calculates the exposure for the aperture at which you will actually shoot. The other

A relatively fast shutter speed is necessary here so the automatic-exposure camera must not be allowed to set a slow speed.

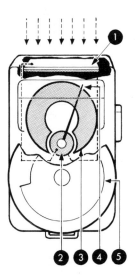

Basic design of an exposure meter. 1, Light-transmitting window. 2, Galvanometer. 3, Scale. 4, Needle. 5, Film speed and exposure settings.

requires that you close the lens aperture down to the aperture at which you intend to shoot and then take the meter reading. As most SLRs have automatic-diaphragm lenses that do not stop down until you press the shutter release, cameras that use stop-down metering usually have a separate meter switch that also acts as a stop-down control. The switch is sometimes incorporated in the shutter release.

Now that miniature lamps (light-emitting diodes, or LEDs) are commonly used as meter indicators, there is little to choose between the two types. When meter needles were universal, the stopped-down metering camera was not too popular because it was difficult to see the needle in the viewfinder in dim light.

Automatic cameras The built-in meter was adapted to fully-automatic working when electronically-operated shutters became a practical proposition. It is now possible to have a camera with no controls at all. The meter can set both aperture and shutter speed automatically. Such a camera can have only a limited 'program' however and it may choose an inappropriate aperture or exposure time for the particular subject, as far as movement or depth of field are concerned.

The current crop of automatic cameras is generally of two types: 'shutter priority' and 'aperture priority'. The terms are more or less self explanatory. With the shutter-priority type, you set the shutter speed of your choice and the meter then calculates the appropriate aperture and sets it automatically on the lens. With the aperture-priority type, you choose the lens aperture, and the meter then calculates and sets the appropriate exposure time.

The choice between the two systems is largely one of personal preference, as either type gives you full control over both shutter speed and aperture. The aperture-priority type has perhaps a slight advantage in that the system is appropriate to the use of any lens. It can read through a fully open lens with the appropriate coupling or through a stopped-down lens without any adjustment of the camera. With rapid-acting sensors, it can even be made to read always in the stopped-down mode, taking its reading after the lens stops down but before the shutter opens. On the other hand, many people find the shutter-priority type a more 'natural' procedure.

All automatic cameras need a battery or batteries and many are totally inoperative without battery power.

The fallibility of the exposure meter We emphasise once again that all exposure meters, no matter what their type, TTL or otherwise, work on exactly the same principle. They measure the light reflected from the subject and accept that the subject is

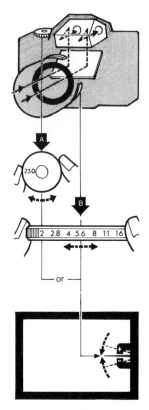

TTL meter readings are affected by light transmitted through the camera lens. The meter circuit is linked electrically or mechanically to the shutter speed control (A) and, in most types, to the lens aperture control (B), so that the reading may be made at full aperture and translated to a reading at the shooting aperture.

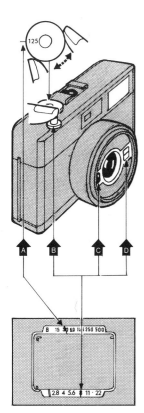

Non-reflex cameras have sensors external to the lens (C, D) often setting the lens aperture and shutter speed automatically as the shutter is released (B). The film speed setting (A) and light intensity control the shutter speed and aperture settings, which are displayed in the viewfinder.

average. They then give an exposure to reproduce that subject as average. If the subject is reasonably normal, say a landscape with a variety of mid-tones, some highlights, some shadows, then it probably is indeed 'average'. If you were to scramble all the light reflected from the subject to a single tone, that tone would probably be about an 18% grey. So an exposure to reproduce the subject as a mid-tone will, within the capability of the film, give a reasonable reproduction of all the tones in the subject.

The snag is obvious. Suppose you take a picture of a sheet of white paper? Why not? Stranger things have been done in the name of art. The meter has been told that all subjects average to grey. It can do nothing else but recommend an exposure to reproduce the sheet of white paper as grey. Now what do you think you would get if you tried to shoot a sheet of black paper?

Of course, the meter will tell you to expose it so that it reproduces as grey again. When developed the two negatives will be of equal density!

In more practical terms, the meter is misled if the subject does not integrate to a mid-tone. The darker its average tone the greater the overexposure the meter will indicate, trying to make the average tone lighter. The lighter the average tone, the greater the underexposure the meter indicates, trying to make the tone darker.

Every type of exposure meter works in this manner. We have not yet managed to design a meter to recalibrate itself according to the distribution of tones it reads.

Exposure meters are fallible. Nevertheless, they are of great value to every photographer. Paradoxically, their most valuable work is performed in the conditions they cannot cope with by themselves. And the moral is obvious. The exposure meter has no brain. You yourself have to supply that. How you do it is what this book is all about.

Acknowledgements

Black and white photographs by Jack Taylor
except where listed below:

Carlo Bevilacqua, pages 90—91; Ed Buziak, page 68; Jaakko
Julkunen, page 120; L B Ferešovi, pages 129 and 187;
Raymond Lea, pages 58—59 and 135; Zdeněk Lin, title page
and pages 27, 106—107; R A MacGregor, pages 48—49 and
74—75; Pentti Paschinsky, page 96; John Rocha, page 8; Peter
Tooming, page 121; page 23 courtesy of Swiss National Tourist
Office and Swiss Federal Railways.

Colour photographs by Ed Buziak
except where listed below:

Paul Petzold, pages 154 and 156.

Cover photograph by Peter Stiles.

Index

Donation J. Esterhuijen A. —